LUIS JACOB

SEEING AND BELIEVING

mocca
museum of
contemporary
canadian art

black dog
publishing
london uk

CONTENTS

6

DAVID LISS

Artistic Director and Curator
Museum of Contemporary
Canadian Art

CAROLINE

ANDRIEUX

Founder and Artistic Director
Darling Foundry

FOREWORD

Seeing is one thing, believing is another. It is experience that connects the two. In the series of three projects in Toronto and Montreal that are covered in this volume, Luis Jacob explores exhibition spaces as sites where meaning is negotiated and created through experiential encounters with images, objects, methodologies of display and the architectures that frame them. Through his precise selection and astute arrangement of works within each of the venues, Jacob places the viewer at the centre of a stage, into the space between the real and the imagined, into the very locus where meaning is constructed through perception and experience. Jacob believes in the power of images and objects, and the role that perception plays in shaping meaning and understanding. How we engage with his work—how we perceive and understand it—reflects ways in which we relate to each other and the world around us. These exhibition projects and this publication take place as Luis Jacob's rigorous, theoretically-based practice increasingly receives international acclaim. His extraordinary vision in conceiving these unusual approaches to exhibition-making and the very generous time, professionalism and good humour that he has committed to these projects have served as an inspiration to us.

Behind every great artistic vision there are of, of course, many people and organisations required to realise those visions. We are very grateful to Marie Fraser for her curatorial role and insightful text related to Tableaux Vivants at the Darling Foundry and to Anne-Marie Ninacs for her curatorial work and enlightening text for L'œil, la brèche, l'image/The Eye, The Hole, The Picture at the McCord Museum. We wish to acknowledge the hard work, dedication and encouragement of the members of the Board, staff and volunteers at the McCord Museum, the Darling Foundry and the Museum of Contemporary Canadian Art. We furthermore appreciate the McCord Museum for their supporting partnership of this publication. We would also like to take this opportunity to thank Duncan McCorquodale and his staff at Black Dog Publishing for their diligent work, unwavering dedication and enthusiastic participation in designing and producing this impressive publication that will significantly enhance the various discourses embedded within Luis Jacob's practice.

All exhibitions, programmes and activities at the Museum of Contemporary Canadian Art are supported by Toronto Culture, BMO Financial Group, the Ontario Arts Council, the Canada Council for the Arts, Cisco, individual membership and private donations. Programmes at the Darling Foundry are supported by Conseil des arts et des lettres du Québec, the Canada Council for the Arts, Montreal Arts Council, foundations, individual and corporate members.

Finally, the Museum of Contemporary Canadian Art, the Darling Foundry, the McCord Museum and all involved in this exhibitions and publication project consider this book to be a celebration of the many contributions that Luis Jacob has made to the culture of our times as a thinker, as a writer, as a teacher and as one of the foremost Canadian artists of his generation.

TABLEAUX
VIVANTS

DARLING

FOUNDRY,

MONTREAL,

17 JUNE–

29 AUGUST 2010,

CURATED BY

MARIE FRASER

MARIE FRASER

ART LOOKS AT YOU IN THE WAY YOU ARE LOOKING AT IT:

ALBUMS, CABINETS AND LIVING PAINTINGS

IN THE WORK OF LUIS JACOB

1/ Luis Jacob cited in Sara Angel, "The art of seeing. Toronto artist Luis Jacob's new retrospective asks 'Why do we look at pictures?'", 16 February 2011, http://saraangel.ca/the-art-of-seeing/, consulted in October 2012.

"Art looks at you in the way you are looking at it." This is an expression that I picked up from a comment by Luis Jacob, when asked why he addressed the paintings of the Abstract Expressionist painter Mark Rothko in his 2008 work *They Sleep With One Eye Open*.[1] This expression more or less sums up one of the greatest riddles of art, one that appeals to and is repeatedly referred to throughout the work of Luis Jacob, especially in his Albums. My intention here is not to reflect specifically on the challenges of modernism but to consider the relationship, the reciprocity implicit in the experience of art. Working in different media—video, installation, sculpture, photography, painting and performance—Jacob's works are often considered so heterogeneous that they could have been created by more than one artist. Beyond his highly complex multi-disciplinary approach, in this case 'reciprocity' suggests a very simple and direct concept: that to look is to engage. It is this idea that stimulates the vast conceptual project of Jacob's Album series, commenced in 2000, and that reaches a degree of resolution in his installation *Tableaux: Pictures at an Exhibition*, 2010, specially conceived for the ex-industrial space of the Darling Foundry in Montreal.

2/ The *Albums* were exhibited at the Guggenheim Museum in New York in 2010, within the framework of the group exhibition Haunted: Contemporary Photography/Video/Performance, as well as at Documenta 12 in Kassel, 2007.

Jacob's Albums have earned him international recognition.[2] From the first to the tenth in the series (produced in 2010), they constitute a huge archive composed of thousands of images from diverse printed sources: books, magazines and other paper publications. The found images are assembled and juxtaposed like photomontages, on laminated plastic panels, hung sequentially directly on the wall. Jacob has never catalogued the number of reproductions collected in the Albums, but one can easily imagine the extent of such an archive if we consider the very number of images involved. To work out an approximate number: the smallest, *Album IX*, 2010, comprises 16 panels, while the largest, *Album III*, 2003–2004, comprises 159. Each panel can contain between two and eight images. The Albums therefore represent a daunting process of collection and association, motivated by a heuristic approach, which forms part of the artist's practice.

Jacob commenced production of the Albums at a time when he felt the need to expand his working method in order to prevent his subjectivity from overdetermining the work. His process involves choosing images, initially using predetermined and objective criteria. As he explains in a discussion of his first Album, based on the principle of regrouping vertical and horizontal elements: "I produced *Album I* in 2000, when I realised that the steps of development in my work were becoming too close to one another, the process was becoming too tight. So I decided to throw it open and project my thinking in a different direction [...]. The images for the first Album were selected because they all depicted things that are vertical and things that are horizontal. This simple process became a way to crack my authorship a little, and to work with other people's 'works', [...]—other people's images—and

10

3/ Luis Jacob in Rosemary Heather, "Artists at Work: Luis Jacob", *Afterall/Online*, 12 March 2008, http://www.afterall.org/online/artists. at.work.luis.jacob, consulted October 2012.

4/ Heather, "Artists at Work: Luis Jacob", 2008.

5/ Heather, "Artists at Work: Luis Jacob", 2008.

6/ These include Philippe Alain-Michaud, *Aby Warburg et l'image en mouvement*, Paris: Macula, 2000; the republication of Warburg's *Essais Florentins* in French, translated from the German by Sibylle Müller, Klincksieck, [1990], 2003; also see the many works of George Didi-Huberman, of which *Ce que nous voyons ce qui nous regarde*, Paris: Minuit, 1992, which is not explicitly concerned with Aby Warburg but on an experience of art which approaches Jacob; also, by the same author *L'image survivante. Histoire de l'art et temps des fantômes selon Aby Warburg*, Paris: Minuit, 2002, without doubt the most important work to revisit the methodological principles of Aby Warburg and one of his fundamental concepts of survivance.

have them determine the narrative that I wanted to shape, allow that to land me somewhere unexpected."[3]

In recycling these printed documents, these elements that constitute a part of culture, Jacob does not attempt to contribute to the production of new images but rather to work with "other people's images" to participate in the production of new relationships. This distinction is important. It enables us to understand the Albums as a sort of collective project whose aim is to liberate existing systems, to reorganise the world around us according to new modes of relation. This process is double: it takes into account the existence of images in their original context as much as their co-existence within a system or a language, which can be constantly replayed or reorganised. Luis Jacob describes this co-existence in terms of an energy enabling him to generate new meanings.[4] He also underlines the importance of preserving the distinctive quality of photographic documents: "Working with original images gives an artefact quality to the photographs, one that emphasises not only their image content, but also their original context. Their artefact quality brings not only the imagery into dynamic play within the Album, but also brings into play the various life-worlds that the images originally inhabited. Once they are laminated on the panels they almost have a scrapbook feel, and especially with the pins [used to mount the Album to the wall] it refers on the one hand to a bulletin board, and on the other hand, it alludes to those insect... specimens."[5] The Albums sustain a mode of presentation closer to the 'image bank', the archive or atlas, than to a museum exhibition. It is very tempting to consider this aspect of the images and their exhibition in connection to Aby Warburg's *Atlas Mnemosyme*, a prodigious project at the intersection of art history and visual anthropology. In his work as art historian and anthropologist, we know the role that Warburg played in proposing a radical reformulation of historic models and of the role of images in the interpretation of art and culture. His *Atlas*, considered a "history of art without text", functions through the juxtaposition of documents from many different fields of knowledge. Without implying that Luis Jacob was directly inspired by Warburg's *Atlas*, the beginning of Jacob's work on the Albums in 2000 coincided with an unprecedented interest in Warburg's methodology within the field of art history and the publication of a number of important works showing this influence.[6]

Jacob's Albums are not thematic, although certain leitmotifs reoccur from one to another, and we can see the omnipresence of certain models of representation and discover narrative threads when looking through the works. Like Warburg's work, the Albums develop through juxtaposition, association, play, combination, repetition, accumulation, inventory; and they explore many languages: pictorial, plastic, formal, aesthetic, narrative. Their way of functioning is often linked to the artist's involvement in anarchist practices and to his studies in political theory. While this explanation deserves closer examination, we can discern several characteristics shared between the two methodologies. Effectively, the project is carried by a desire to liberate systems. The principle of montage blocks any possibility of reading hierarchically between the different images. Visual associations can appear suddenly outside the established conventions and without necessarily being bound to any particular order. The gaze can encounter discontinuities, interrupt the sequence and defer the process of association.

Each Album develops its own series of narratives. Perhaps it is appropriate to say that each Album constitutes a collection that functions like a narrative process, and that the images exist and get their meaning from their interaction with each other, able at each moment to transform and generate new meanings. This is why it is difficult, even impossible, to separate distinct themes in the works, other than

11

to see a certain appeal in the spaces within which the experience of looking— whether at art, design, architecture or the wider environment—occurs. During his exhibition at the Darling Foundry, Jacob noted how many of the images assembled in *Album VIII*, 2009, represented spaces built and designed to be seen, be they models or elements of architecture, design or artworks which presented looking as a process of active engagement. The installation *Tableaux: Pictures at an Exhibition*, presented alongside *Album VIII* in the same exhibition, explored precisely that act of looking, to which I will later return. *Album X*, 2010, exhibited at MOCCA, explores these ideas more specifically within the context of the art world, and revisits images made in the modernist tradition, the aesthetic of the sublime and monochrome painting. This work presents itself as a sort of museum archive through the continuous inclusion of frames, screens, paintings, minimalist and conceptual works, various surfaces on which we focus our gaze, wall hangings in exhibition rooms, images showing spectators in front of artworks, mirror games such as in Jeff Wall's *Picture for Women*, 1979, different *mises en abymes*, and visual clichés such as Barnett Newman or Mark Rothko posing in front of their canvases. *Album X* thus expands its reflection on the conditions of aesthetic experience and, above all, on the reciprocity that it instils, as Jacob discusses in a recent interview: "At times, the entirety of the Albums, or the broader activity of assembling them in the studio or experiencing them in the gallery, is represented 'in microcosm' within a particular section of the narrative. This is the case, for instance, in the extended section in *Album X* that thematises the very processes of making and viewing an Album. This process of constructing a synecdoche creates a vertiginous 'hall of mirrors' where the viewer in the gallery may find herself or himself pre-figured in miniature inside the Album, and more significantly, where the artist's role and the viewer's role begin to trade places within shifting, theatrical frames of reference. [...] each Album presents itself as 'a model', as a picture of the world."[7]

7/ Luis Jacob in an interview with Thimothée Chaillou, *ETC*, no. 94, October–January 2011, p. 40.c

We can consider the Albums as seeking a new experience of art, inviting us to view images differently, to reposition certain major issues in art history and to rethink the role of vision: "The Albums call you… the Albums frame the viewer as being able to grasp a large and complex whole."[8]

8/ Heather, "Artists at Work: Luis Jacob", 2008.

Scarcely two years after making his first Album, Jacob began to work with museum collections as part of his artistic production. An early example of this is the video *Towards a Theory of Impressionist and Expressionist Spectatorship*, 2002, in which children use their own bodies to mimic and interpret the sculptures exhibited in the Henry Moore room at the Art Gallery of Ontario. This is an elaboration of the idea of the *tableau vivant* in the strictest sense of the term: a living representation of an inanimate object. The children perform the sculptures. The experiment reveals Jacob's intention to push the spectator's activity until it can be considered as a new mode of experience akin to the *tableau vivant*. His explanation seeks to reconcile two theoretical models: "An 'impressionist' model of spectatorship defines us primarily as viewers engaging with art objects in a contemplative, receptive manner; an 'expressionist' model defines us primarily as actors, as people engaging with art objects in an active and fully embodied manner. Together, these two views suggest the possibility of a participatory model of spectatorship in which our role as visitors in the gallery is to animate and give life to the objects we encounter there, by investing our contemplative faculties and our performative bodies."[9]

9/ Email from Luis Jacob, 26 August 2012.

Jacob subsequently undertook a series of projects collectively titled Cabinets, where he applied the Albums' logic and principle of montage to the works of other artists, without taking genre or art-historical considerations into account. *Cabinet (Mönchengladbach)*, 2009, was the first work in this series, and used artworks from

the permanent collection of the Städtisches Museum Abteiberg. Two other Cabinet works followed in 2011: *Cabinet (NGC Toronto)*, which assembled works from the permanent collection of the National Gallery of Canada, and *Cabinet (Montréal)*, which involved the presentation of photographs from the archives of the McCord Museum in Montreal (the latter work was exhibited alongside *Album X*). With his Cabinets, Jacob adopts the pose of curator, and substitutes the role of the museum. He selects works from various museums' collections, reclaims the models and systems of hanging, of pedestals, of vitrines, and he reconstructs or readjusts the exhibition spaces, so that it is the forms of display that are themselves put on display. This reconstitution of a 'museographic' space within the walls of the gallery reveals the effect of these spaces on the experience of seeing. Jacob, however, does not exhibit the works here for their own sake; rather, he puts on display the manner or the act of exhibiting them. The Cabinets are conceived as a new structure added to an existing structure: an exhibition within an exhibition. Each of these interventions is intended to make viewers aware of their own gaze, of their own experience of art, at the same time as they become conscious of the mechanisms that stimulate, even control that experience. This is reminiscent of the ideas of the philosopher Giorgio Agamben regarding the proliferation of apparatuses in contemporary society. In revisiting the unfinished theories of Michel Foucault, Agamben delivers a wider definition of 'apparatuses' and puts us on guard against their effects: "I will call an apparatus literally anything that has in some way the capacity to capture, orient, determine, intercept, model, control, or secure the gestures, behaviours, opinions, or discourses of living beings."[10]

Tableaux: Pictures at an Exhibition is the work where Jacob pushes furthest this conceptualisation of the gaze with a new exhibition space constructed in the middle of the Darling Foundry. On entering, the viewer discovers a huge space built inside the gallery, a white cube with a glass wall providing all the necessary conditions for aesthetic contemplation: a rug covers the ground, the most neutral lighting system available illuminates the scene, a bench in the very centre of the space encourages the spectator to contemplate a series of 12 monochrome paintings hung on the white walls. Jacob refers here to the purest modernist tradition: monochrome painting, and the white cube, which Brian O'Doherty describes in his essential work *White Cube: The Ideology of the Gallery Space*, as the "complimentary extension of the modernist painting", "unshadowed, white, clean, artificial".[11] Jacob does not try to deconstruct the paradigm of aesthetic experience; in fact, he seeks to expose it and maximise its effects by contrasting it with the existing Foundry space that still retains its industrial character. We thus find ourselves facing a zero-degree of painting, painting reduced to its most simple expression, of which the sole remaining referent is the work, and opposite the most simple image of its representation, of its exhibition for viewing: the white cube.

This reflection relies on the heritage of modern art. The consciousness of the act of looking, looking at looking, is, in effect, a leitmotif of modernity. Michael Fried, one of its principal theoreticians, has recently revisited his famous essay "Art and Objecthood", 1967, in the light of contemporary artists whom he perceives as being engaged in bringing back to the fore and renewing certain fundamental qualities and values of modernism.[12] Without implying that Jacob participates in the same effort as these artists, it seems essential to me to consider Fried's ideas and his insistence that painting is created essentially to be viewed and that it must forcefully assert that primordial convention.[13] With *Déjeuner sur l'herbe*, 1863, Manet introduced a new ontological dimension to painting. The painting is created to be looked at and, simultaneously, it is the corollary of my own look. The woman in the painting looks at me and I simultaneously experience that it is the painting in its entirety

10/ Agamben, Giorgio, *Qu'est-ce qu'un dispositif?*, Paris: Éditions Payot et Petite Bibliothèque Rivage, 2007, p. 31.

11/ O'Doherty, Brian, White Cube. *L'espace d'exposition de la galerie et son idéologie*, Dijon: Les presses du réel, 2008, p. 15.

12/ Fried, Michael, *Four Honest Outlaws: Sala, Ray, Marioni, Gordon*, New Haven and London: Yale University Press, 2011.

13/ Fried, Michael, *Four Honest Outlaws: Sala, Ray, Marioni, Gordon*, p. 16.

14/ Fried, Michael, *Four Honest Outlaws: Sala, Ray, Marioni, Gordon*, pp. 16–17.

15/ Soulignons, ne serait-ce que trop rapidement, que cette projection relèverait selon moi davantage d'une politique de la vision que d'un anthropomorphisme ou d'une phénoménologie, ce qui serait plus proche de la réflexion que développe de Georges Didi-Huberman dans *Ce que nous voyons ce qui nous regarde*.

16/ Amado, Miguel, "Luis Jacob. Darling Foundry", *ArtForum*, November 2010, pp. 271–272.

14

that looks at me. Manet, continues Fried, was thus able to reconcile the idea of the painting as a painting with the active presence of the spectator.[14]

Tableaux: Pictures at an Exhibition offers a representation of this particular quality of modernism, with regards to our experience, not simply to painting. Although referring to the apogee of modernism, the monochrome paintings are not exhibited for their own sake. At most, one can think that they are anecdotal. They are an incarnation of the idea of painting as painting, and represent a part of an apparatus where our own gaze is determined. This reversal rests in the fact that the white cube is presented as an object that you perceive from the outside, but that you can also penetrate from the inside without subtracting anything from its exteriority. It is the exhibition within an exhibition. The glass wall represents a kind of screen on which is projected our own gaze, at the same time as it provokes a *mise en abyme* in which the spectator performs their own experience under the gaze of others.[15] As Miguel Amado remarked, the spectator becomes in turn an object of aesthetic contemplation.[16] It is in this reciprocity, it seems to me, that the reference to the *tableau vivant* in the title of the exhibition, gets its meaning. Obviously, however, the objective is not to give a living representation of a biblical, mythical or narrative scene, as in the traditional nineteenth-century *tableau vivant*. The spectator performs his or her own gaze; all the conditions are set in place for the exhibition space to open up to its own spectacle.

The Inhabitants, 2008.
Chromogenic print, selection of two images from a series of five, installation view at Darling Foundry, Montreal.

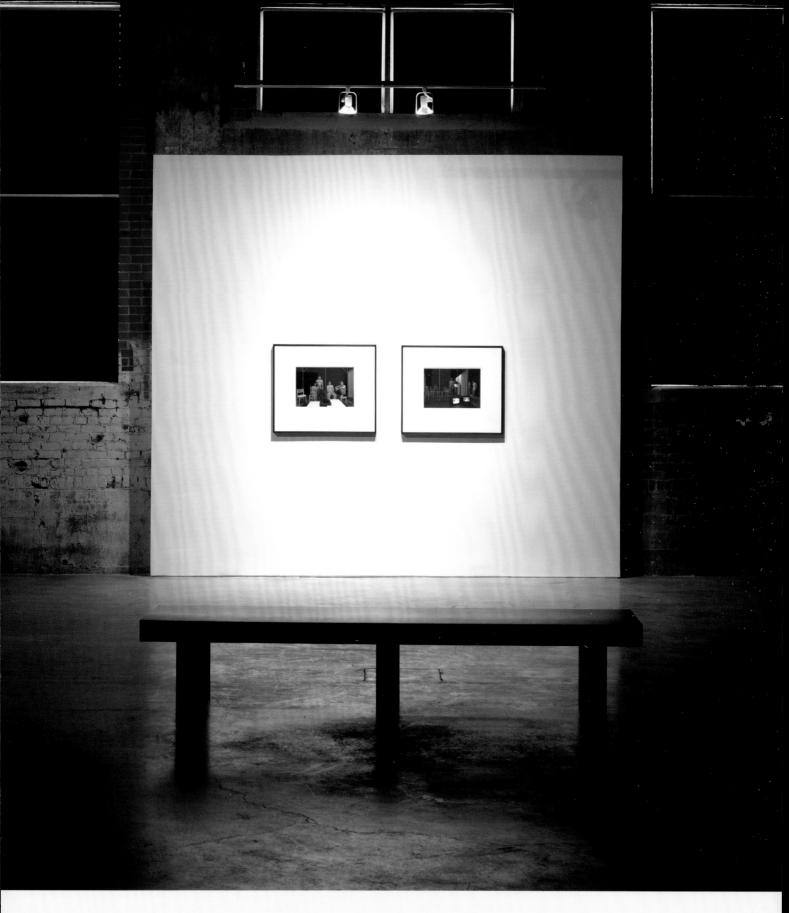

The Inhabitants, 2008.
Chromogenic print, 33 x 49.2 cm
(13 x 19 3/8 in) each.

overleaf/ Exhibition view,
Darling Foundry, Montreal.

LUIS JACOB

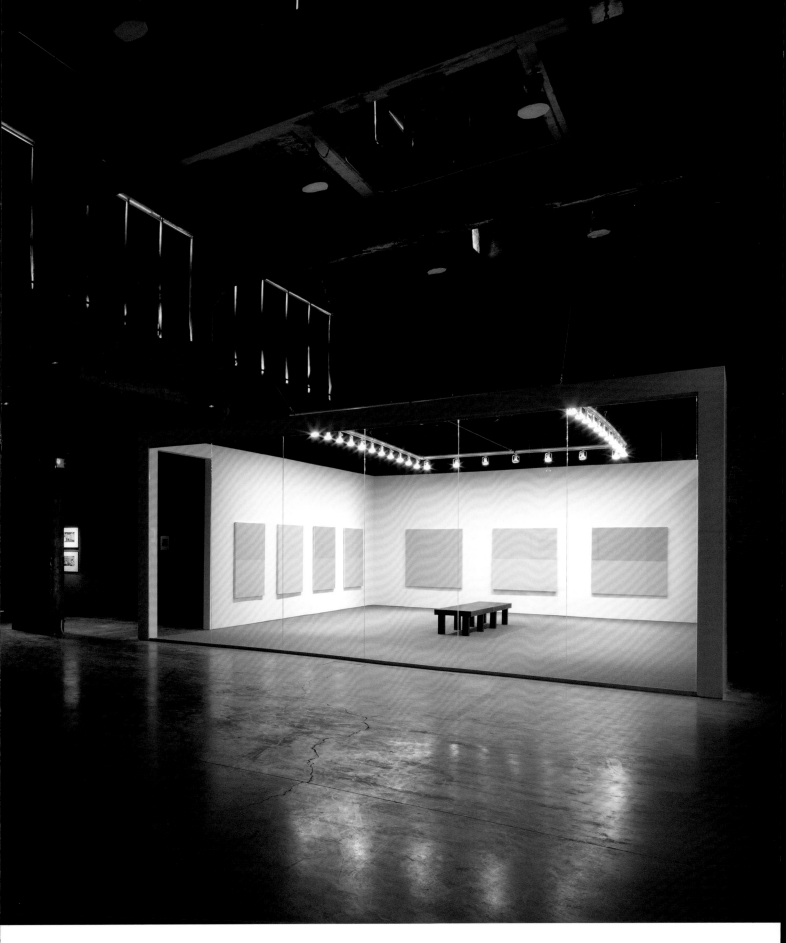

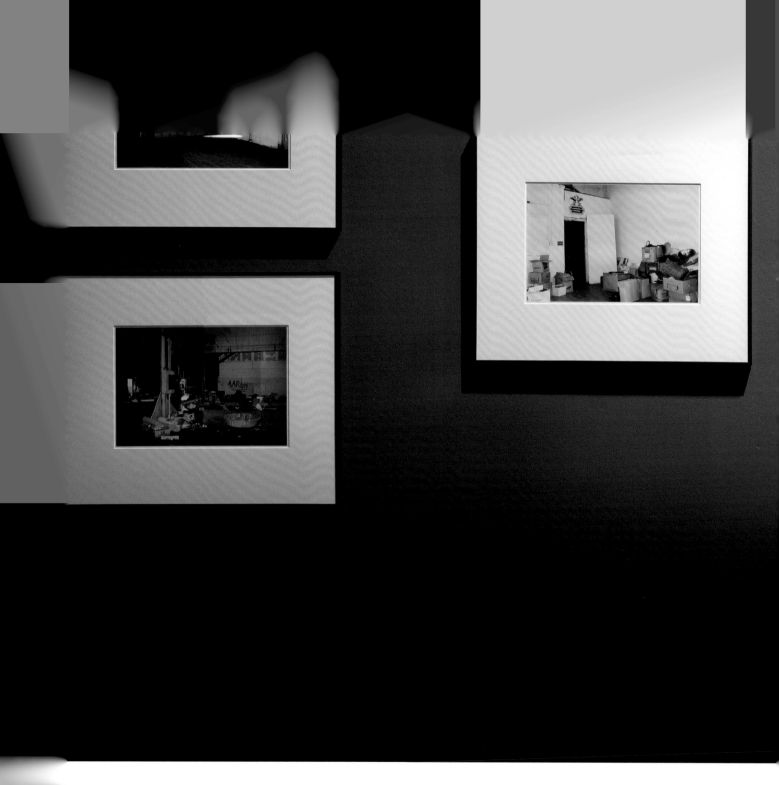

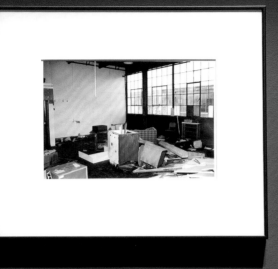

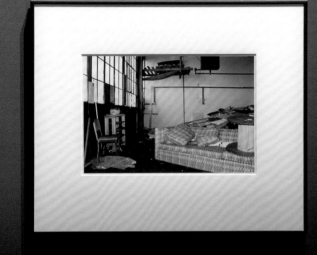

previous pages/ *Evicted Studios at 9 Hanna Avenue; November 1999*, 1999. Colour photography, selection of 13 images from a series of 15.

opposite/ *Evicted Studios at 9 Hanna Avenue; November 1999*, 1999. Colour photography, 23.2 x 34.6 cm (9 1/8 x 13 5/8 in) each.

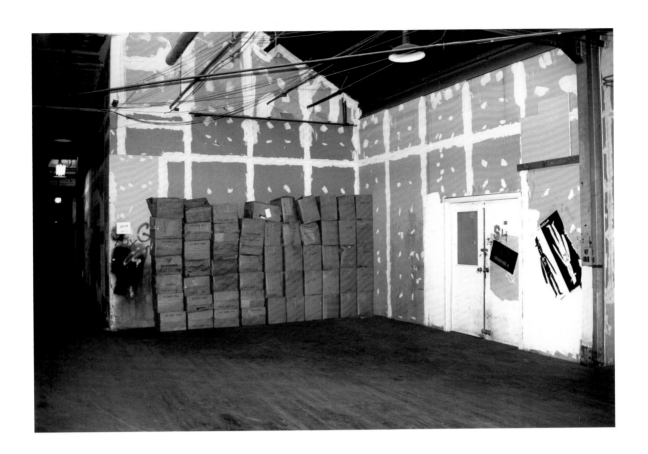

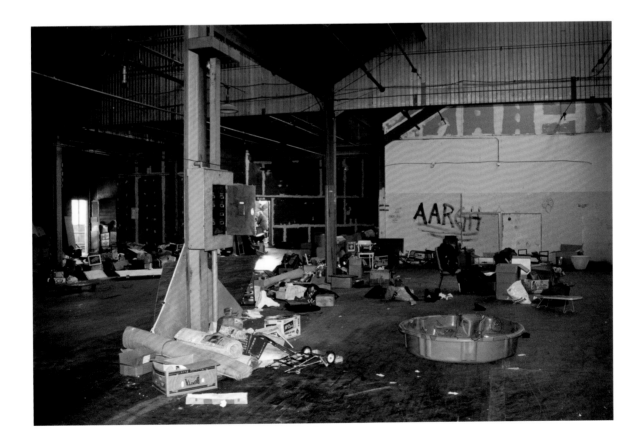

Evicted Studios at 9 Hanna Avenue;
November 1999, 1999.
Colour photography, 23.2 x 34.6 cm
(9 1/8 x 13 5/8 in) each.

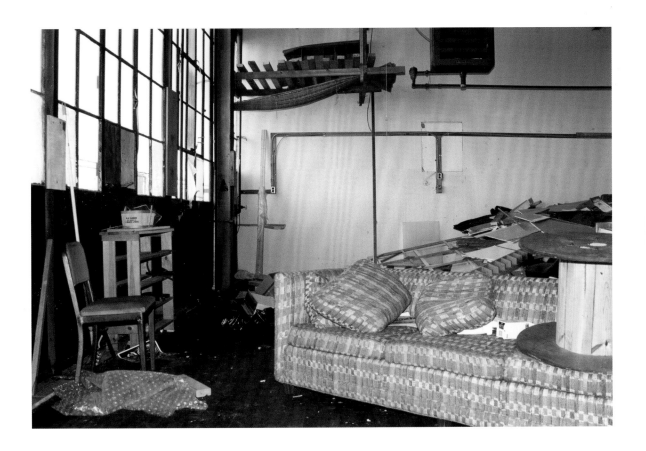

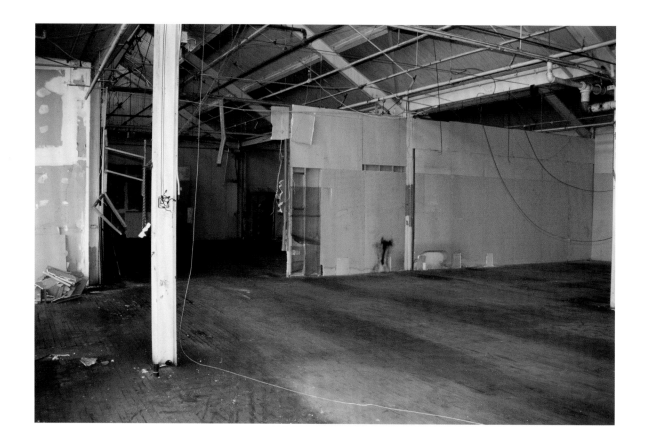

Evicted Studios at 9 Hanna Avenue;
November 1999, 1999.
Colour photography, 23.2 x 34.6 cm
(9 1/8 x 13 5/8 in) each.

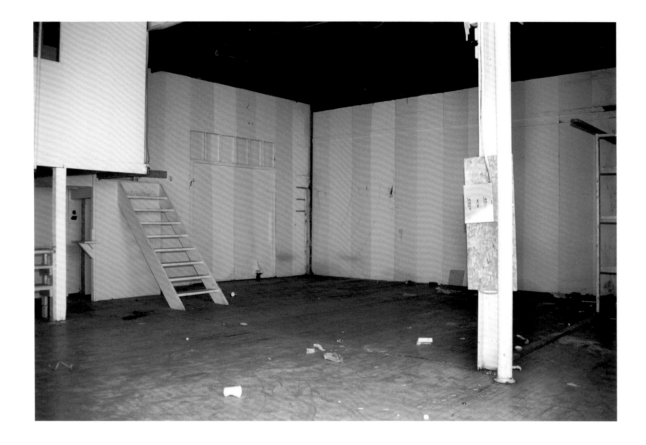

Evicted Studios at 9 Hanna Avenue;
November 1999, 1999.
Colour photography, 23.2 x 34.6 cm
(9 1/8 x 13 5/8 in) each.

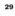

Evicted Studios at 9 Hanna Avenue;
November 1999, 1999.
Colour photography, 23.2 x 34.6 cm
(9 1/8 x 13 5/8 in) each.

overleaf/ Exhibition view,
Darling Foundry, Montreal.

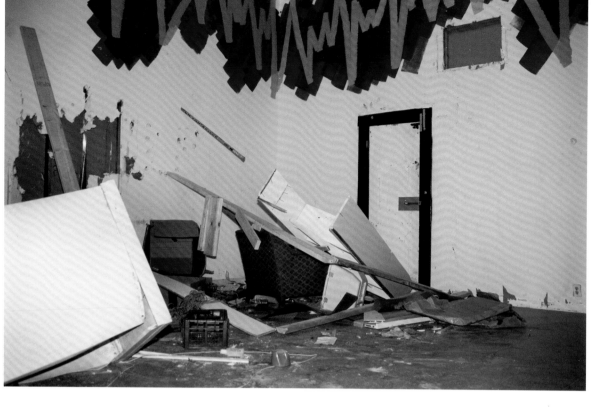

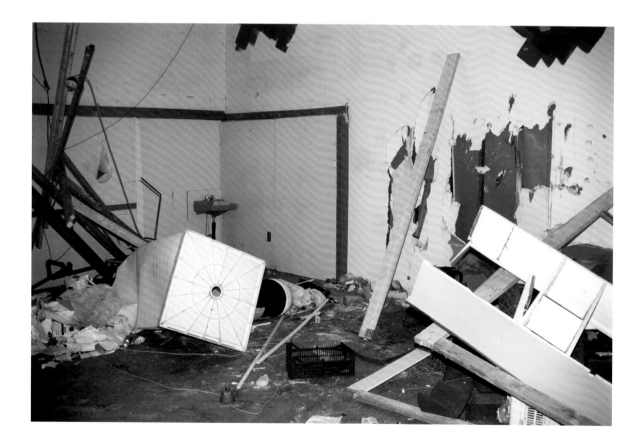

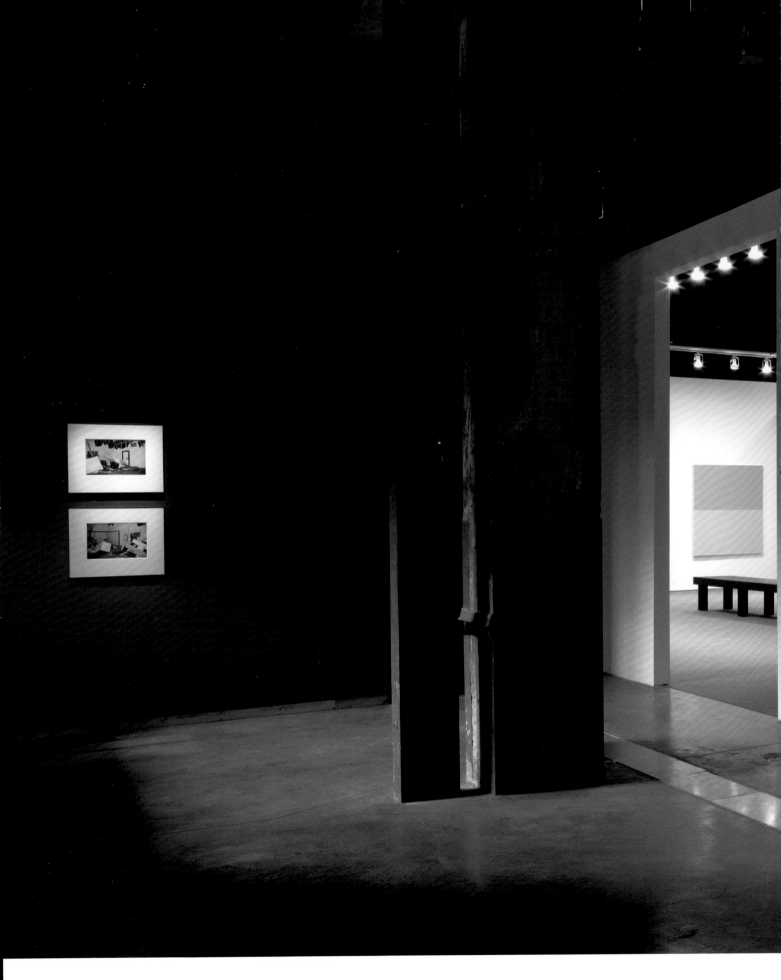

LUIS JACOB

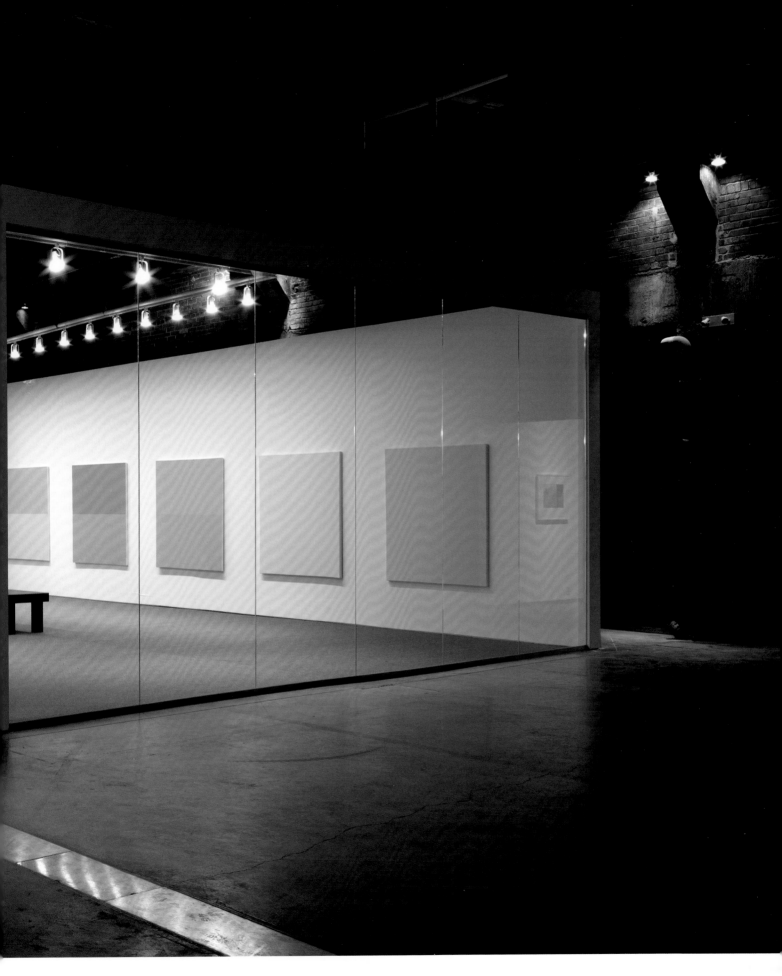

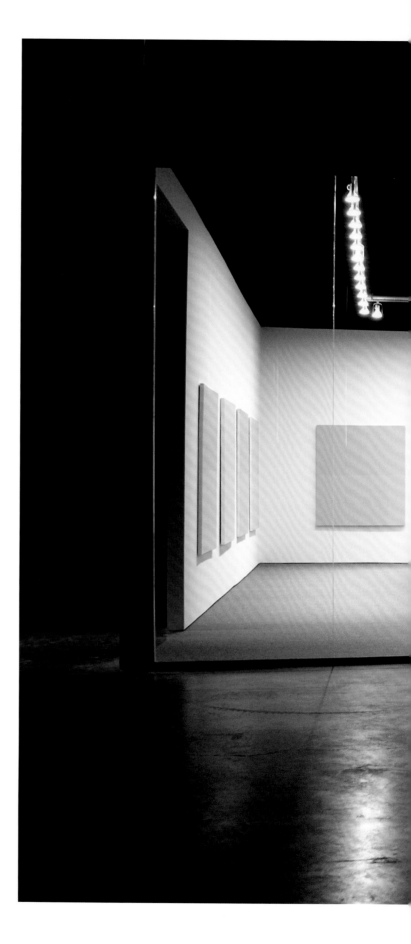

right and pages 36–49/
Tableaux: Pictures at an Exhibition, 2010.
Installation comprised of 12 paintings in a
custom-built room: Overall: 12.12 x 7.51 x
3.53 m (477 x 296 x 139 in)/ Paintings: oil on
canvas, 137.2 x 152.4 cm (54 x 60 in) each/
Glass wall: 3.28 x 7.11 m (129 x 280 in).

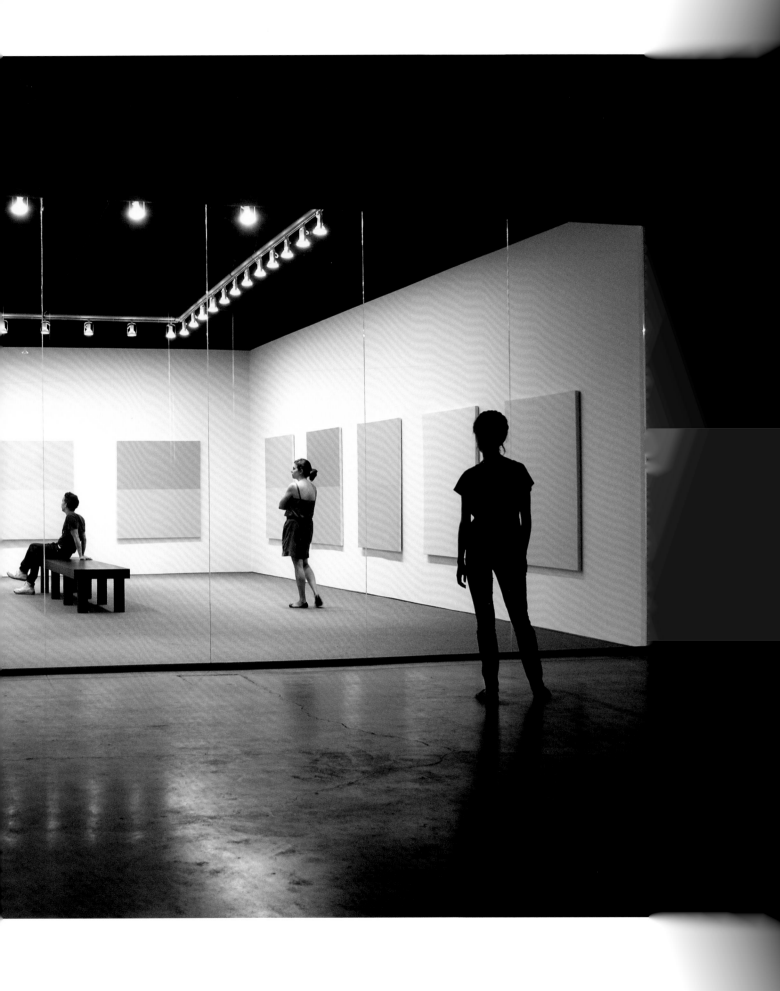

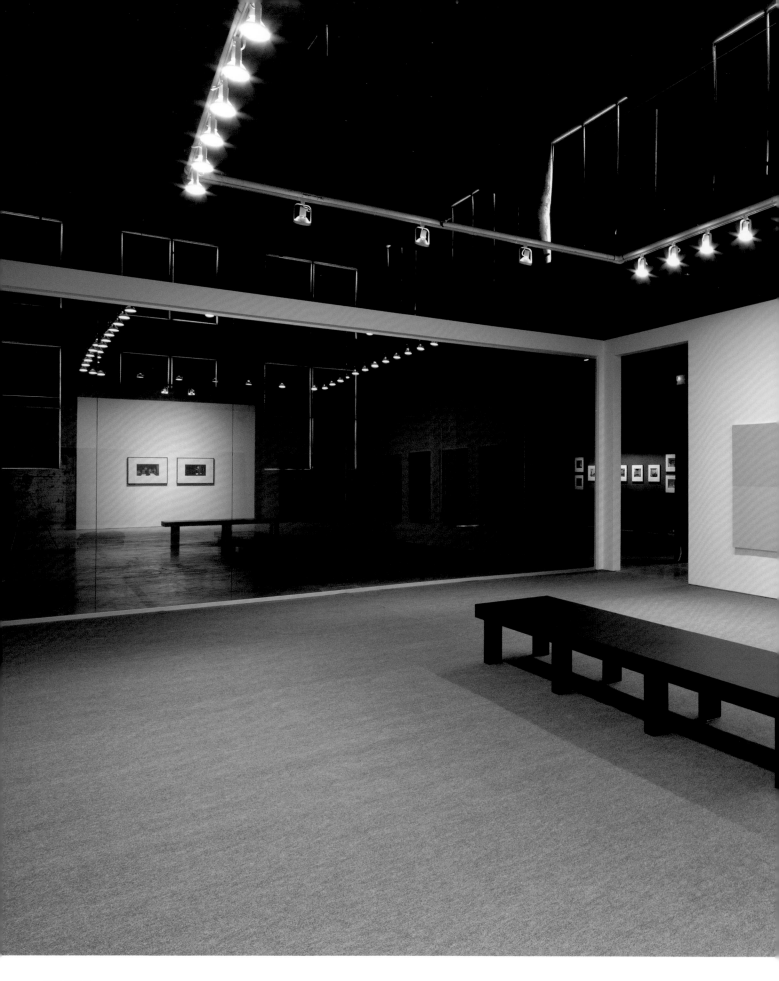

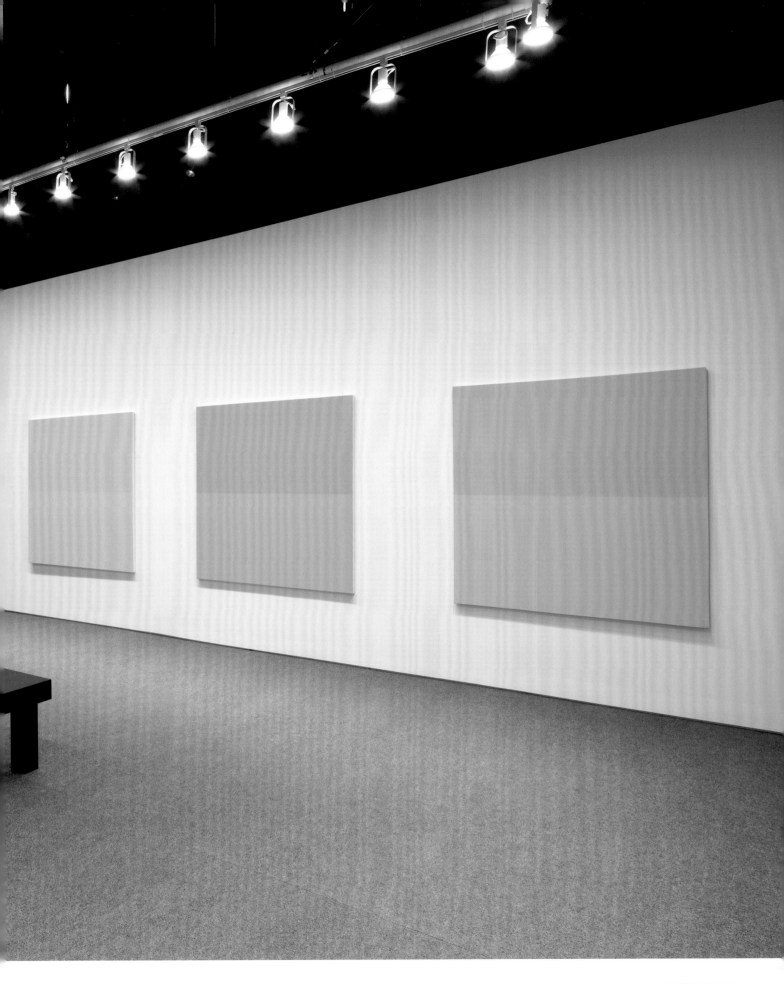

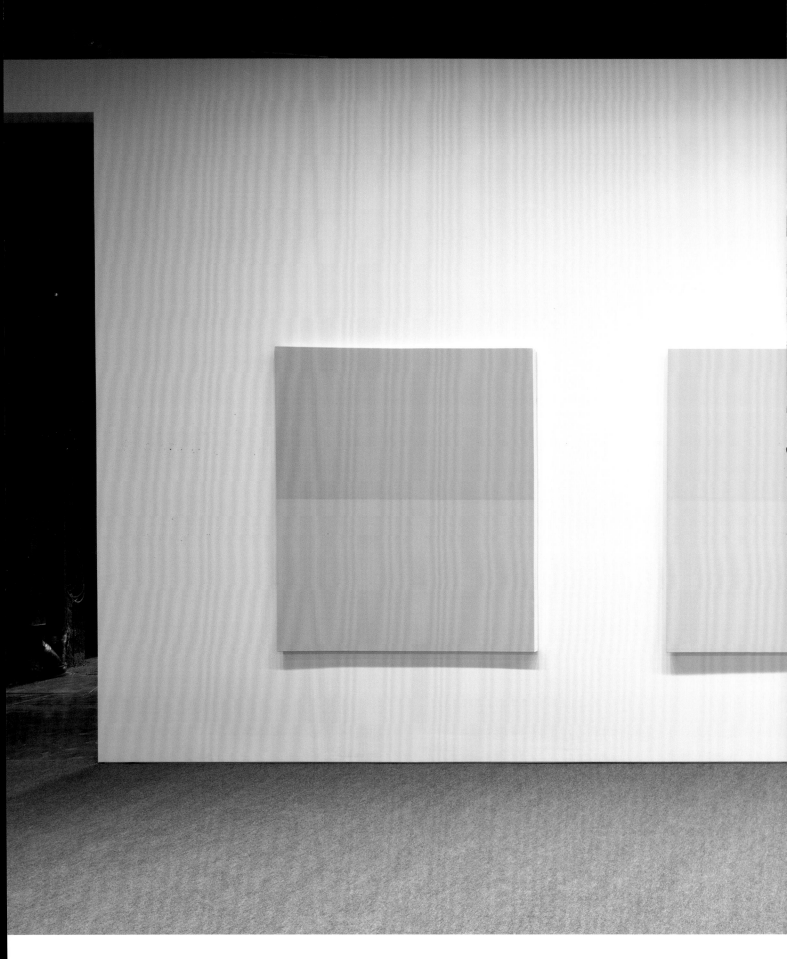

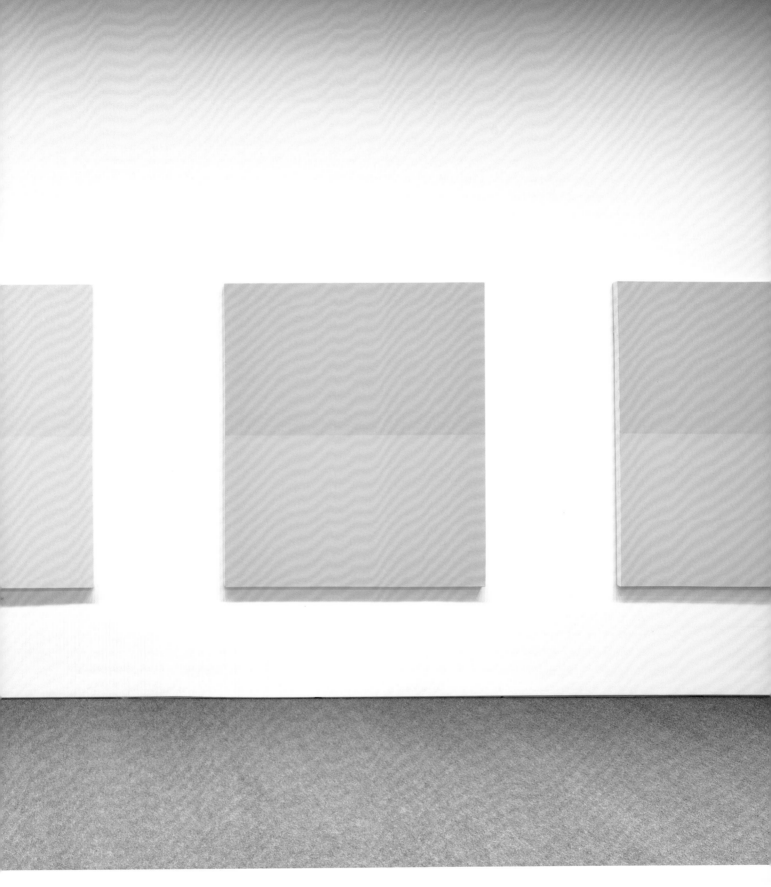

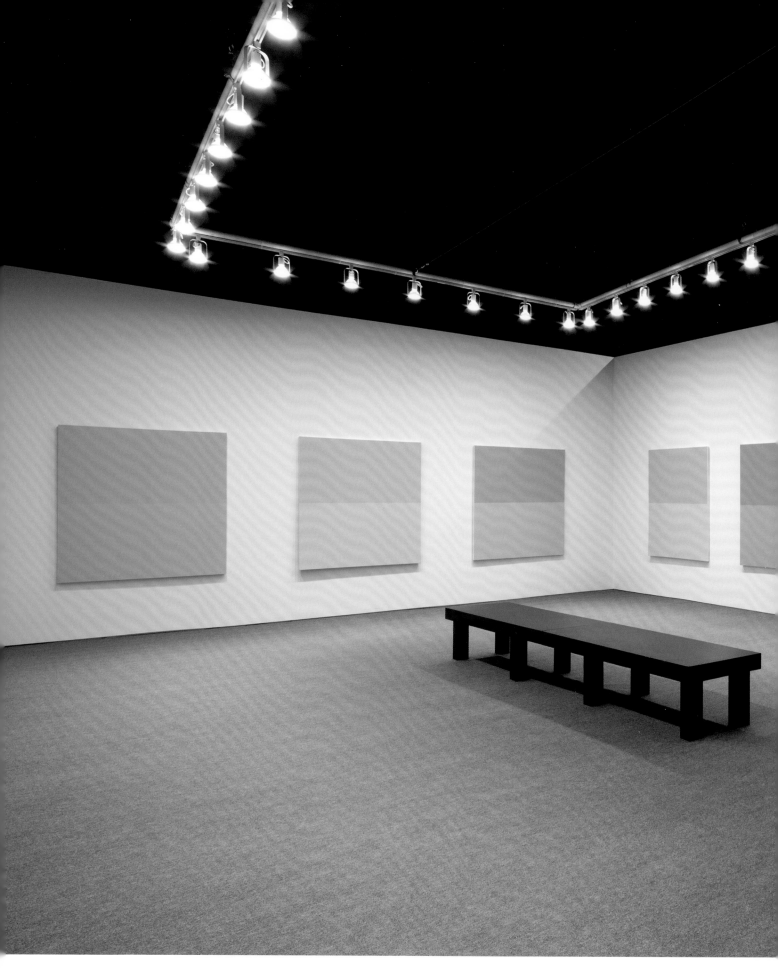

LUIS JACOB

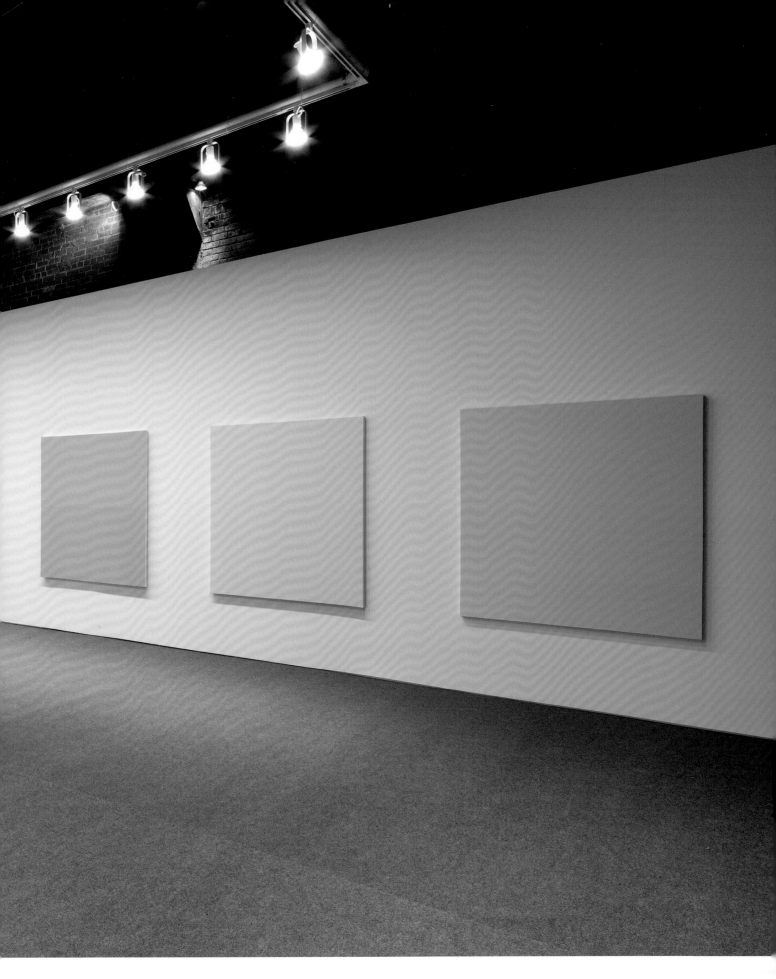

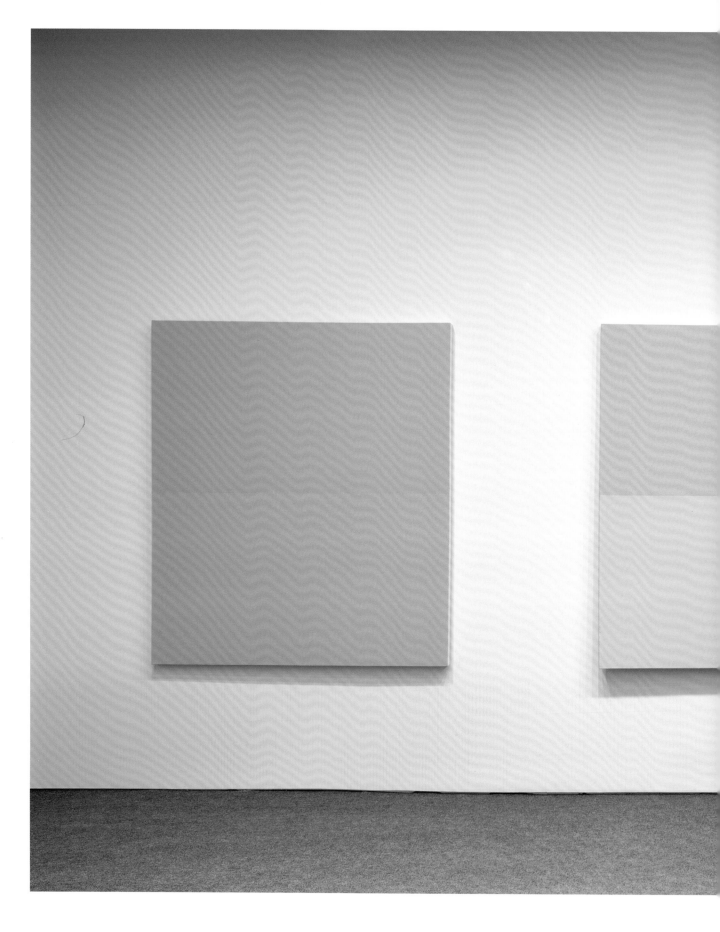

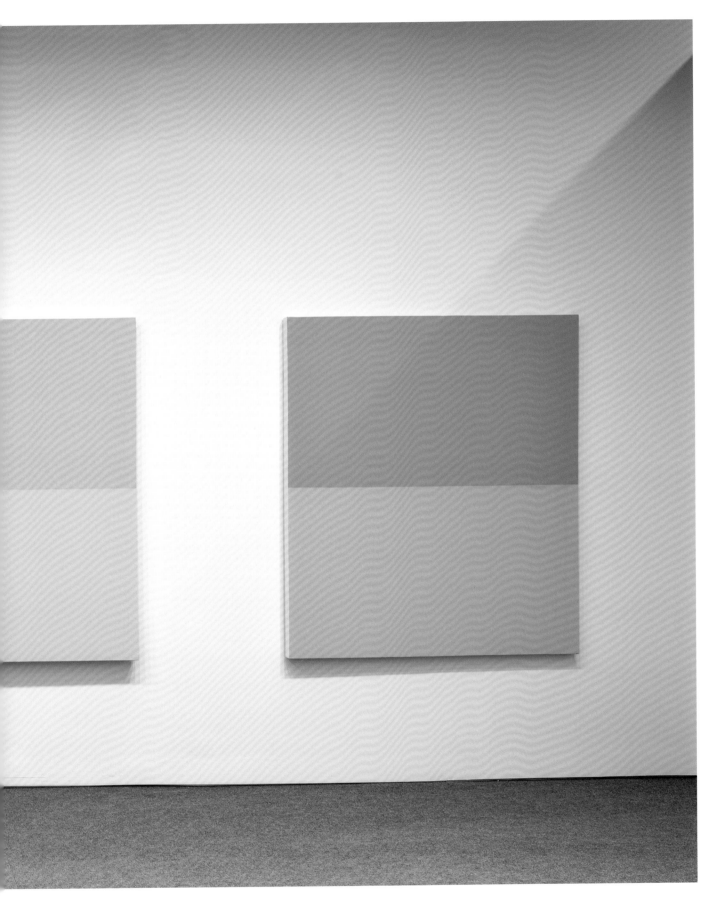

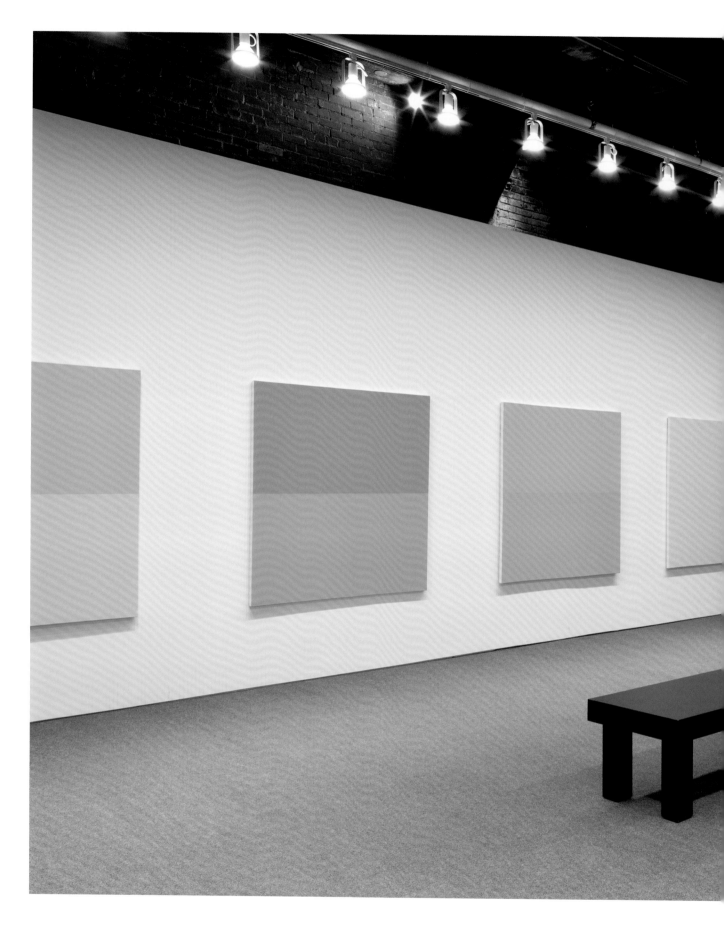

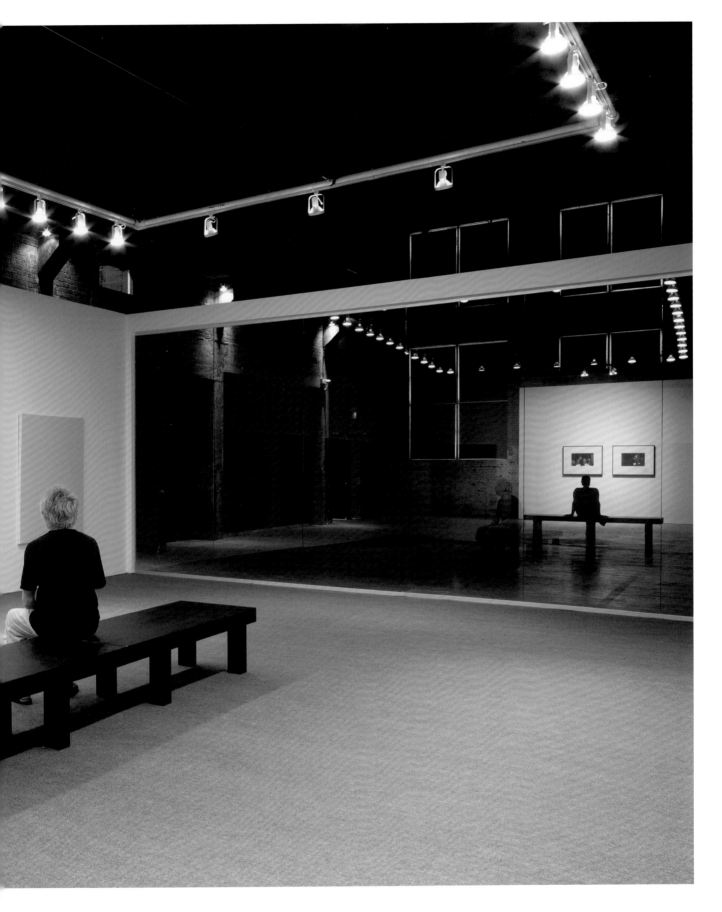

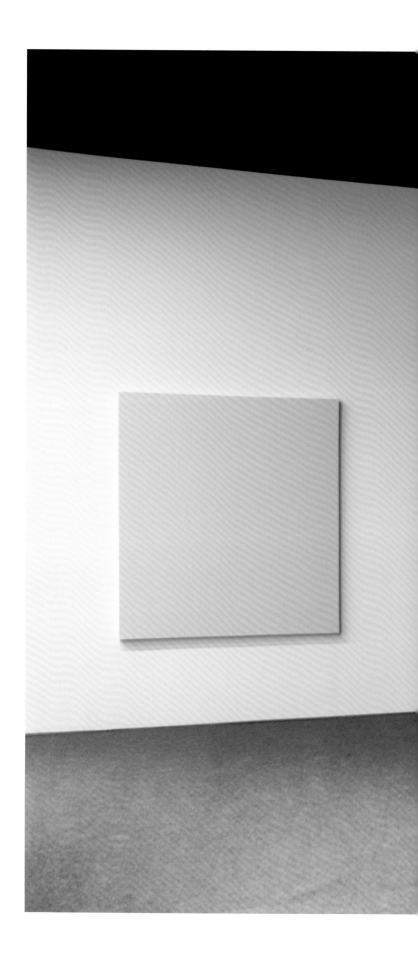

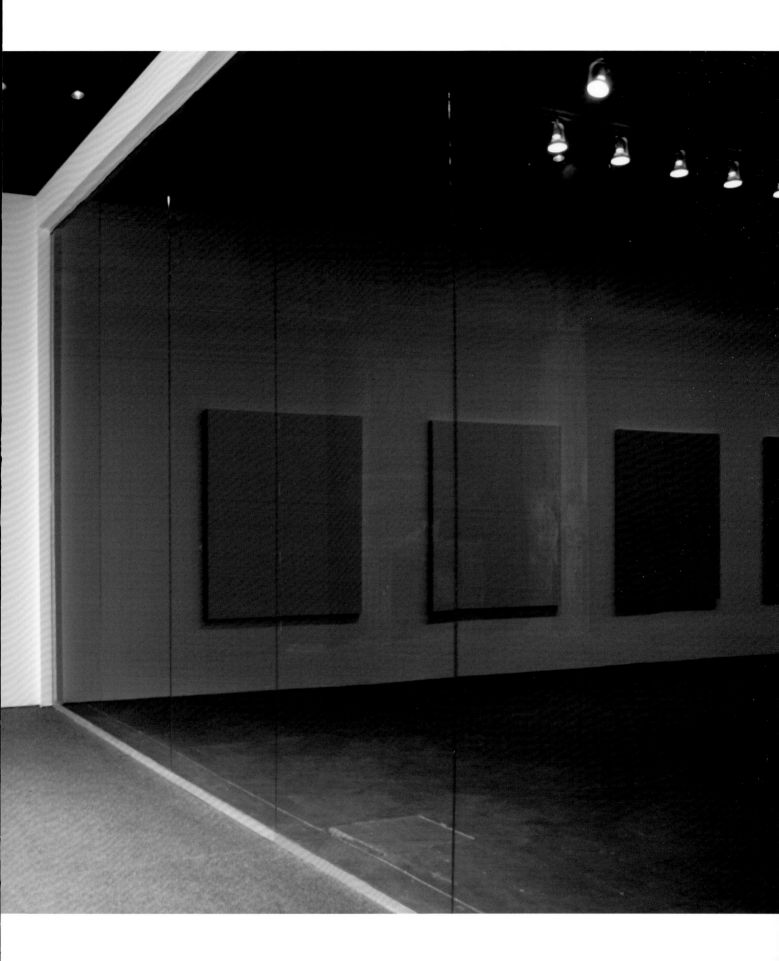

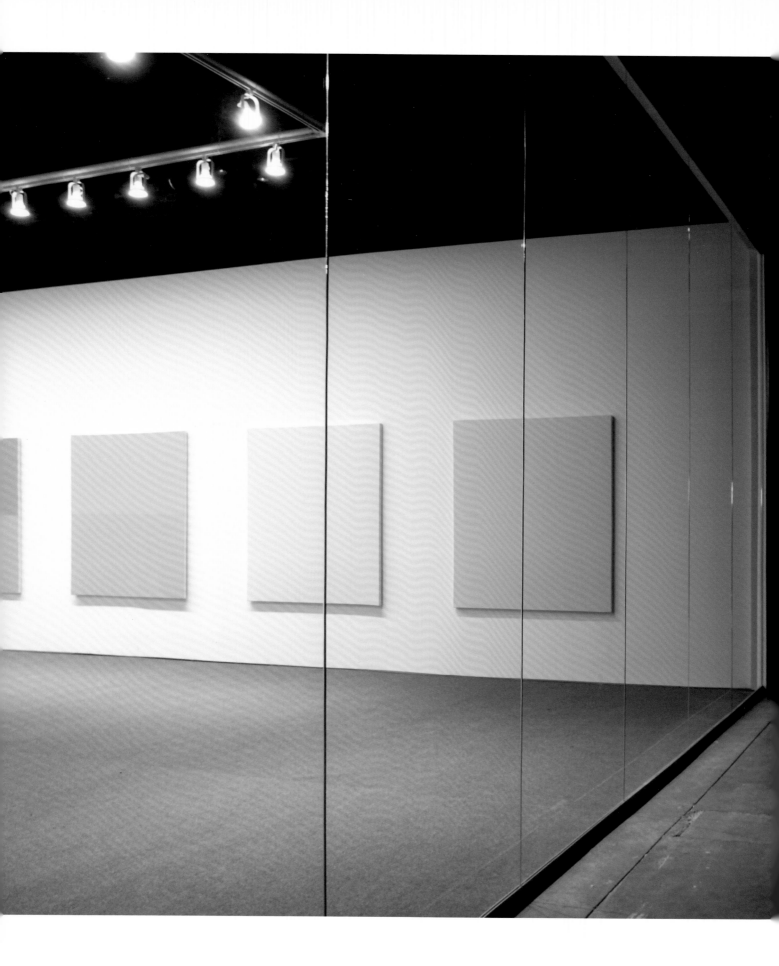

49

Oct15/91

A10-3

A9-3

A10-4

A9-4

A7-3

A8-3

A7-4

A8-4

A12-3

A16-3

A12-4

A16-4

50

A6-3

A11-3

A6-4

A11-4

A14-3

A13-3

A14-4

A13-4

A16-5

A10-5

opposite/ *Untitled*, 15 October 1991.
Colour chips and pen on paper,
49.2 x 33 cm (11 x 8 1/2 in).

above/ *Untitled*, 15 October 1991.
Pen on paper, 49.2 x 33 cm, (11 x 8 1/2 in).

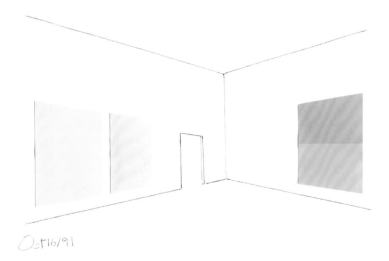

Oct 16/91

52

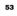

opposite and above/ *Untitled*, 16 October 1991.
Colour chips and pen on paper,
49.2 x 33 cm (11 x 8 1/2 in).

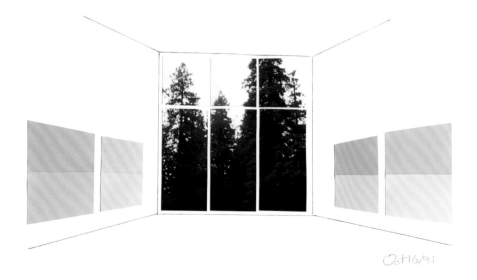

Oct 16/91

54

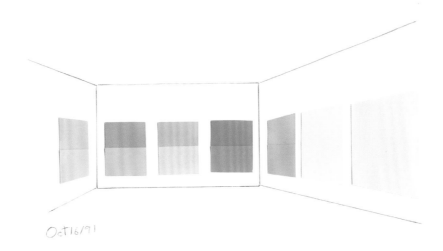

Oct 16/91

opposite and above/ *Untitled*, 16 October 1991.
Colour chips and pen on paper,
49.2 x 33 cm (11 x 8 1/2 in).

overleaf/ *Album VIII*, 2009.
Image montage in plastic laminate, 76
panels, 44.5 x 29 cm (17 1/2 x 11 1/2 in) each.
Collection of Generali Foundation, Vienna.

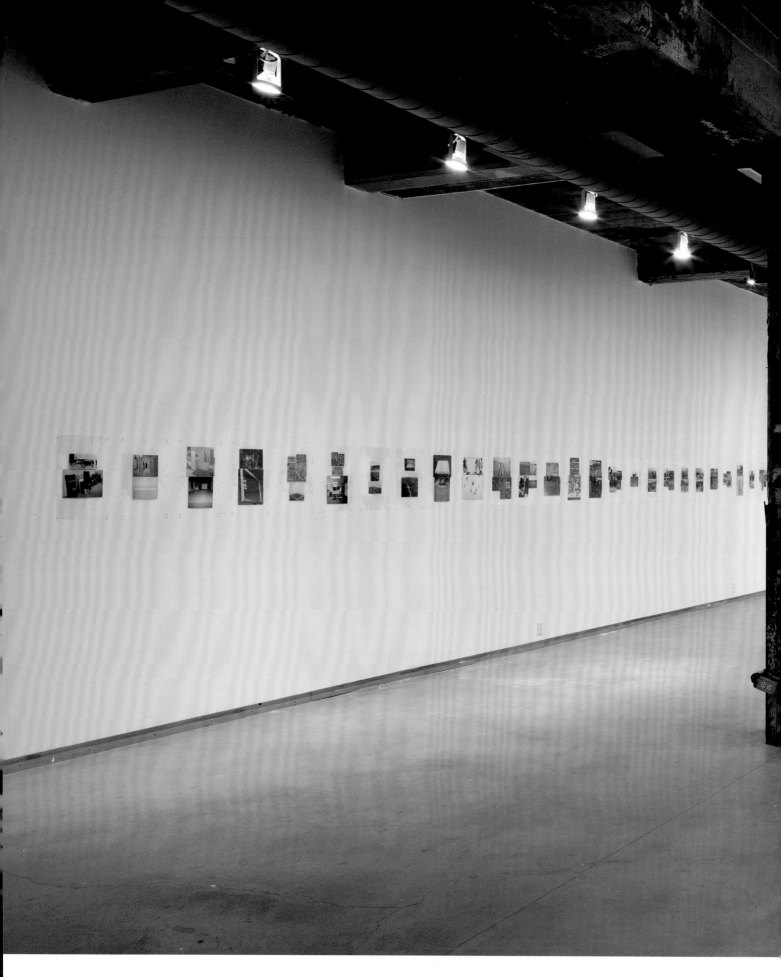

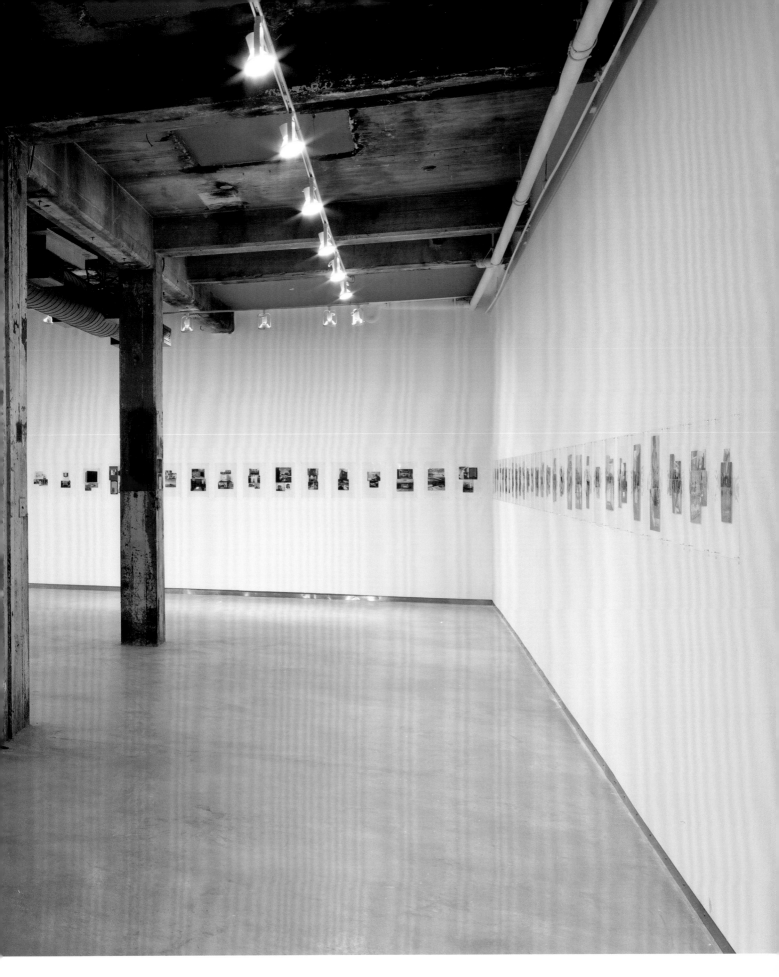

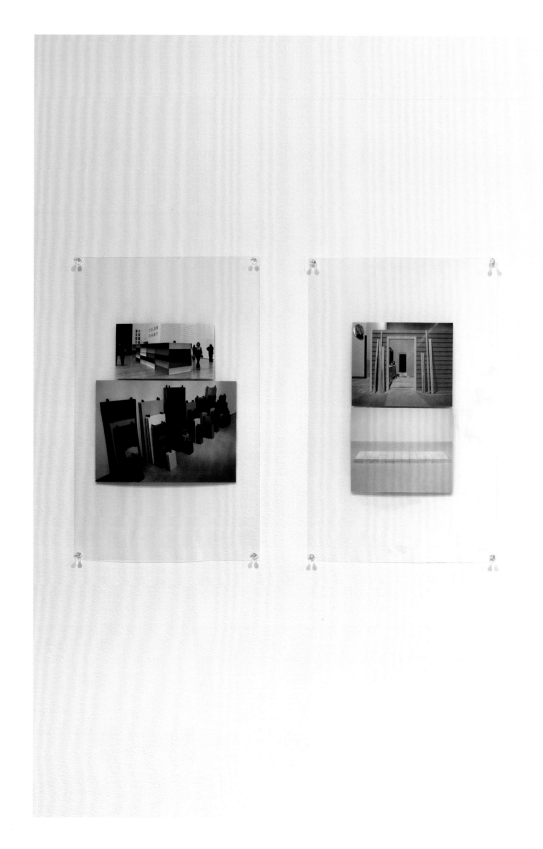

above and opposite/ *Album VIII*, 2009.
Image montage in plastic laminate, 76
panels, 44.5 x 29 cm (17 1/2 x 11 1/2 in)
each, view of panels one to four. Collection
of Generali Foundation, Vienna.

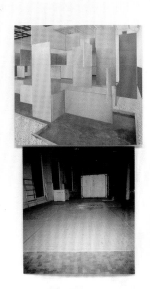

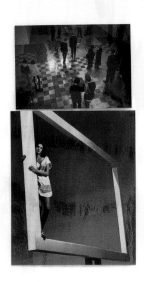

59

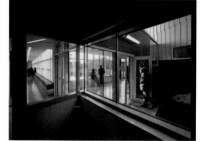

above and opposite/ *Album VIII*, 2009.
Image montage in plastic laminate, 76
panels, 44.5 x 29 cm (17 1/2 x 11 1/2 in)
each, view of panels 44 and 45. Collection of
Generali Foundation, Vienna.

LUIS JACOB

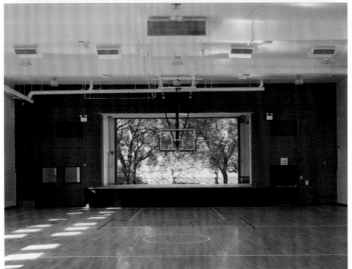

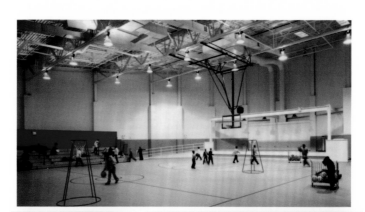

above and opposite/ *Album VIII*, 2009.
Image montage in plastic laminate, 80
panels, 44.5 x 29 cm (17 1/2 x 11 1/2 in)
each, view of panels 46 and 47. Collection of
Generali Foundation, Vienna.

63

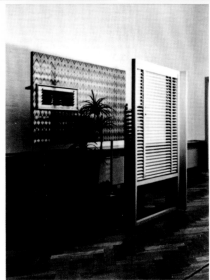

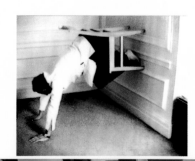

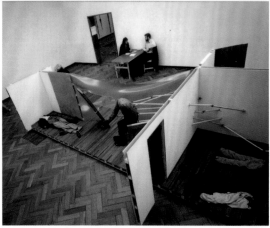

above and opposite/ *Album VIII*, 2009.
Image montage in plastic laminate, 80
panels, 44.5 x 29 cm (17 1/2 x 11 1/2 in)
each, view of panels 48 and 49. Collection of
Generali Foundation, Vienna.

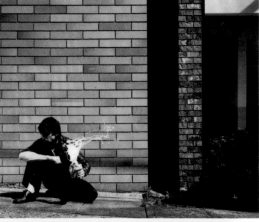

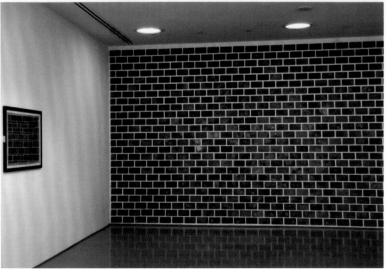

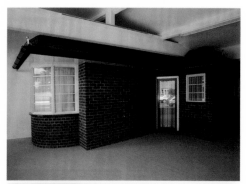

above and opposite/ *Album VIII*, 2009.
Image montage in plastic laminate, 76
panels, 44.5 x 29 cm (17 1/2 x 11 1/2 in)
each, view of panels 50 and 51. Collection of
Generali Foundation, Vienna.

overleaf/ *Album VIII*, 2009.
Image montage in plastic laminate,
76 panels.

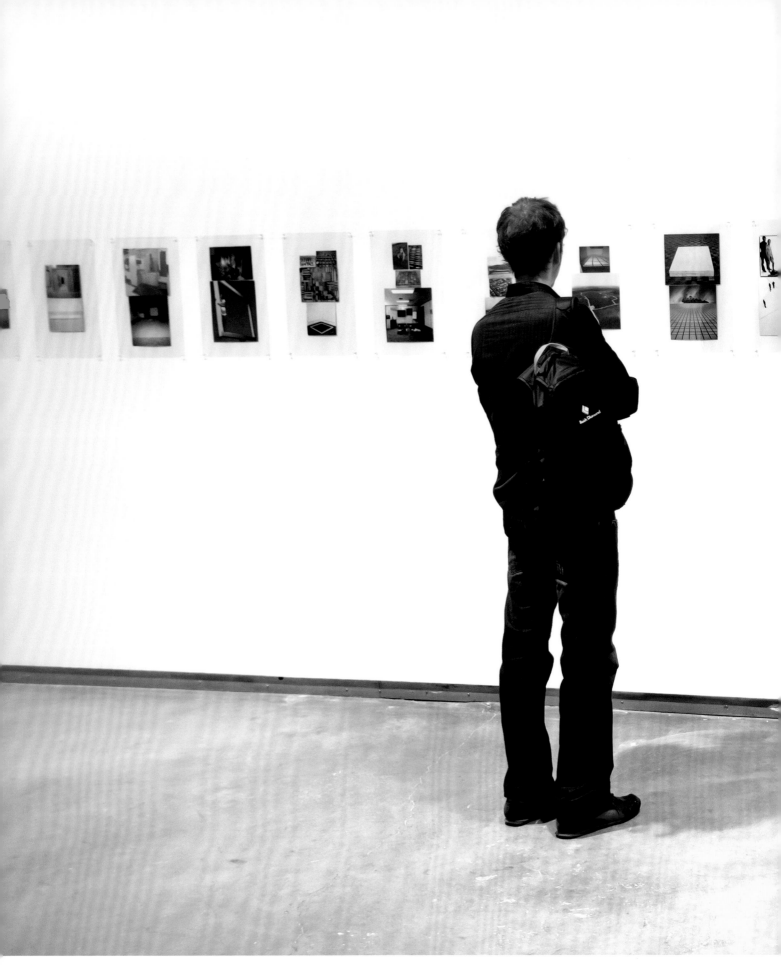

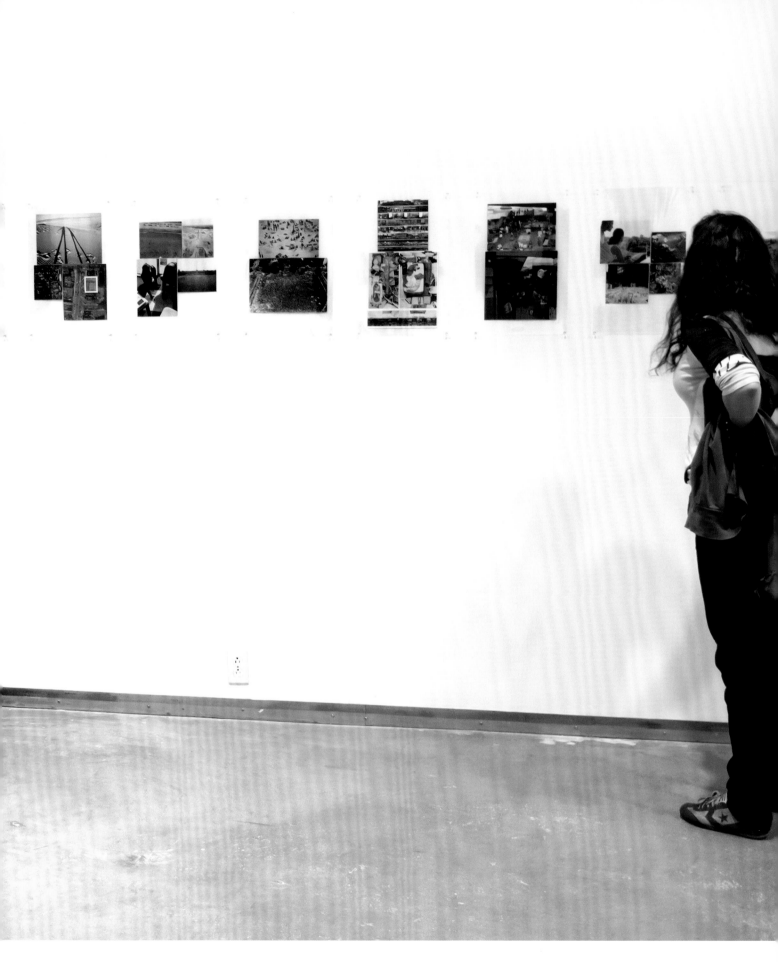

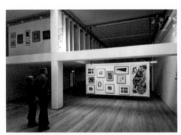

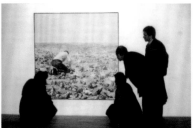

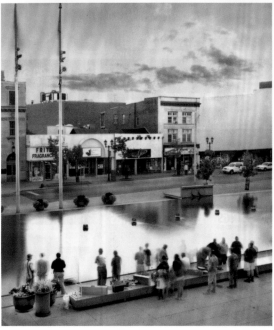

above and opposite/ *Album VIII*, 2009.
Image montage in plastic laminate, 80
panels, 44.5 x 29 cm (17 1/2 x 11 1/2 in)
each, view of panels 75 and 76. Collection of
Generali Foundation, Vienna.

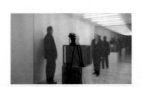

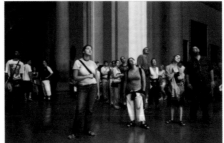

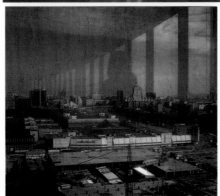

The Model, 2010.
Chromogenic print,
33.7 x 50.8 cm (13 1/4 x 20 in).

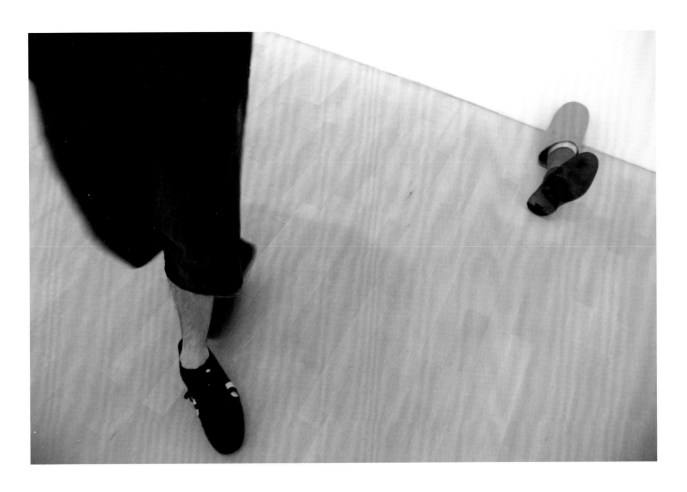

73

PICTURES
AT AN
EXHIBITION

MUSEUM OF

CONTEMPORARY

CANADIAN ART,

TORONTO,

4 FEBRUARY–

27 MARCH 2011,

CURATED BY

DAVID LISS

DAVID LISS

LUIS JACOB/ PICTURES AT AN EXHIBITION

Luis Jacob's exhibition, Pictures at an Exhibition is precisely that: a gallery display of paintings, drawings and photographs produced between 1990 and 2011. The exhibition's title refers to Russian composer Modest Mussorgsky's well-known 1874 piano suite, created to evoke an imaginary tour of an art exhibition, pointing to relationships between the aural and the visual, and to the interconnectedness of sensorial experience. A similar effort of interconnecting different kinds of experiences is present here, as Jacob draws our attention not only to the 'pictures' displayed on the museum walls, but also to the 'exhibition' context of which we, as viewers, are part.

Pictures at an Exhibition was introduced on the exhibition announcement card and on the gallery's title wall by a photograph (by Elaine Yau) from 1988 that featured the artist pulling back his right eyelid in a provocative gesture that exaggerated his bulging eyeball. Upon entering the gallery through a narrow passage, viewers were abruptly confronted with a small wooden case that contained a prosthetic glass eye. This work, titled *Eclipse*, 2009, immediately introduced the theme of viewing and spectatorship. We engage the world and each other through our senses, through our permeable bodies, and the act of viewing—how we look at pictures, how we perceive and understand them, how we engage with them—reflects ways in which we relate to each other and the world around us. Pictures, as well as exhibitions, embody so many models of the world. They propose possible ways of seeing and being.

Conceived as the second part in a trilogy of exhibitions, the presentation at the Museum of Contemporary Canadian Art was initially proposed to Jacob as a timely mid-career survey of his work, the very first in his hometown. While the prospect of a survey intrigued him, the conventional presentation of works as isolated specimens that suggest only past relevance appeared less interesting. It was important for the artist that the exhibition format and methodologies of display would invigorate the exhibition space as a site for reciprocal, sensory engagement between image and viewer. In this exhibition he re-imagines the gallery space as a living, breathing entity: one that is alive with objects, meaning and experience; a theatre upon which viewers, the audience, bring ideas to life through physical presence and active engagement.

Jacob utilised techniques associated with theatrical storytelling by converting a section of the exhibition space into a proscenium-like structure illuminated by stage lighting, to display *Album X*, 2010. This work consists of a collection of photographic images sourced from an expansive range of pre-existing, or 'found', publications, laminated into a series of 80 panels. Each panel contains an arrangement of pictures that frequently portray people engaged in the act of directed looking: looking at paintings and photographs, at blank surfaces, at empty picture frames, at theatre stages and open curtains, through panoramas behind glass, and through windows. These images—and the display structure, considered as a stage-set—depict and create various framing devices. These are

76

charged sites embedded with information and meaning. To engage the intimately scaled images it was necessary for viewers to enter the proscenium, to become players upon the stage, thus immediately implicating the spectator as active participant, as performer sharing the bill with the artwork, and transgressing barriers between artwork and audience. The experience of being both witness and performer is depicted in several images from *Album X*, in scenes of people watching their reflections in mirrors, and in images of architectural settings that themselves mirrored the proscenium in the gallery space.

While viewing *Album X* from within the staged area, viewers may also sense that they are being watched from across the gallery by three paintings from the series, *They Sleep With One Eye Open*, 2008. These are extraordinarily vivid pictures, colourful airbrush paintings reminiscent of 1960s-style tie-dye patterns, readily evoking the heightened state of awareness precipitated by psychedelic experience. Darkly painted forms resembling two eyes punctuate each canvas. These pictures loom intently, like personifications of over-sized heads, faces, masks or totems. Their symmetrical images resemble the Rorschach patterns used in psychological tests of perception and cognition in subjects. As we look at them, they return our gaze. They show us *how* we look at pictures. The title of the series returns us to the single eye of the exhibition signage, and the prosthetic eye of *Eclipse* first encountered at the exhibition's entrance, and suggests a state between sleep and wakefulness, between consciousness and the unconscious, between the physical and the psychic: a condition of perpetually vigilant awareness.

Quietly surrounding these intense canvases are groupings of modestly scaled works on paper and painted panels selected from among Jacob's earliest works, created during the early 1990s. *Dot Drawings*, 1991, consists of seven sheets of standard grid paper on which the artist has plotted constellations by adding patterns of dots in felt-tipped marker, mapping various configurations reminiscent of the converging lines of single-point perspective. As similar as the drawings are to each other, they are nevertheless each embedded with their own unique spatial dynamic and codes of information. The *Good Heavens Series*, 1990, are photocopy 'drawings' based on a repeated image of clouds pierced by sun rays, arranged in various permutations: some cover the entire surface, while others only occupy portions of the sheet, juxtaposing image with empty sections of paper. Like clouds themselves, the images are present but elusive and never fixed. Both the *Dot Drawings* and the *Good Heavens Series* drawings describe dynamic fields that are intimate, focussed and finite; yet by the very nature of the structures and systems from which they have been constructed—the grid, the mapped constellations, and the sequenced images of clouds—these drawings imply open, ephemeral, infinite space; fixed material fields that are alive to subjective perceptual experience and yield boundless possibility.

Displayed throughout the exhibition are several abstract paintings of various configurations. *Sun (For John Russon)*, 1992, consists of two canvas panels framed together. The left-hand panel is an arrangement of two rectangular blocks of colour, the upper block painted red and the lower green. The right-hand panel is identical in size with a pale yellow block placed above a dark brown one. Hanging next to this is, *Moon (For Derrick May)*, 1992, a single panel of similar scale containing a rectangular block of dark blue over another painted a pale grey. In proximity to each other, the coloured panels create an animated visual rhythm of colour and form that activates the viewer's perceptual faculties, attuning us to the possibilities of colour and chromatic harmonies. The titles *Sun* and *Moon* refer to the inherent dualities that characterise our existence: day and night, male and

female, wakefulness and slumber, life and death. The dedications in the titles provide hints of further reference. John Russon is an influential Toronto-based philosopher specialising in Continental philosophy; in the early 1990s, Jacob attended classes on the work of Maurice Merleau-Ponty and Martin Heidegger, offered by John Russon at the University of Toronto. Derrick May is a Detroit-based pioneer in electronic dance-music who emphasises the physicality of rhythm and musical form; in the 1990s Jacob was part of the House and Techno music scenes in Toronto, and regularly attended all-night electronic-music events. While making reference to formative daytime and night-time experiences of his early adulthood, here Jacob returns to one of the thematic touchstones of the exhibition with references to the relationship between visual and aural experience.

Untitled, 1994, consists of five joined canvas panels. Three of the panels are divided in half, with the upper sections painted in oil paints in muted primary colours— the left panel is yellow, the middle panel bluish green, and the right panel is red— and the lower sections painted in white oil paint. Interspersed between are two panels coated in white gesso, the material traditionally used to prepare canvases for painting. The rhythmic pattern across the surfaces of the five panels evokes movement in space between colour and material, in a way reminiscent of musical language. There is a subtle play in the correspondences between the 'artistic' white of the oil paint, the 'preparatory' white of the gesso, and the 'non-artistic' white of the gallery walls. This actively creates the kind of interconnection between object and context, between 'picture' and 'exhibition' that is alluded to in the title of this exhibition.

Jacob refers to his series of colour-block abstractions as both "monochromes" and "pictures of nothing"—empty pictures located within an historical trajectory of abstract painting from Malevich and Rodchenko to Albers, Barnett Newman and Mark Rothko. In the work of these artists the role of painting shifts from the representation of concrete, material fact to the creation of ephemeral, perceptual phenomena. Here, the narrative structures associated with representational pictures are replaced by the vibrancy and openness of pure colour, and the reductionist form of 'empty' space that is at the same time full of possibility.

Monochrome III, 1991, is divided into equal halves painted in two different tones of green paint, while *Brimley III*, 1991, is split into two sections of unequal sizes bearing two tones of blue paint. Here, it is this dividing line between tonal fields of colour that draws one's attention and becomes the dramatically charged subject matter. These works call to mind the tradition of landscape painting; the line between the two colour blocks resembles that of a horizon, a perceptible yet fictional line that appears to intersect the earth and sky. Always visible in the distance as a limit, the horizon can never be definitively fixed, yet it resides in our imaginations as an enchanted point of sublime contemplation: a space to project our desires and aspirations. The horizon is an open, subjective space that resides beyond the grasp of understanding and beyond the reach of authoritative definition and appropriation. Like the tropes of theatre, where the border separating the real and the play-acted becomes a malleable element; like the mirror reflection, where self and other become confused—and like the site of his exhibition—the horizon is an ambiguous space that lies beyond the real, an abstract space for the unfettered imagination and the locus of meaning. These horizons—the 'virtual' line that divides the colour blocks in all of Jacob's *Monochromes*, and the 'real' line that divides the surfaces of his multi-panelled works—and the very entrance of the gallery itself all become a threshold to limitless vistas into the worlds of sensory experience, possibility and meaning.

In a corridor leading away from the main gallery space, the exhibition concludes with drawings in ink and felt marker that explicitly engage the notion of abstraction. *Untitled (Blue Hand with Lines)*, 1993, is a drawing on grid paper that depicts the open palm of a hand. The loosely drawn creases of the palm resemble a map, a physical geography common to us all while simultaneously revealing the distinct identity of the individual. Produced some four months later, *Untitled (Green Drawing)*, 1993, depicts these creases as a grouping of abstract lines, as if they had become detached and newly independent from the hand that they originally belonged to. Both drawings are made on pre-printed grid paper, creating a complex formal play between the 'found' lines of the paper, the 'illustrational' lines that depict the hand in the blue drawing, the 'abstract' lines in the green drawing, and the 'real' lines of the palm of the artist's hand. By extension, these drawings reaffirm the physicality of the work of art, the artist's as well as the viewer's body, and the pre-existing architectural context of the exhibition, while allowing these to intermingle in the imaginary space of fiction, illusionistic space, and theatricality. These works point towards the dual processes of disconnection and re-connection; to the interconnectedness of mind and body so essential to the construction of meaning.

The final picture in the exhibition is a photograph, titled *The Model*, 2010, that depicts two legs: a gallery visitor's shoe-clad foot and rolled up pant leg are visible next to a meticulously detailed but disembodied, lower leg that appears to be protruding from the wall of an art gallery. The leg extending from the wall is, in fact, a sculpture: *Untitled (Leg)*, 1989–1990, made by the American artist Robert Gober, well-known for producing works that address our perception and understanding of bodily experience. *The Model* presents a juxtaposition of the real and the fictional, an encounter between viewer and artwork, in a manner that evokes the differentiated panels in his monochrome paintings. It is within this charged space between image, object and body that meaning is formed, through perception and the activation of body and mind. The photograph's angle of view creates a dynamic composition that activates the picture, extending Jacob's notion of the gallery as a living, breathing, theatrical space where narrative is formed in the encounter between viewer and image/object. But there is something of the macabre present in the image of the disembodied leg lying on the floor. There is a perplexing strangeness to this scene that unsettles our established certainty of things, a disorientation that opens up a space for new experiences and new readings.

The disembodied eye that opens the exhibition, the theatrical play between real and fictional found in *Album X*, the 'virtual' and 'real' horizon lines present in all the monochromes, the line that both depicts the hand and detaches itself from it—all of these aim to unsettle, and thus liberate the imagination. These shifts between real and fictional spaces, between spaces of the body and spaces of the mind, emphasise experiences of metamorphosis and transformation, and envision the body as a permeable vessel where these experiences of disconnection and re-connection take place—a site of transmission for the creation of individual and collective meaning.

Through his art, his writings and his teachings, Jacob has openly professed himself to be an anarchist, a person who strives for a non-hierarchical social existence. Luis Jacob produces artworks intended for the viewer to negotiate within a context of open possibility. The exhibition itself, this finite space, becomes the site of interplay between the real and the imaginary, an unfamiliar territory with infinite potential for seeing and believing.

79

Exhibition view, Museum of Contemporary
Canadian Art, Toronto.

LUIS JACOB

Pictures at an Exhibition

Canada Council
for the Arts

Conseil des Arts
du Canada

TORONTO
ARTS
COUNCIL

Eclipse, 2009.
Artist multiple, 14 x 18 x 8 cm (5 1/2 x 7
x 3 1/8 in). Published by Museumsverein
Mönchengladbach.

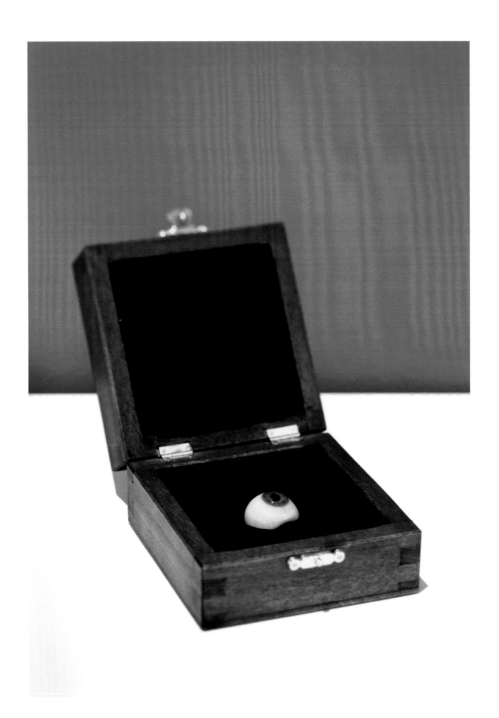

83

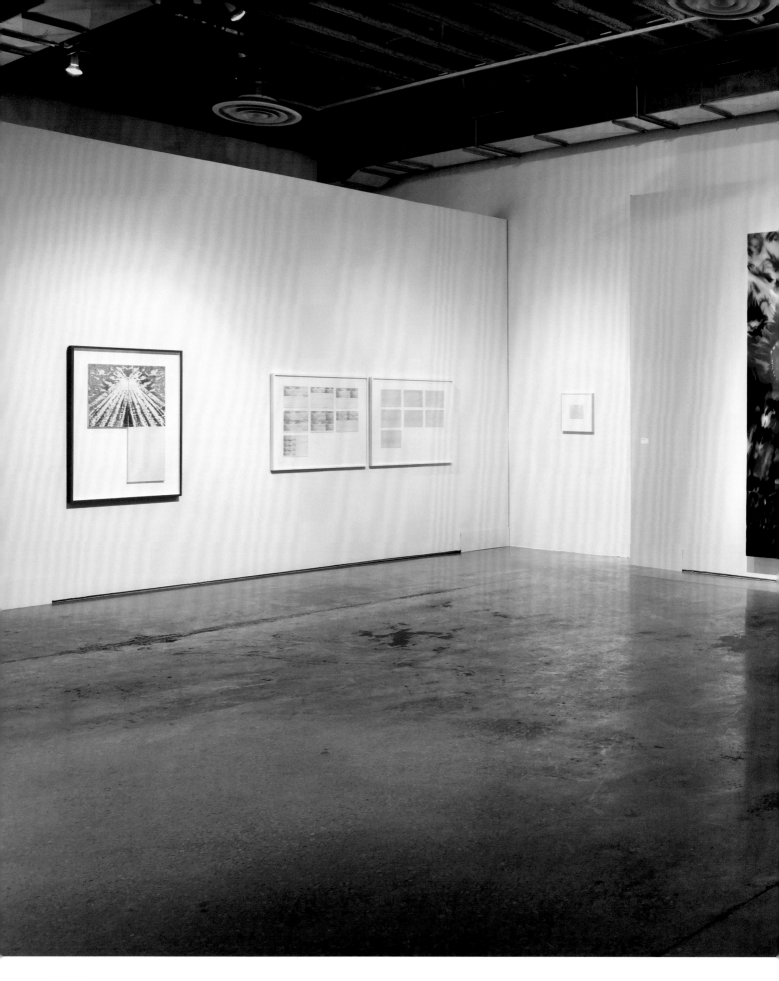

LUIS JACOB

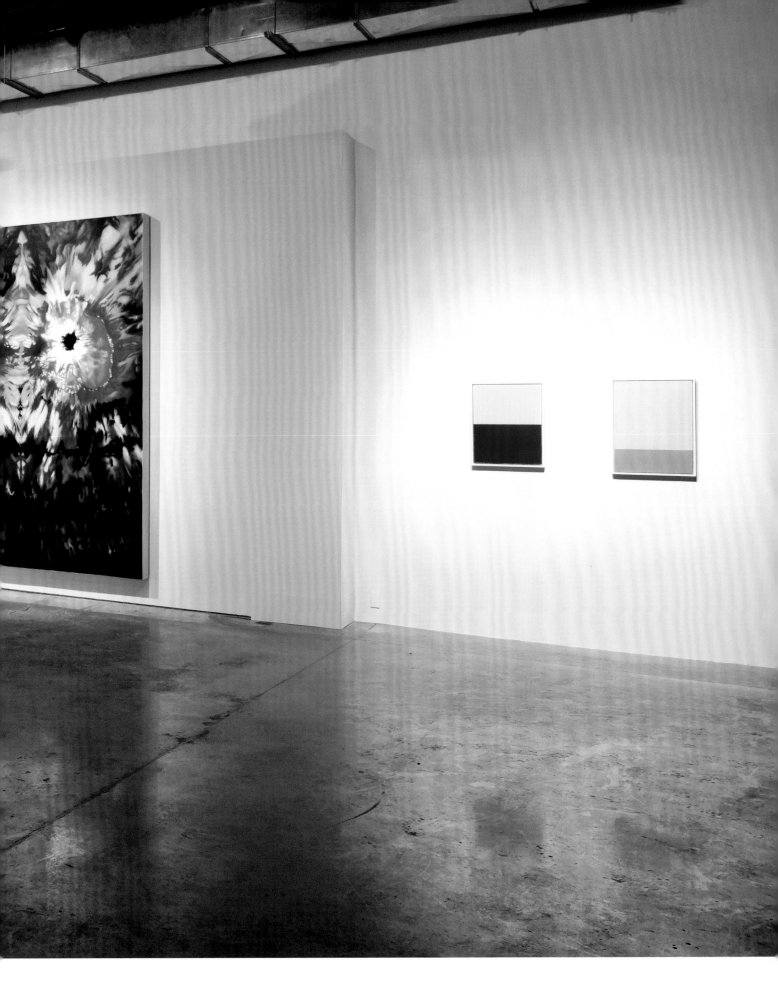

previous pages/ Exhibition view, Museum of
Contemporary Canadian Art, Toronto.

opposite/ *Heavenheaven and a half*, 1990.
Tempera and gesso on canvas, two joined
parts, 96.5 x 61 cm (38 x 24 in).

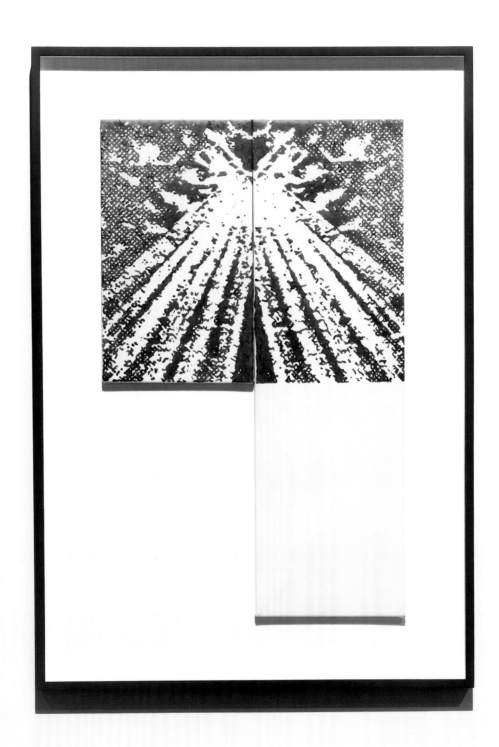

88

opposite/ *Good Heavens Series (#1–7)*, 1990.
Photocopy on paper, seven parts,
20.3 x 25.4 cm. (8 x 10 in) each.
Collection of Zuly Jacob, Toronto.
top/ *#1—heaven.*
bottom/ *#2—small heaven and a half.*

above/ *Dot Drawings (#1–7)*, 1991.
Felt-tip marker on photocopy on paper,
seven parts, 17.8 x 24.8 cm (7 x 9 3/4 in) each.
Collection of Zuly Jacob, Toronto.
top/ *#1—heaven.*
bottom/ *#2—small heaven and a half.*

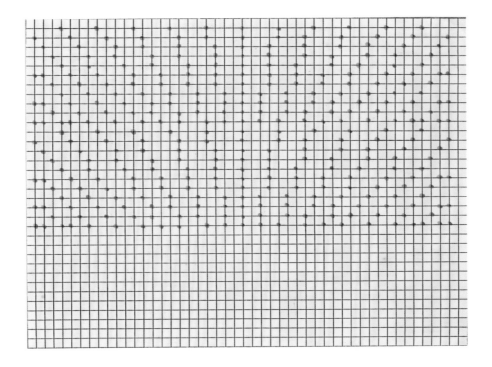

opposite/ *Good Heavens Series (#1–7)*, 1990.
Photocopy on paper, seven parts,
20.3 x 25.4 cm (8 x 10 in) each.
Collection of Zuly Jacob, Toronto.
top/ *#3—big heaven and a half.*
bottom/ *#4—heaven twice.*

above/ *Dot Drawings (#1–7)*, 1991.
Felt-tip marker on photocopy on paper,
seven parts, 17.8 x 24.8 cm (7 x 9 3/4 in) each.
Collection of Zuly Jacob, Toronto.
top/ *#3—big heaven and a half.*
bottom/ *#4—heaven twice.*

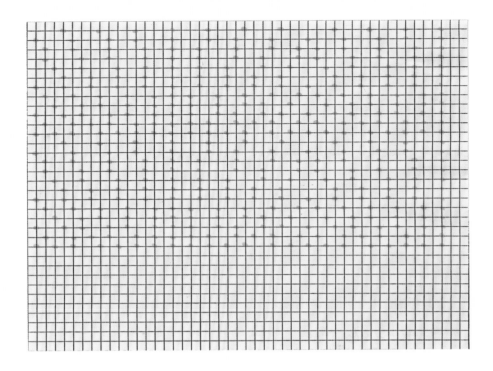

opposite/ *Good Heavens Series (#1–7)*, 1990.
Photocopy on paper, seven parts,
20.3 x 25.4 cm (8 x 10 in) each.
Collection of Zuly Jacob, Toronto.
top/ *#5—heaven and a half twice.*
bottom/ *#6—heavenheaven twice.*

above/ *Dot Drawings (#1–7)*, 1991.
Felt-tip marker on photocopy on paper,
seven parts, 17.8 x 24.8 cm (7 x 9 3/4 in) each.
Collection of Zuly Jacob, Toronto.
top/ *#5—heaven and a half twice.*
bottom/ *#6—heavenheaven twice.*

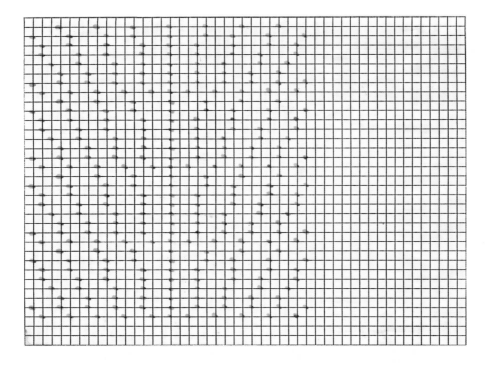

opposite/ *Good Heavens Series (#1–7)*, 1990.
Photocopy on paper, seven parts,
20.3 x 25.4 cm (8 x 10 in) each.
Collection of Zuly Jacob, Toronto.
#7—heaven four times.

above/ *Dot Drawings (#1–7)*, 1991.
Felt-tip marker on photocopy on paper,
seven parts, 17.8 x 24.8 cm (7 x 9 3/4 in) each.
Collection of Zuly Jacob, Toronto.
#7—heaven four times.

Untitled (Dot Drawing), July 13, 1990.
Ballpoint pen on printed paper,
14.6 x 21.3 cm (5 3/4 x 8 3/8 in).

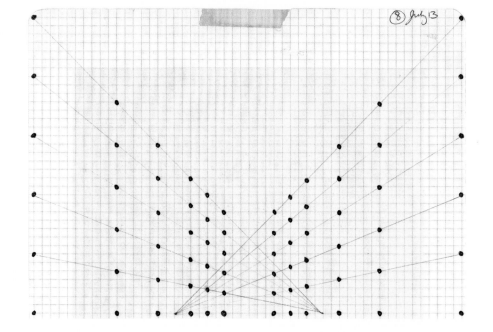

97

opposite/ *They Sleep With One Eye Open #1*, 2008. Acrylic on canvas, 294 x 232 cm (116 x 92 in).

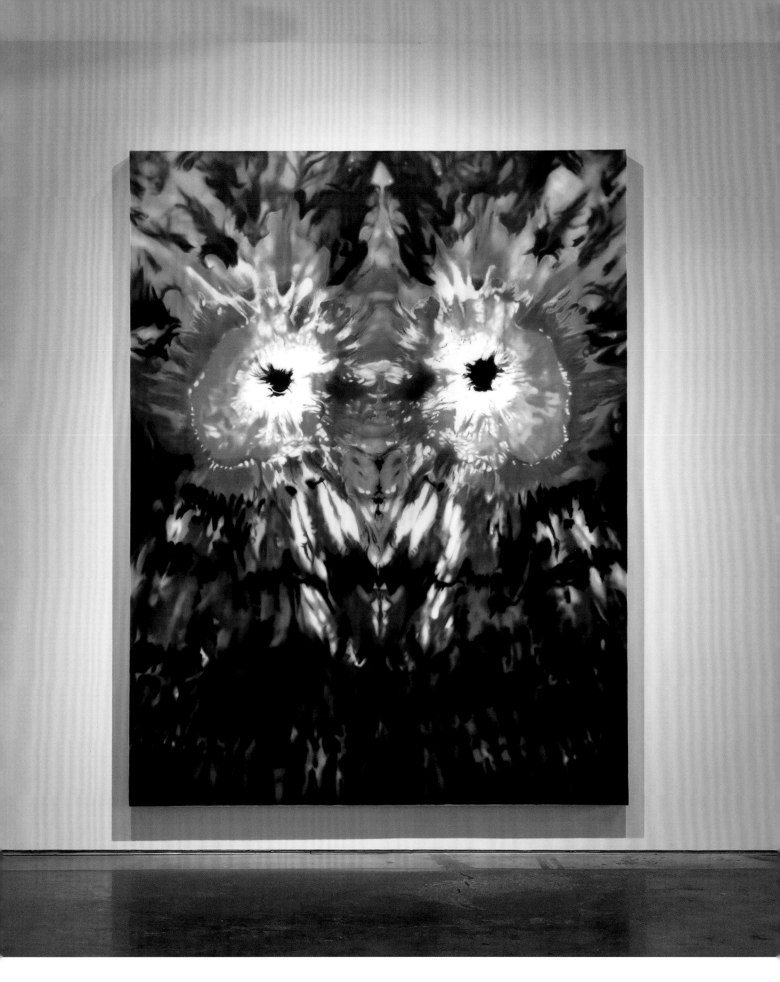

opposite left/ *Monochrome III*, 1991.
Oil on canvas, 55.9 x 45.7 cm (22 x 18 in).
opposite right/ *Brimley III*, 1991.
Oil on canvas, 61 x 40.6 cm (24 x 16 in).

overleaf/ *Album X*, 2010.
Image montage in plastic laminate,
80 panels, 44.5 x 29 cm (17 1/2 x 11 1/2 in)
each. Collection of Musée d'art contemporain
de Montréal.

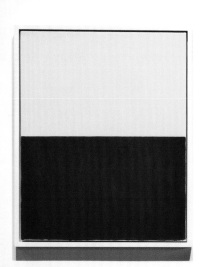

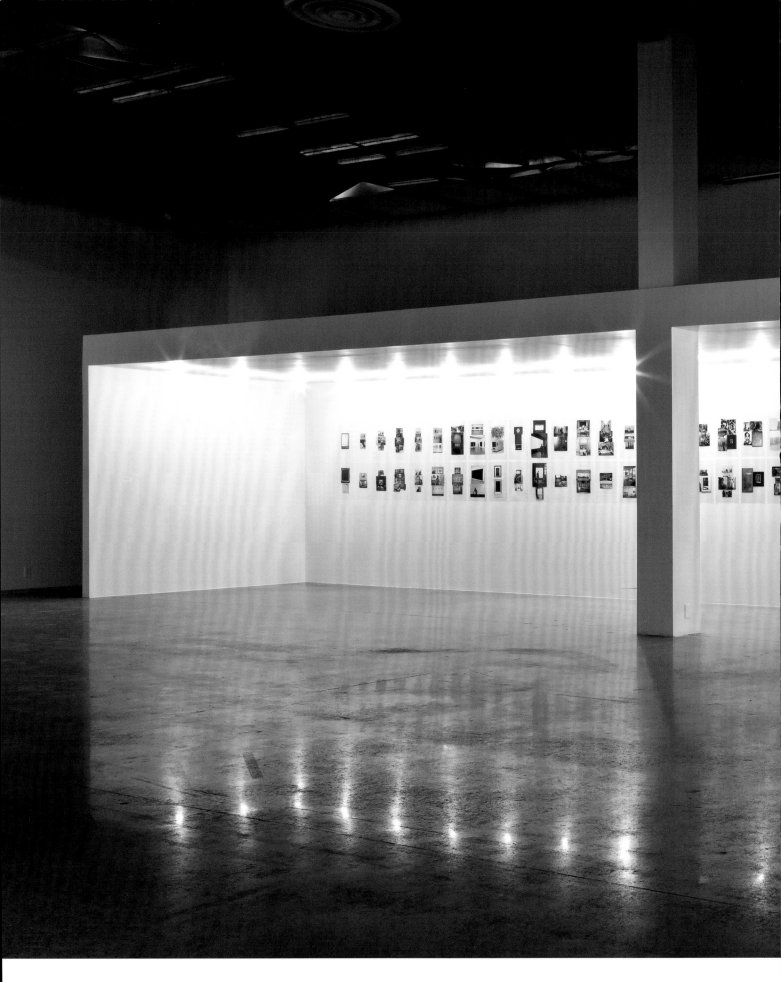

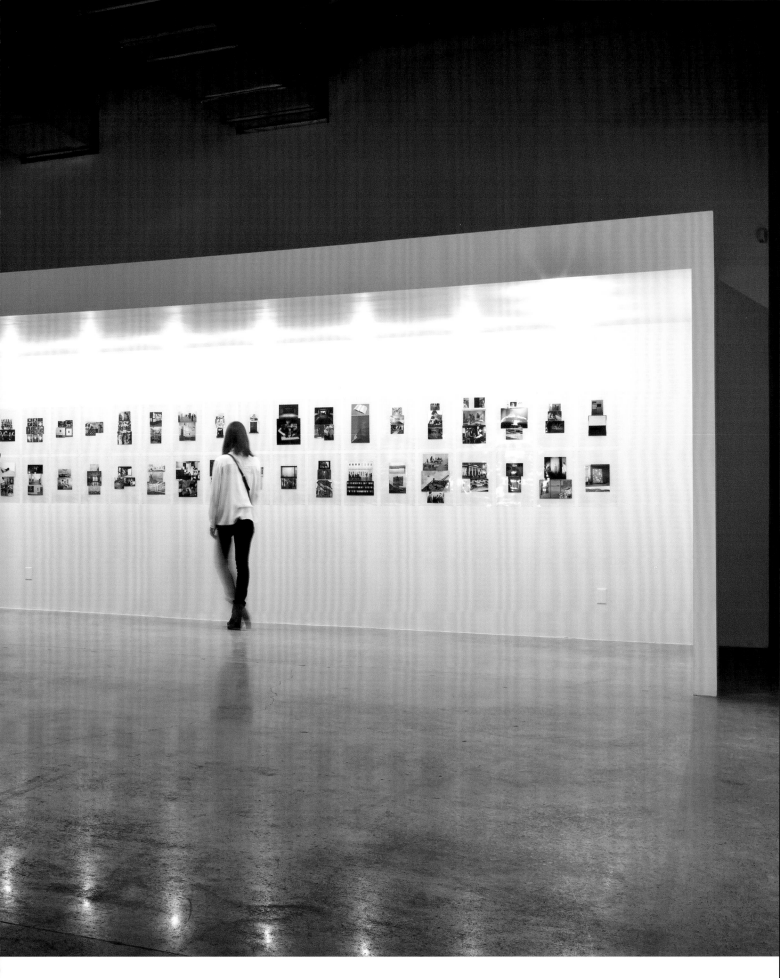

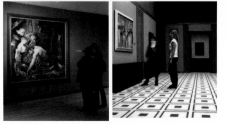

above and opposite/ *Album X*, 2010.
Image montage in plastic laminate,
80 panels, 44.5 x 29 cm (17 1/2 x 11 1/2 in) each,
view of panels 7 and 8. Collection of Musée
d'art contemporain de Montréal.

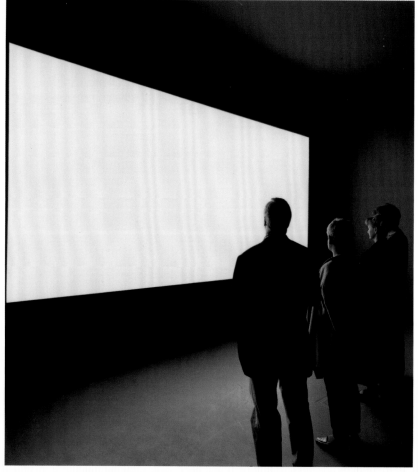

above and opposite/ *Album X*, 2010.
Image montage in plastic laminate,
80 panels, 44.5 x 29 cm (17 1/2 x 11 1/2 in)
each, view of panels 21 and 22. Collection of
Musée d'art contemporain de Montréal.

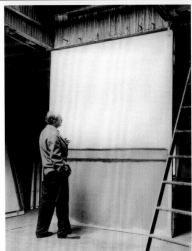

108

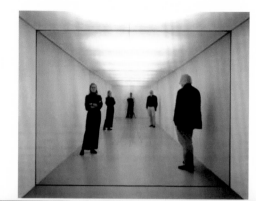

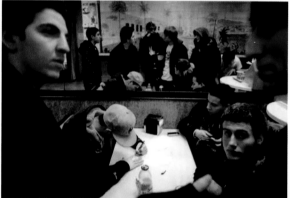

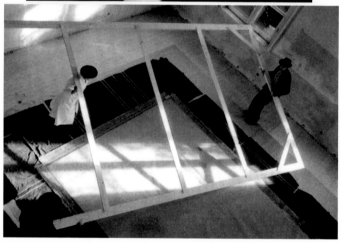

above and opposite/ *Album X*, 2010.
Image montage in plastic laminate,
80 panels, 44.5 x 29 cm (17 1/2 x 11 1/2 in)
each, view of panels 27 and 28. Collection of
Musée d'art contemporain de Montréal.

overleaf/ Exhibition view, Museum of
Contemporary Canadian Art, Toronto.

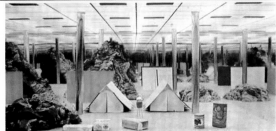

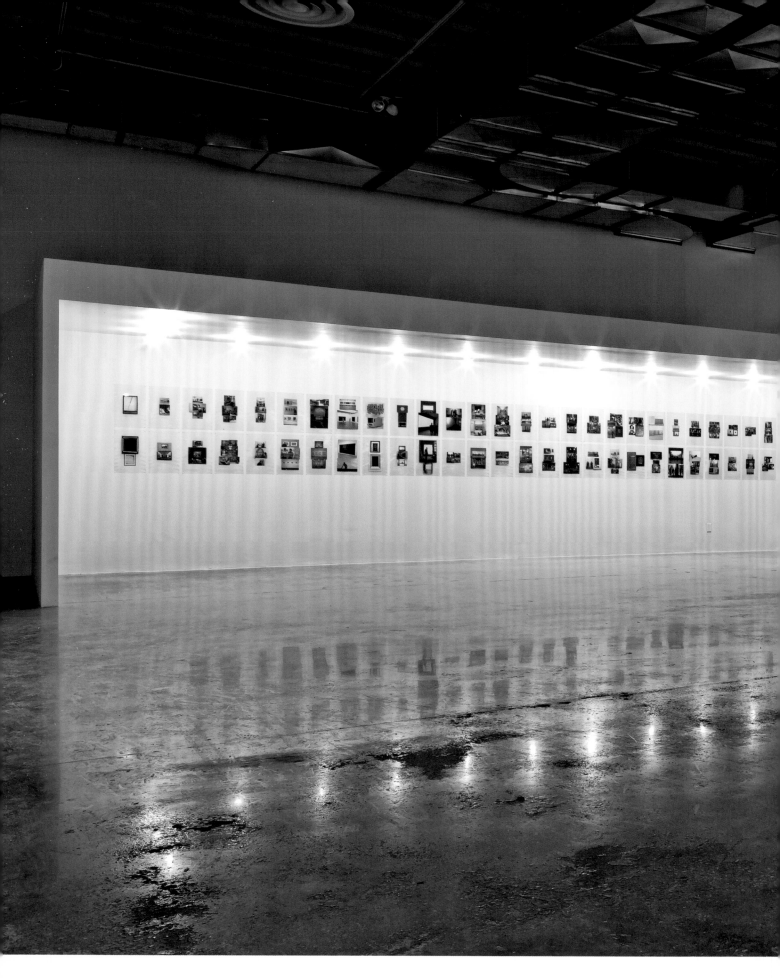

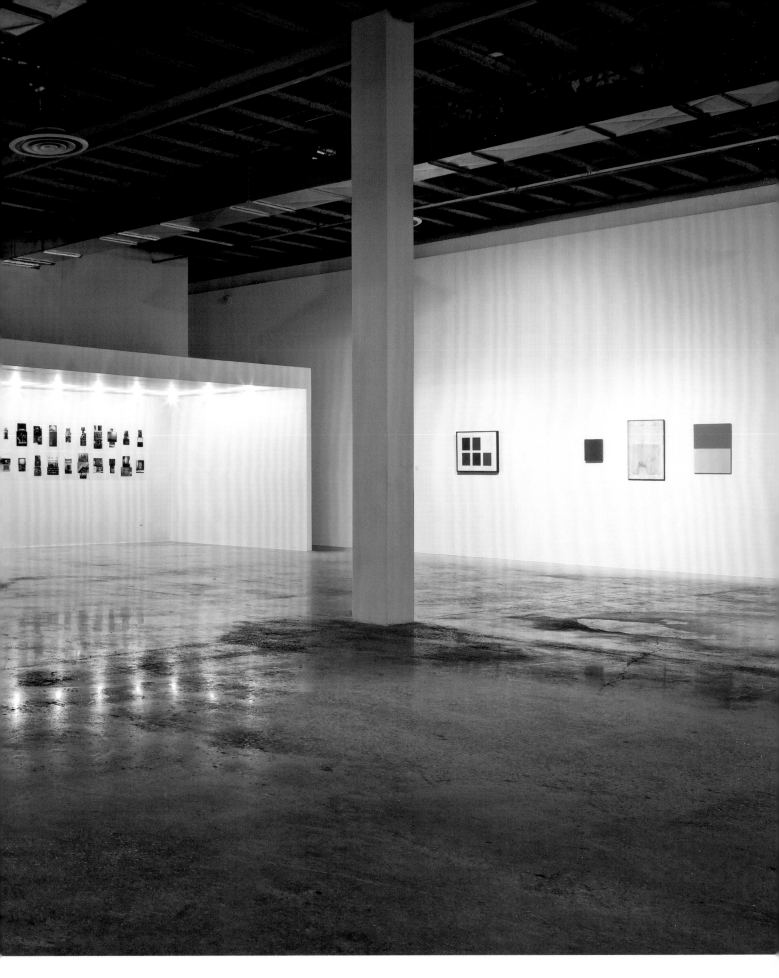

Yellow, White, Pink, Lilac, 1992.
Oil and gesso on canvas, 55.9 x 61 cm
(22 x 24 in). Collection of Patricia Fagan,
Windsor.

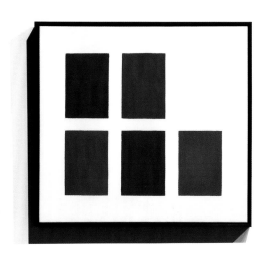

opposite/ *Untitled*, 1993–2010.
Painting comprising three elements:
(left) oil and found paint on wood,
28.6 x 23.5 x 3.8 cm (11 1/4 x 9 1/4 x 1 1/2 in),
(centre) gesso on wood, 76.2 x 45.1 cm
(30 x 17 3/4 in), (right) acrylic latex on wood,
59 x 41.8 cm (23 1/4 x 16 1/2 in).

overleaf/ Exhibition view, Museum of
Contemporary Canadian Art, Toronto.

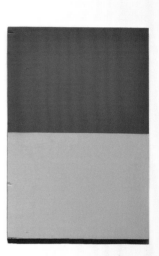

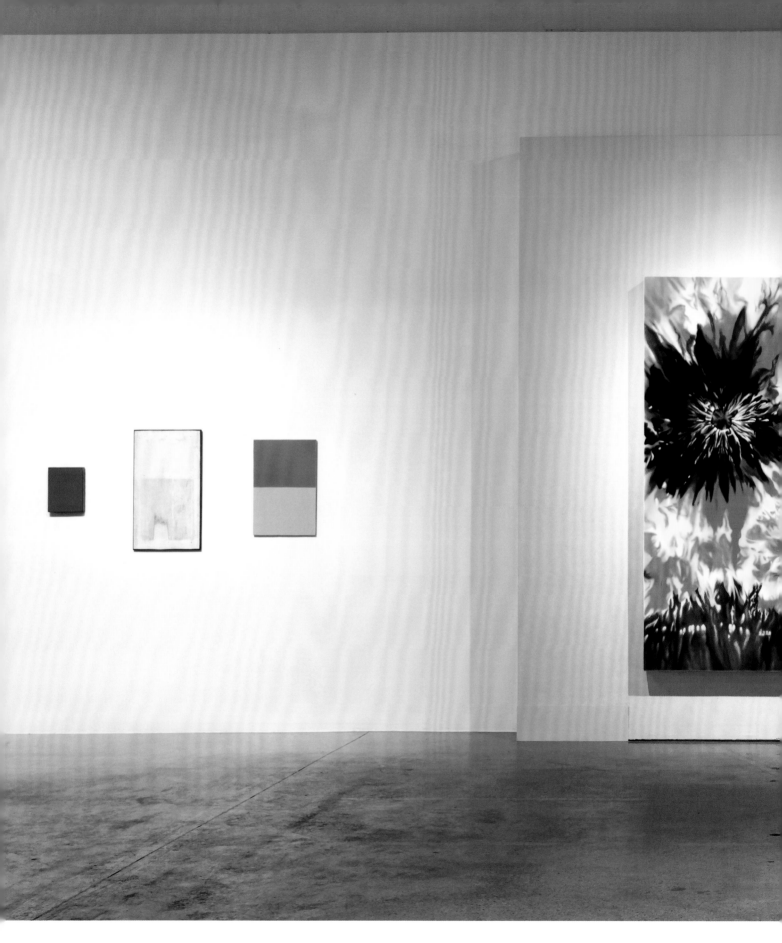

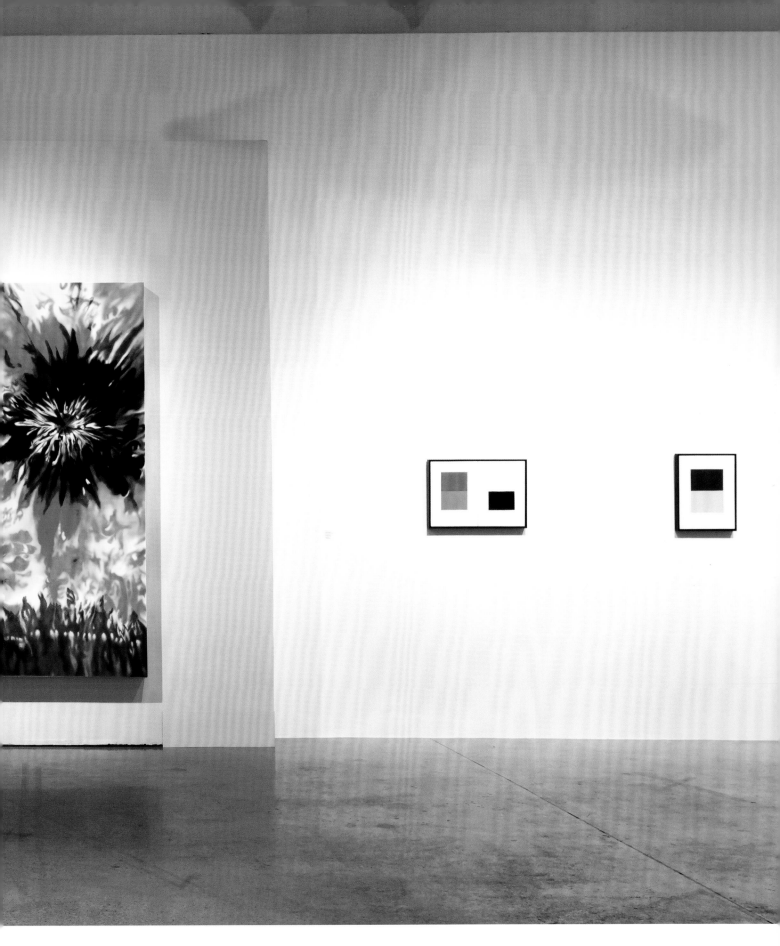

Untitled (Dot Drawing), July 1990.
Permanent marker ink on printed paper,
20 x 27.6 cm (7 7/8 x 10 7/8 in).

LUIS JACOB

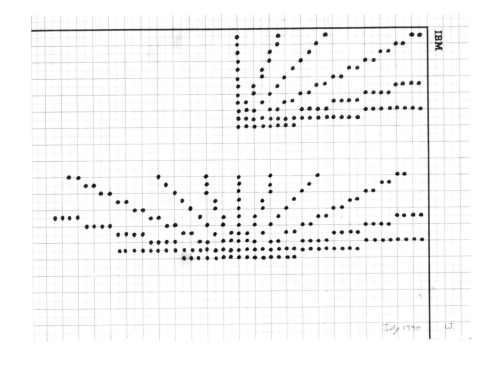

July 1990 IJ.

IBM

opposite/ *They Sleep With One Eye Open #6*, 2008.
Acrylic on canvas, 236 x 205 cm (93 x 81 in).
Collection of CI Financial Corp., Toronto.

overleaf/ Exhibition view, Museum of
Contemporary Canadian Art, Toronto.

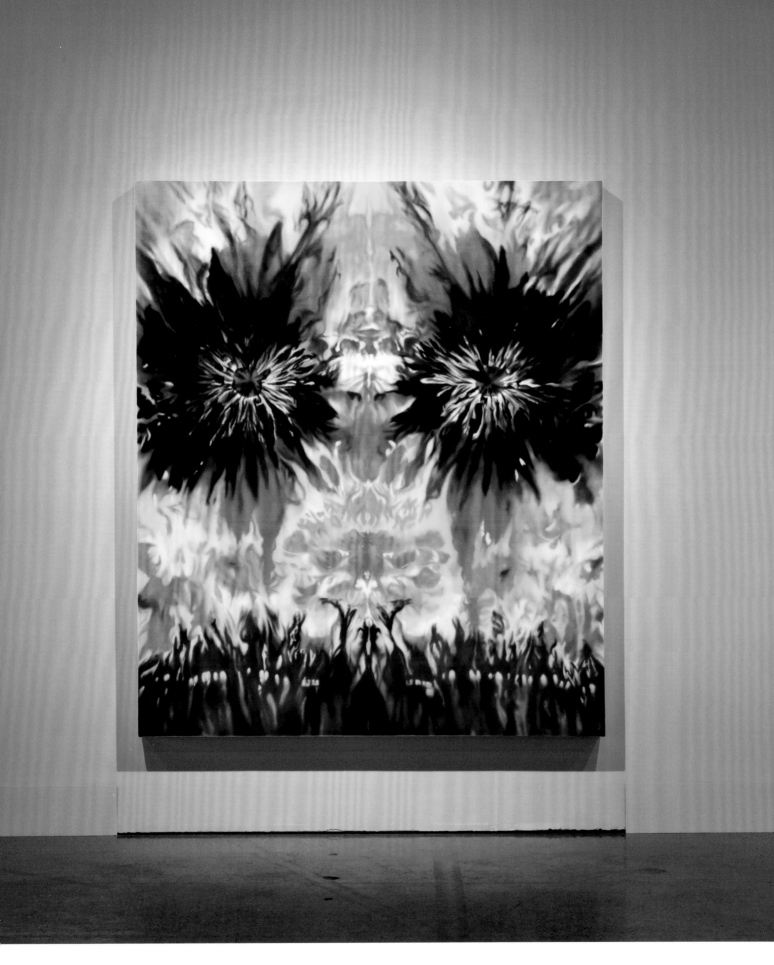

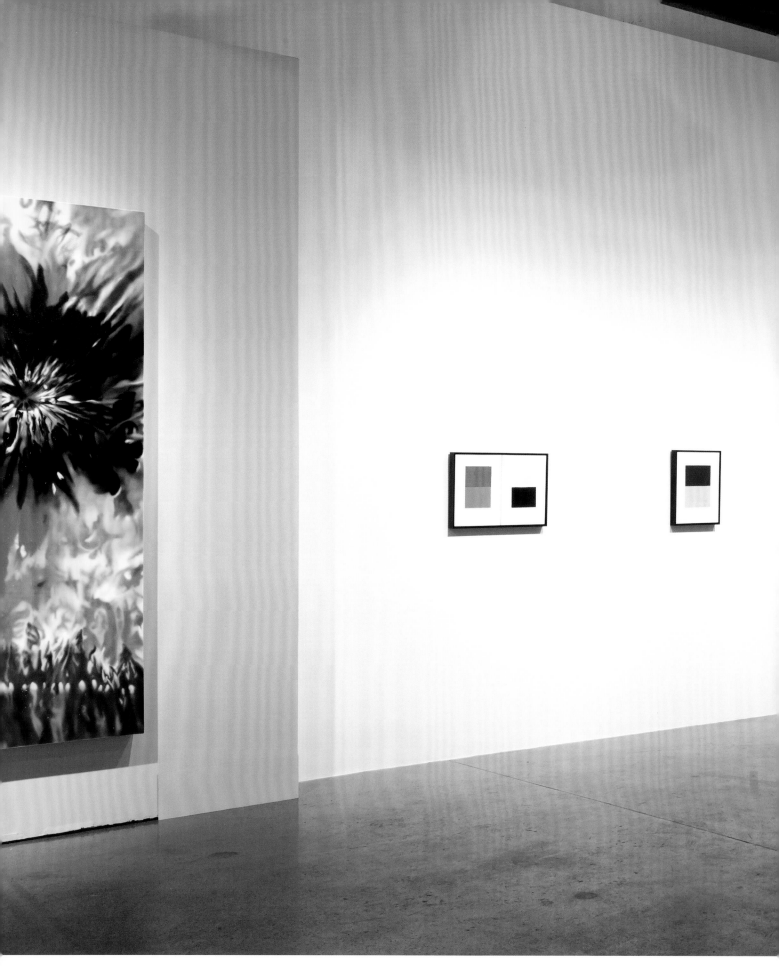

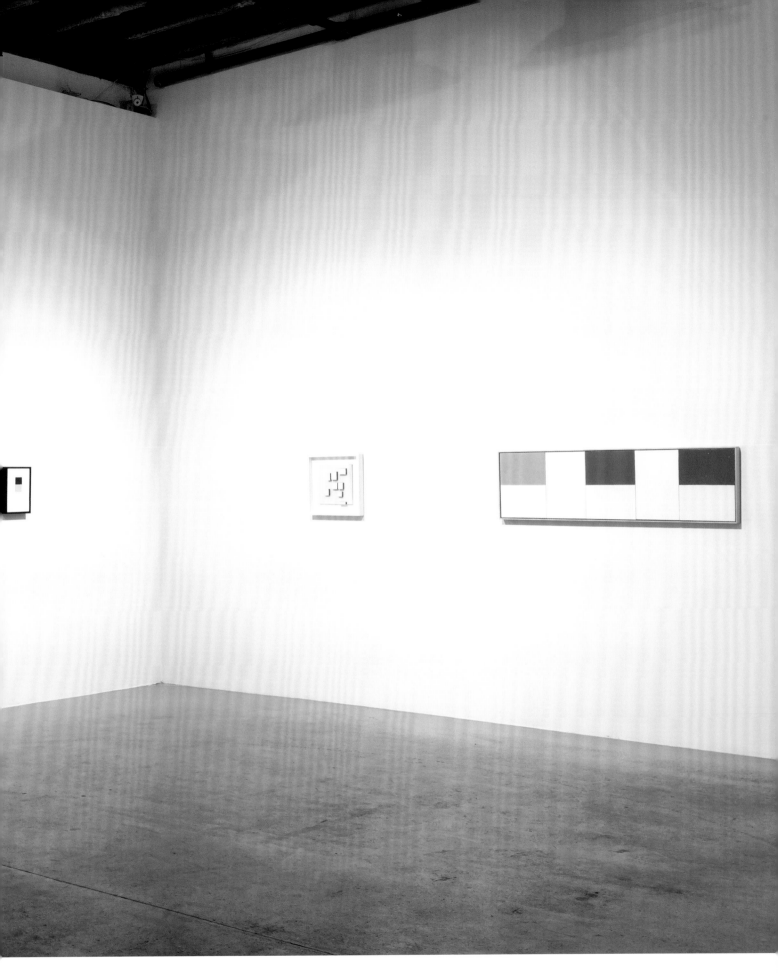

opposite left/ *Sun (For John Russon)*, 1992.
Oil and gesso on canvas, two joined panels,
40.6 x 61 cm (16 x 24 in). Collection of John
Russon, Toronto.

opposite right/ *Moon (For Derrick May)*, 1992.
Oil and gesso on canvas,
45.7 x 35.6 cm (18 x 14 in).

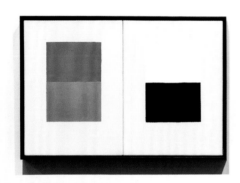

Little Eye, 1993.
Oil and gesso on canvas,
30.5 x 22.9 cm (12 x 9 in).

Untitled (Eight Red Rectangles), 1993.
Gesso and oil on wood, 27.9 x 28.6 x 3.2 cm
(11 x 11 1/4 x 1 1/4 in). Collection of Bev and
Jim Morlock, Toronto.

opposite/ *Untitled*, 1994.
Oil and gesso on five joined canvas panels,
40.6 x 143.4 cm (16 x 56 1/2 in).

overleaf/ Exhibition view, Museum of
Contemporary Canadian Art, Toronto.

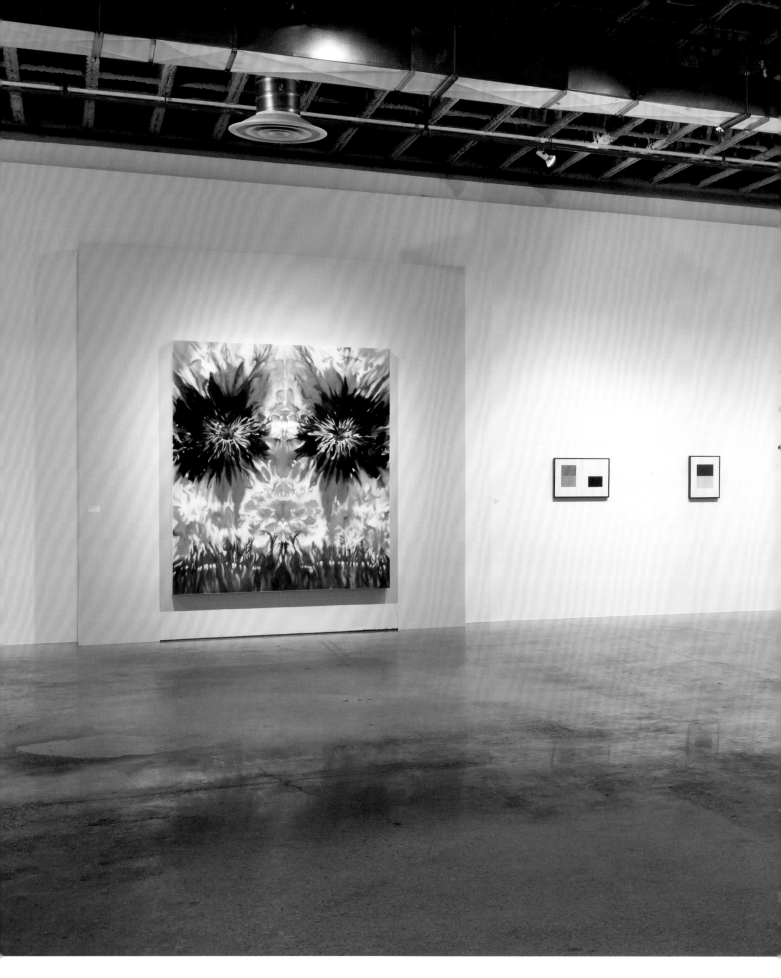

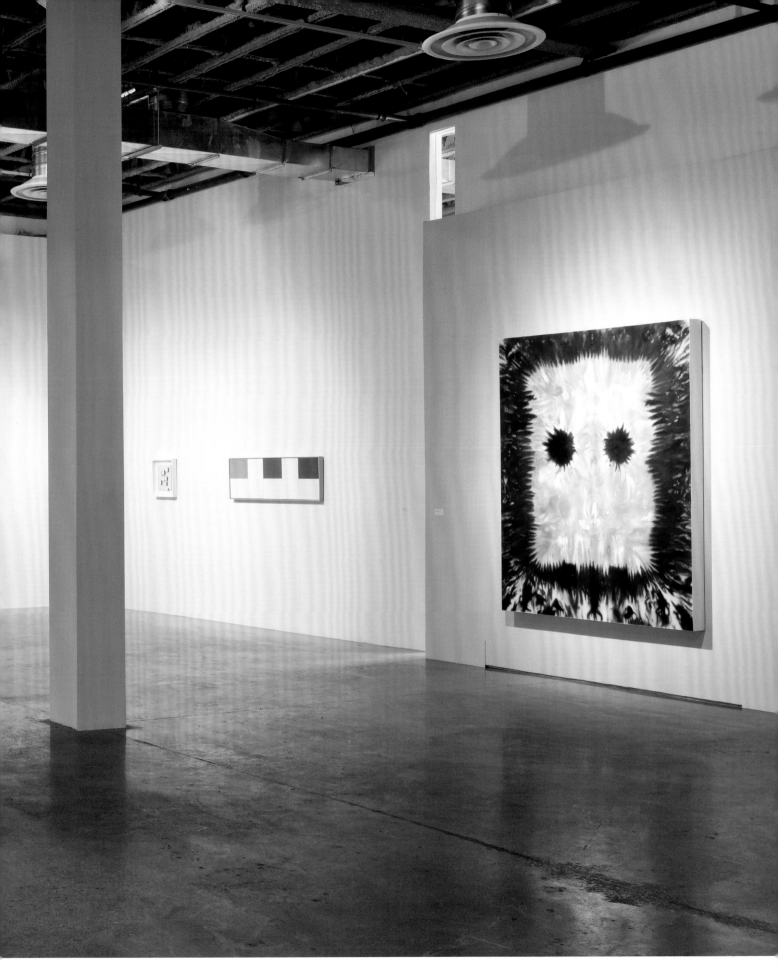

They Sleep With One Eye Open #2, 2008.
Acrylic on canvas, 212 x 172 cm (84 x 68 in).

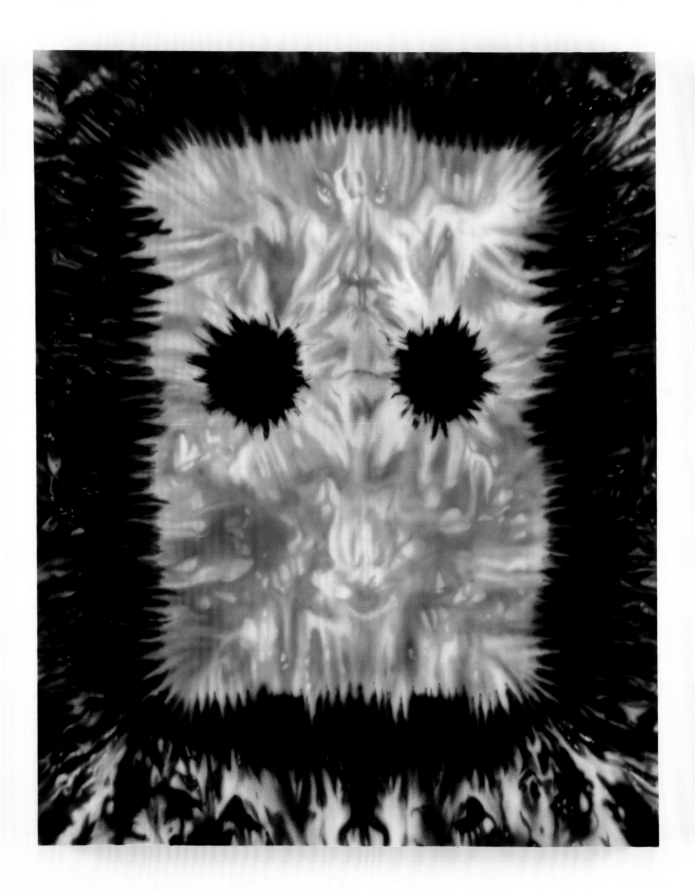

Untitled (Blockhead Drawing), 4 April 1995.
Ballpoint pen and pencil on paper,
21.6 x 14 cm (8 1/2 x 5 1/2 in).

LUIS JACOB

24 × 72

ORANGE PEKO
TEA BAGS

Apr.14,95

137

Aug 5 / 93

LJ.
2236—3

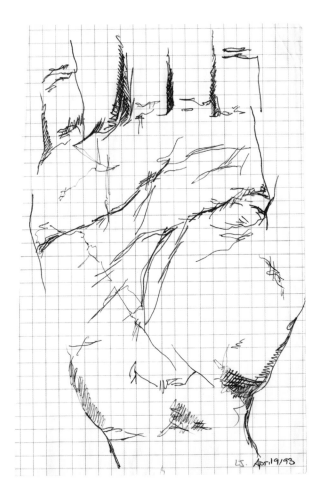

opposite/
Untitled (Green Drawing), 5 August 1993.
Felt-tip marker ink on printed paper,
27.9 x 21.6 cm (11 x 8 1/2 in).

above/
Untitled (Blue Hand with Lines), 19 April 1993.
Ballpoint pen ink on printed paper,
21.3 x 14.3 cm (8 3/8 x 5 5/8 in).

The Model, 2010.
Chromogenic print,
33.7 x 50.8 cm (13 1/4 x 20 in).

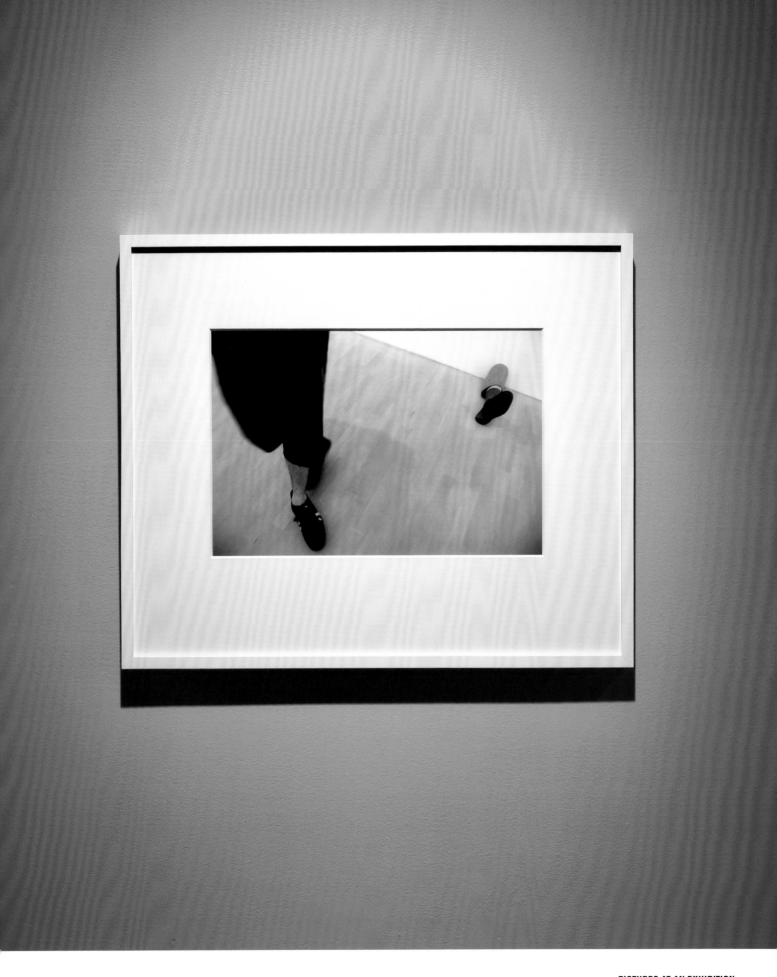

THE EYE,
THE HOLE,
THE PICTURE

McCORD MUSEUM,

MONTREAL,

2 SEPTEMBER 2011–

26 FEBRUARY 2012,

CURATED BY

ANNE-MARIE NINACS

ANNE-MARIE NINACS

LEARNING TO LIVE FROM WORKS OF ART

1/ The exhibition The Eye, the Hole, the Picture was curated by Anne-Marie Ninacs as part of Lucidity. Inward Views: Le Mois de la Photo à Montréal 2011, and presented at the McCord Museum of Canadian History, in Montreal, from 2 September 2011 to 26 February 2012.

The Eye, the Hole, the Picture was displayed in a spiral.[1] *Album X*, 2010, the most recent sequence of Luis Jacob's found images, at first enticed us to hug the coffered walls of the McCord Museum and, pinned to the inside of these big white frames, to look at photographs of more frames, of paintings, and of museum visitors absorbed in looking at the works, just like us. Then, the exhibition wound in on itself in the middle of the space, pursuing its *mise en abyme* in the display cases which contained *Cabinet (Montréal)*, 2011, a work comprising a selection of photographic archives drawn directly from the museum's storehouse. The associations made by Jacob in this work all underlined the materiality of the image—presented here flat and bare—from the photographic apparatus to the cultural construction of framing, not forgetting the physiological action of the eye. Our route ended facing a glazed column, where an imposing photo album made us stop, framed our gaze in the small mirror on its cover, transformed it into a picture and, with the effect of a period at the end of a sentence, absorbed conceptually in its closed pages all that we come to see.

Described in brief like this, or skimmed over by the eyes as one often does, the self-referential exhibition of *Album X* and *Cabinet (Montréal)* appears to align itself perfectly with a distanced and conceptual approach to the idea of art. In the event however, the two document-based works set out a demanding practice of vision. This is why it is important to retrace our steps, paying closer attention as we go.

2/ In this respect, the panel recalls *Album IV*, which opened with images of pregnant women.

3/ For his Albums, the artist uses images, which he cuts out of printed publications found at home and on his travels. To this day, none of these images have been taken from the internet or from digital sources.

4/ Jacob quoted in Hickey, Andria, "Without Persons: Luis Jacob interviewed by Andria Hickey", *Luis Jacob: Pictures at an Exhibition / Cabinet (NGC Toronto) / Project by Luis Jacob*, Toronto: Museum of Contemporary Canadian Art, 2011, n. p.

THE PICTURE There is very little on the panel which opens *Album X*: there is whiteness—that is to say emptiness—on which a plain, simple wooden frame defines a space that is at once physical and conceptual; there is a lead pencil and the idea of a line to trace; there is, in other words, nothing less than an artwork in the process of formation. Frame and pencil form the modest physical embodiment of an action which originates in the mind: a productive decision.[2] A Spanish caption (Jacob's mother tongue) indeed confirms that their assemblage depicts "*el instrumento y su obra*" ("the instrument and its work"), and, as a result, may suggest a reading of this work-in-progress as a subtle self-portrait of the artist. But in insisting from the outset, backed up by this phrase, that we see simultaneously the instrument and its work, Jacob above all installs at the foundation of *Album X* the powerful dialectic which will be at work throughout the following 80 panels of photographic reproductions,[3] namely that, for him, the image is inseparable from the frame: to see the one (the work, the picture), is inevitably to perceive the other (the instrument, the frame). "In my mind", he explains "'the image' is essentially an act of framing. What is an image? That which suits framing."[4]

Jacob's Album thus proceeds to show that the frame is at once specific and arbitrary and, consequently, that one can play with it, deconstructing it to better re-form it. From one image to the next, the Album links, without respite, the space defined by the frame; the frame as object; the spontaneous bricolage, framed by artistic classification; the frame filled with an accomplished work of art; the work in its framing context (the museum, the house, the forest); and then the viewers looking at a work, that is to say framing it with their own gaze, while seeing themselves reframed through the eyes of an invisible photographer whose photograph we, here and now standing in the McCord Museum, are regarding.

144

The sequence continues and certain works begin to exceed the scope of the frame and enter the museum space in search of new boundaries. Others are linked in an exhibition, shown side by side, thereby creating new frames of reference for each other. In upcoming images, technicians handle a picture, and reiterate with their hands its status as a rectangle, materially bound by stretchers, cloth, pigment, frame and hanging devices. Then this very restricted object tips over into the infinite space of symbolic representation; the image and the viewer begin to interact, they look each other in the eyes. The act of looking becomes more and more present, obvious; it is finally extracted and transferred to the projection screens of modernist paintings and to a panoply of empty frames, blank surfaces and windows. Jacob slowly mingles with these the frames constantly formed by our architectural environment, as well as the acts of framing which exist at the unconscious level of our daily life driven by conventions, in such a way that reality itself soon becomes the picture. Viewers turn into actors in a play, inseparable from the works which they enter and step through like Alice passing magically from one side of the looking glass to the other. Alice, however, quickly metamorphoses into Pipilotti bumping her nose against the glass partition, for a series of obscured surfaces shows us that true clarity is not available to the human eye. Clear glass can only evoke a relative lucidity, which is, at best, our consciousness of seeing the world through a limited device.

Thus begins a multiplication of viewpoints produced by images split, doubled or fragmented, proliferating to the point of invading the entire space and causing the splintering of the restrictive rectangular frame. At least that's what one can read in the following drapes and clothes which turn out to be a subversive version of the frame with their soft and porous borders; in these vibrant colours which stimulate the pure pleasure of creating and seem to demand of the frame that it reverts to being a space of play; and in the textual mural affirming that art is an indeterminate place—meaning that it, by its very nature, uses the frame to better escape it.[5] The two final panels address the viewer directly—they look us in the eyes, as Jacob would put it—and implore us in some way to loosen our grip on the security that any frame represents. On the first panel, a painting says "go home there is nothing to see", therefore reiterating the frame-image dialectic: there is nothing to see, there is 'nothing' to see.[6] Ying and yang. On the other, we read "theshow is over theaud ienceget up toleave the irseats ti metocollect theircoats and gohome theyturn a round nomo recoats and nomorehome". The text, borrowed from a work by Christopher Wool, also leads us back to that "nothing to see". While making manifest the arbitrary conventions on which language is based, the textual work divests us of the extensions of our identity that are our clothing and our homes, refuses to entertain us, returns us to whiteness, emptiness, vacuity, and so leaves us alone with the decision to create—that is to say, to establish our own frames, to choose our instruments, to produce our own images and to set to work. At the end of the trail *Album X* thus gently folds up the reflection of the viewer on the self-portrait of the artist with which it opened.

THE EYE Without us being really aware of it, the framing of the photograph itself, and the reframing which our eyes operate when viewing it in a particular environment—not to mention the conceptual and ideological frames which constantly affect our thoughts—are systematically added to the frames represented or evoked here by the content of the images. It is above all on this level that *Cabinet (Montréal)* takes up the baton from *Album X*, since Jacob has retained from the Notman Photographic Archives a selection of images and objects which render perceptible the transparent matrix of the photograph, as well as the mechanics of vision itself.[7] The first of the six vitrines—capped by a large open book showing, on a sketched easel, the full-length photographic portrait of an artist—pursues questions already

145

5/ A textual mural reproduced in *Album X* reads: "It is wholly indeterminate/ it has no specific traits/ it is entirely ineffable/ it is never seen/ it is not accessible."

6/ The phrase itself is a definition of nihilism by the Situationist writer Raoul Vaneigem. See "Art and Photography: 1990s–Present", *Heilbrunn Timeline of Art History*, The Metropolitan Museum of Art, http://www.metmuseum.org/toah/hd/ap90/hd_ap90.htm (consulted 5 October 2012).

7/ It is interesting to note that Jacob was a member of a queer Toronto band called The Hidden Cameras in the 2000s. "Under Pressure: The Terror—and Joy—of Knowing", *Xtra!*, n 504, 4 March 2004, http://www.darylvocat.com/Xtra-luis%20jacob.htm (consulted 5 October 2012).

well established by *Album X*: framing, sometimes *of* the image, sometimes *in* the image, is here conceived as the place the figure appears; it is the instrument thanks to which the phenomenal world becomes a picture. The second grouping makes visible the indexical quality of the photograph: here children point to images with their little index fingers; adults exhibit artworks or photographs to the camera; subjects pose, offering themselves to view. The third vitrine is alive with looks, which rebound in all directions, often with the help of mirrors: specular looks on oneself, direct looks, looks that are delayed, oblique, cancelled or crossed, which cause constant switches in position between the photographed subject and the viewer, at once intensifying the inside/in front/outside relationships represented in the photographs, and endowing the image with its own gaze onto us—its surface thus akin to the closed doors bearing a wide open eye photographed by David Miller. It seems natural then to consider the political implications of these games of looking, and the photographs of often-marginalised subjects assembled by Jacob in the fourth case bring our attention to that dimension. They ask: Who regards whom? Who frames the 'other'? What power relation, more or less subtle, does that act of definition imply? Their almost unanimous response rests in the action of seizing the camera, of turning it towards oneself, thereby regaining one's own power.

Thanks to this intricate dissection of the conventions which make possible the apparition of the picture, Luis Jacob guides us, slowly but surely, through not only the conceptual but also the physical qualities of the photograph. If he persistently tackles the photo's smooth surface it is, in effect, in order to extract from its core "that which looks back at us", that which *concerns* us (to revisit the maxim "*ce que nous voyons, ce qui nous regarde*" of Georges Didi-Huberman, with whom the artist shares a profound anthropological concern, in addition to a marked enthusiasm for atlases). In the past, Jacob even pushed this metaphor of a 'looking' work to the point of animism, saying that "pictures… fall asleep—but when they do, they do so with one eye open. They watch you from their well-adjusted place in the museum".[8] He otherwise painted a series of abstract faces with hypnotic gazes;[9] selected from worldwide museum collections works that were perforated with eyes and enlivened by glancing games; and made of a prosthetic eyeball the conceptual pivot of one of his recent exhibitions.[10] In *Cabinet (Montréal)*, he picks, little by little, the shreds from the photographic surface, turning it into a raw skin—reminiscent of the picture of a political poster peeled by the elements—or even bringing it closer to corroded flesh, open and gaping, like the flesh which surrounds the eye of that wounded child bearing an expression of frightening depth in one of the photographs.

In doing so, Jacob seeks to open nothing less, it seems, than a 'hole' through which the work may view us. That is to say: a hole through which the picture allows us to glimpse, beneath the gloss of appearances, the indeterminate foundation of reality, thus giving us access to that dimension of experience where there is "nothing to see". This dialectic between form and emptiness, with which we are now familiar, is indeed reiterated one last time in the fifth vitrine, which displays individually each of the interdependent components of photography—natural or artificial light, the single eye, the camera, the photosensitive paper, and the image—in the same manner in which we were shown previously "the instrument and its work", and the fundamentals of language along with signification in Wool's text-work. Moreover, in front of the very last vitrine, a little set back, we also find ourselves just like at the end of *Album X*, alone, facing our reflection, this time in the mirror adorning the cover of a large photograph album, and similarly returned to our own personal means by this closed book—the 'folded back' version of the large open book at the start of *Cabinet (Montréal)*—which denies us access to its contents.

8/ Jacob, Luis, "7 Pictures of Nothing Repeated Four Times, in Gratitude", in *Luis Jacob. 7 Pictures of Nothing Repeated Four Times, In Gratitude*, Cologne: Verlag der Buchhandlung Walther König, 2009, p. 34.

9/ Jacob, Luis, "7 Pictures of Nothing Repeated Four Times, in Gratitude", p. 34.

10/ "[The] first clue to Pictures at an Exhibition… [is] the single prosthetic eyeball, set gently in a black velvet box at the show's entrance." Whyte, Murray, "Luis Jacob: Bringing it all Back Home", *The Toronto Star*, 23 March 2011.

11/ The exhibition at the McCord Museum was first called Groundless in the Museum by Jacob, thus giving the place of honour to the hole. It was simply the difficulty of translating the term "groundless" which led the artist to change it. Work of the author with the artist for the preparation of the exhibition within the framework of Le Mois de la Photo à Montréal, spring 2011.

12/ Onians, John, *Neuroarthistory: From Aristotle and Pliny to Baxandall and Zeki*, New Haven and London: Yale University Press, 2007, p. 40. The neuroscientific data cited are all from this book.

13/ Onians, John, *Neuroarthistory: From Aristotle and Pliny to Baxandall and Zeki*, pp. 3–4.

14/ Brain neurologist Semir Zeki claims that artists are often neuroscientists without knowing it. Onians, John, *Neuroarthistory: From Aristotle and Pliny to Baxandall and Zeki*, p. 13. In the same book, Onians explains that "so-called mirror neurons… cause us unwittingly to prepare to imitate the actions that we see others performing…", p. 25.

THE HOLE As the picture cannot exist without the frame, the hole cannot be perceived without the eye and the picture. Yet it is this hole in conventions, opening up onto life as a process of becoming, that Luis Jacob seeks so ardently to reveal by contrast, and to make us feel in his works.[11] He says for instance that he never begins work on an Album until he is tormented by a question, and the very concern that has not ceased to appear between the lines of each of his Albums for more than ten years, is the question of knowing how to bring to our consciousness—submitted to the positivist and productivist forces of the modern age—the fundamental and fertile indeterminacy on which is set what we call "reality". Jacob uses the word "groundlessness" to describe this opening: the place where we lose our footing. His works therefore aim to shake up our fixed preconceptions, to open them up, to penetrate them with that which has been marginalised by the frame, and recharge them with potential. In the Albums, this potential manifests itself through the images which at first oppose and resist each other, then eventually interpenetrate and are thus transformed. Over the years Jacob has in this way established a rich visual dialogue between the power of the vertical and the potential of the horizontal; corporal strength and spiritual energy; standard education and the capacity to unlearn; the foreseeing of functional objects and the adaptability of the human body; the object-like quality of sentient beings and the vitality of inanimate objects; and even as discussed in this essay, the framed work and the looking picture. Each one of his Albums can thus be read as a translation into the world of physical forms of our mental preoccupations concerning our values, our habits and our prejudices.

To us, the viewer, these visual narratives, eminently mutable and open to interpretation, are far from offering an answer to the question; rather, they provide first and foremost a physically and mentally engaging experience in perception, which can be transformative. For with their use of an enormous number of images belonging to the collective consciousness, which activate the millions of visual files already stored in our mental reserves and our genetic code, Jacob's Albums reveal, on an even more subtle level, the tension which exists between the rigidities of our brains—resistant to novelty, in love with repetition, with categorisation, conservation and always inclined to cling to what they know[12]—and the incredible plasticity of those same brains—constantly transformed by both conscious and unconscious experience, infinitely capable of reorganising their neurones so as to absorb new information, and pushed by an irrepressible force to transmute.[13] Like a skilled neuroscientist stimulating our mirror neurones, Jacob heightens our capacity for empathy and imitation so that we take from his images a more supple, more nuanced, more sensitive relation to the world and newly open-minded attitudes, which we can transfer to our daily lives.[14] It is in this sense that his sequences of found images derive from a pragmatic impulse. The emphasis placed on the equipment and the conditions of perception, explored most recently in his Cabinets, only confirms this desire to put the image to a practical use.

The artist's increasing interest in the artwork and the institutional context of its conservation-preservation-reception, explored in the Albums and Cabinets since 2009, should not surprise us, nor should it be seen as a departure from the queer social issues and underground community art projects for which he initially became known. Rather it is now even more important to discern the position Jacob's recent works make us adopt by constantly returning us to ourselves: that of a 'living' artwork; a work which views the world from an indeterminate place; a work endowed—like that series of little formalist paintings which he made in 1998—with a "superinstinct… that special antenna we carry deep inside our nervous system. It is radical, horizontal. It guides us, it controls each one of us,

15/ Jacob, Luis, "*Superinstinct, 1998*", *Squareheads: Luis Jacob, Richard Kerr, Greg McHarg, Jay Wilson*, Toronto, YYZ Artists' Outlet, 1999, p. 13.

16/ Jacob, Luis, "Groundless in the Museum: Anarchism and the Living Work of Art", text from a presentation first given to the Second Annual North American Anarchist Studies Network Conference, Toronto, 15 January 2011, n. p.

and runs things."[15] We must also understand, I think, that Jacob does not take refuge within the confines of the museum, but that he, on the contrary, uses the museum space to directly address the artistic community—the occasional gallery-goers, art lovers, collectors, tourists, artists, curators, museum professionals, cultural workers and creators in all disciplines—as an active and transformative part of society. If he so closely interrogates the *habitus* of this community, it is in order to make visible the fixed forms, the clichés and the uncharted parts of our relationship with art, as well as to acknowledge in individual works their full capacity to produce a 'hole' and to show us again and again, until we have fully assimilated it, that "art reminds us that we can be at home in the hole, and nowhere else".[16]

148

opposite/ *Young man with an eye patch, Montreal, about 1968.* David Wallace Marvin, gift of Mrs. David Marvin, McCord Museum, MP-1978.186.2.6.40.

overleaf/ Exhibition view, McCord Museum, Montreal.

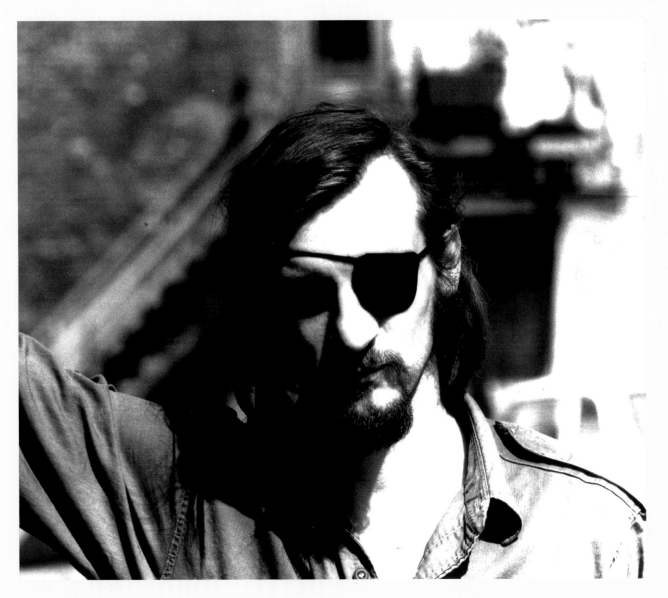

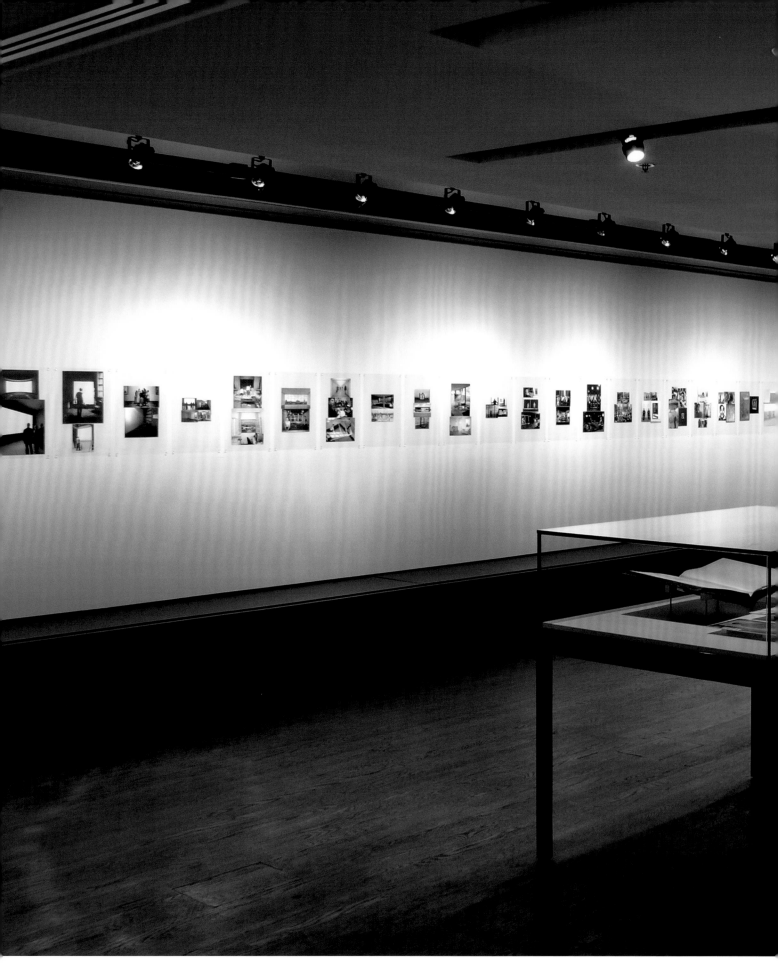

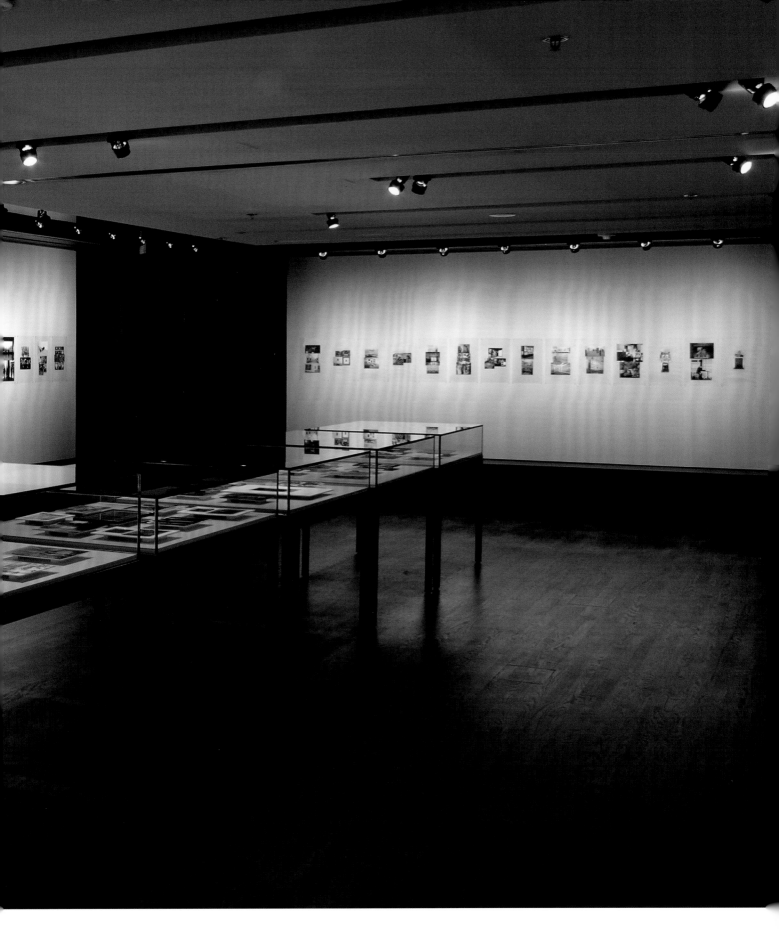

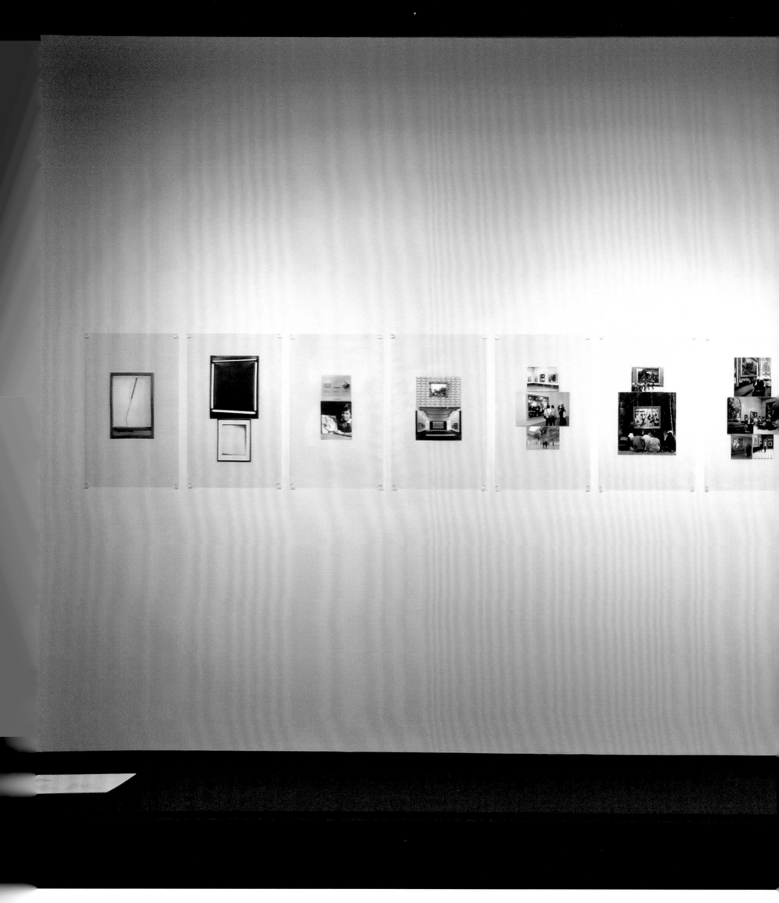

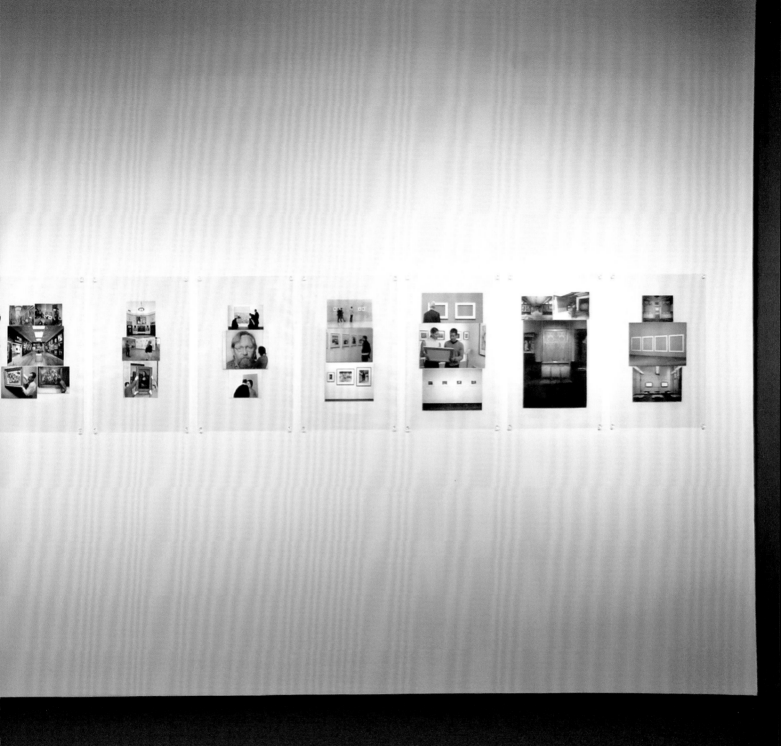

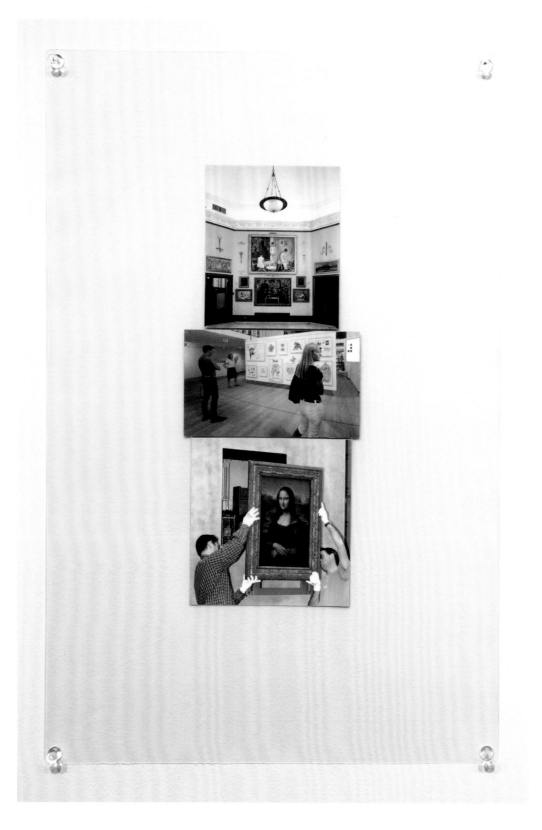

previous pages/ *Album X*, 2010.
Image montage in plastic laminate,
80 panels, 44.5 x 29 cm (17 1/2 x 11 1/2 in)
each. Collection of Musée d'art contemporain
de Montréal.

above and opposite/ *Album X*, 2010.
Image montage in plastic laminate,
80 panels, 44.5 x 29 cm (17 1/2 x 11 1/2 in)
each, view of panels 9 and 10. Collection of
Musée d'art contemporain de Montréal.

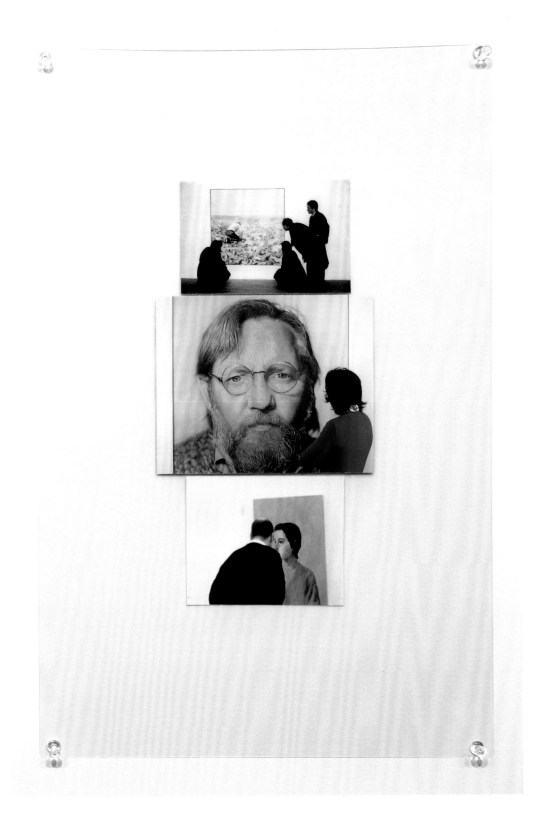

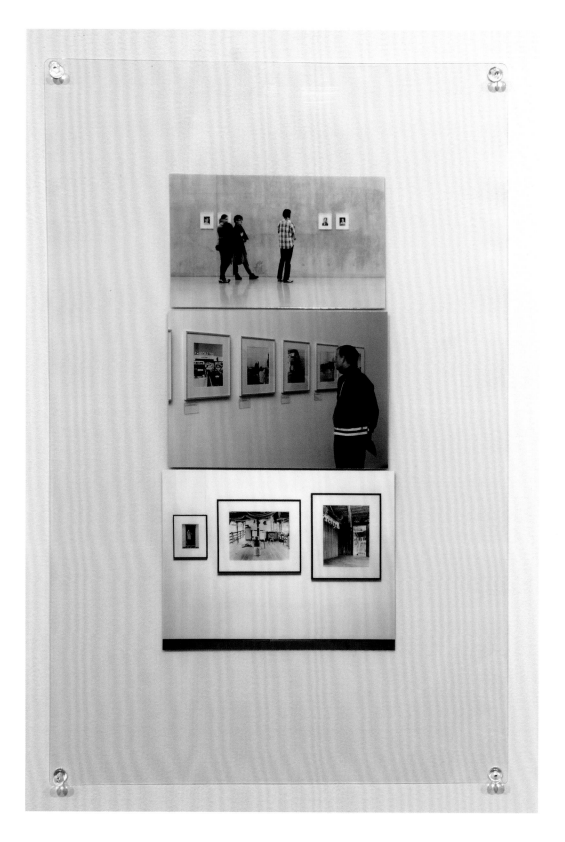

above and opposite/ *Album X*, 2010.
Image montage in plastic laminate,
80 panels, 44.5 x 29 cm (17 1/2 x 11 1/2 in)
each, view of panels 11 and 12. Collection of
Musée d'art contemporain de Montréal.

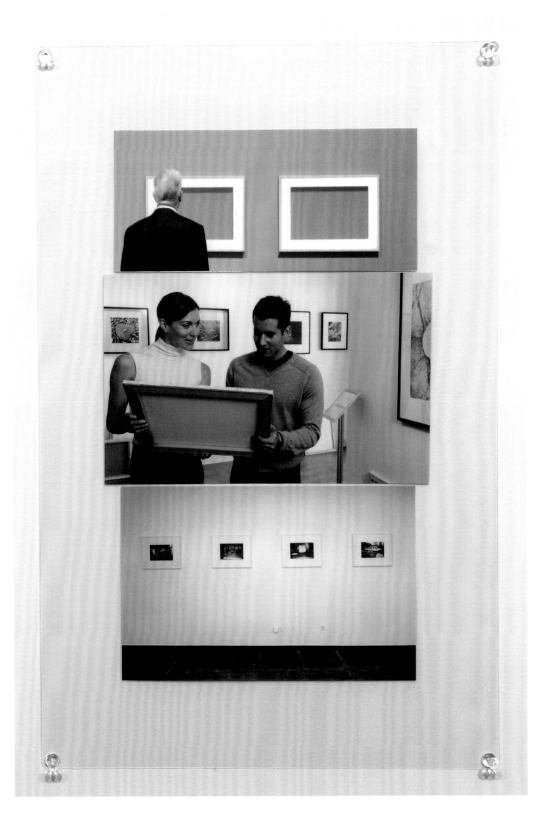

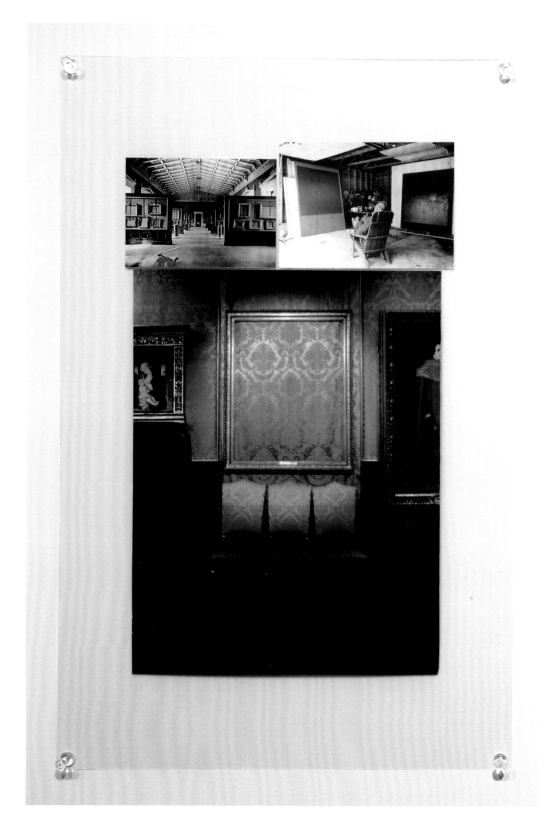

above and opposite/ *Album X*, 2010.
Image montage in plastic laminate,
80 panels, 44.5 x 29 cm (17 1/2 x 11 1/2 in)
each, view of panels 13 and 14. Collection of
Musée d'art contemporain de Montréal.

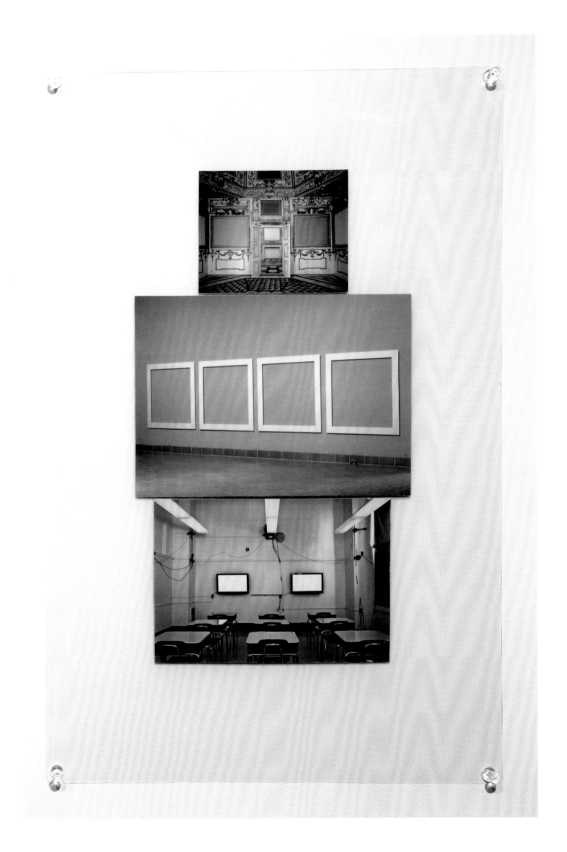

159

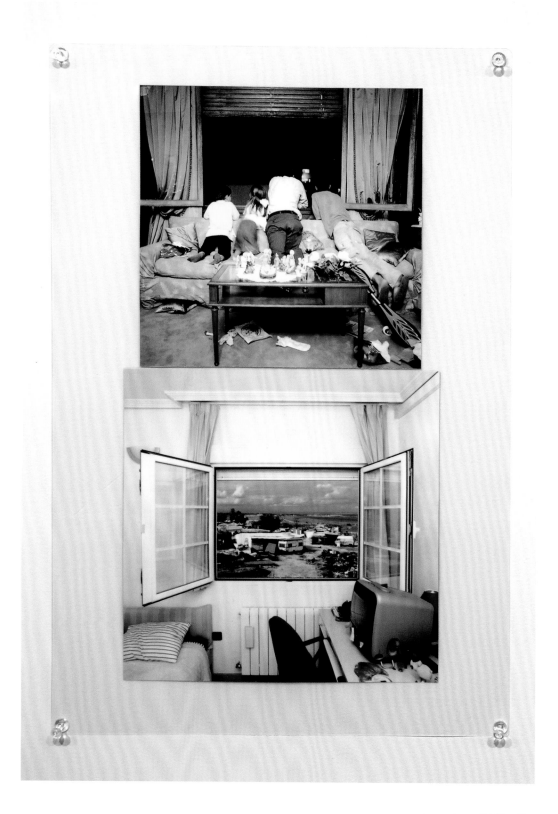

above and opposite/ *Album X*, 2010.
Image montage in plastic laminate,
80 panels, 44.5 x 29 cm (17 1/2 x 11 1/2 in)
each, view of panels 25 and 26. Collection of
Musée d'art contemporain de Montréal.

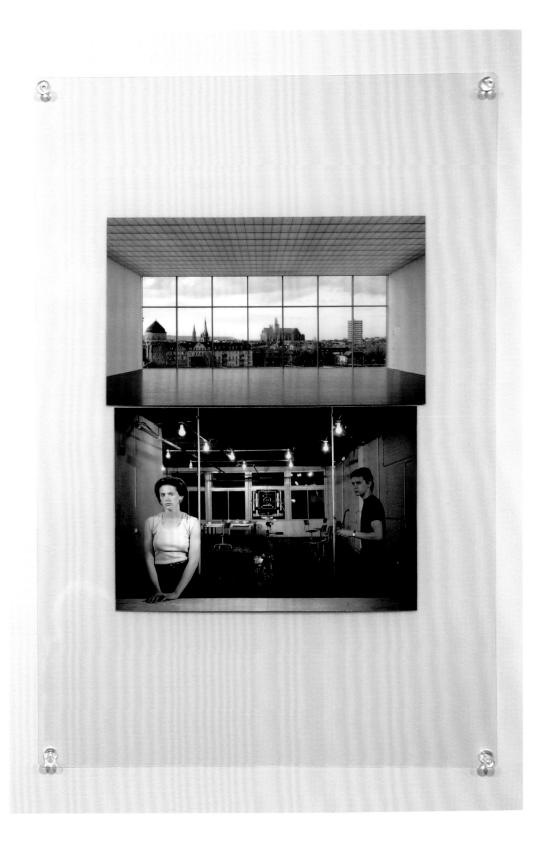

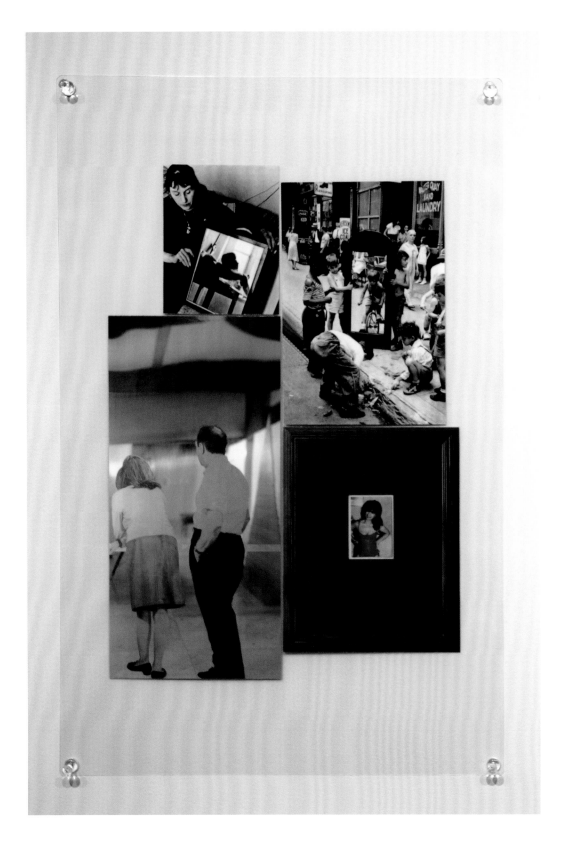

above and opposite/ *Album X*, 2010.
Image montage in plastic laminate,
80 panels, 44.5 x 29 cm (17 1/2 x 11 1/2 in)
each, view of panels 37 and 38. Collection of
Musée d'art contemporain de Montréal.

LUIS JACOB

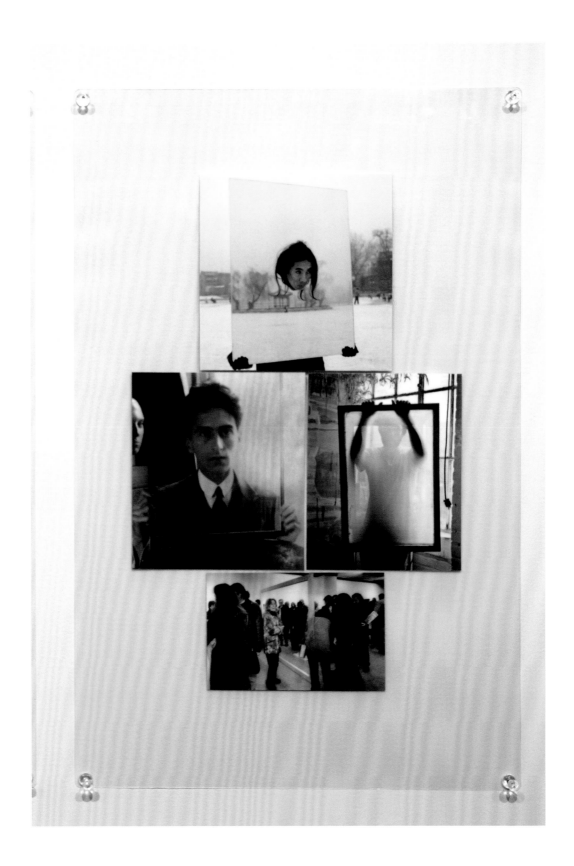

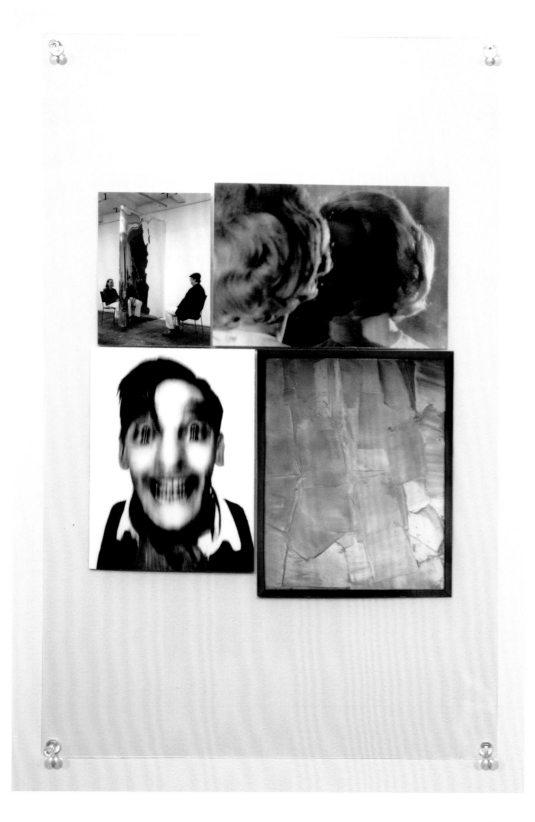

above and opposite/ *Album X*, 2010.
Image montage in plastic laminate,
80 panels, 44.5 x 29 cm (17 1/2 x 11 1/2 in)
each, view of panels 39 and 40. Collection of
Musée d'art contemporain de Montréal.

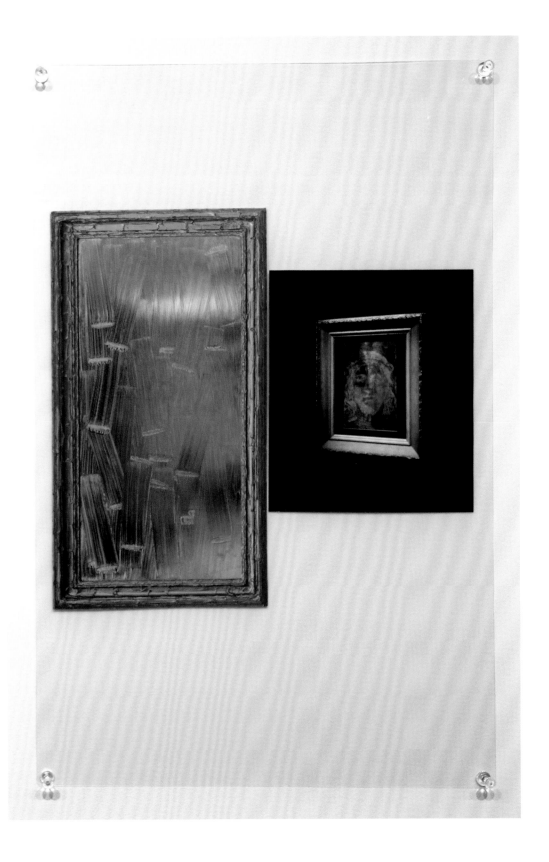

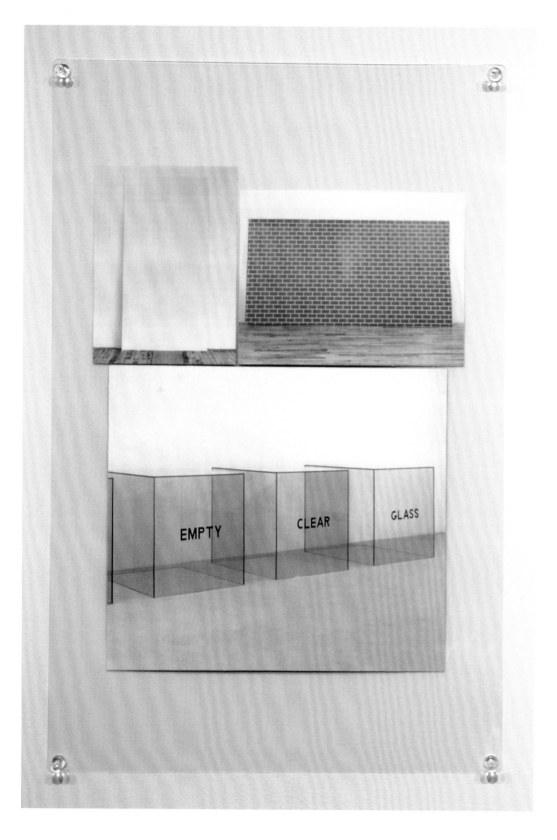

above and opposite/ *Album X*, 2010.
Image montage in plastic laminate,
80 panels, 44.5 x 29 cm (17 1/2 x 11 1/2 in)
each, view of panels 41 and 42. Collection of
Musée d'art contemporain de Montréal.

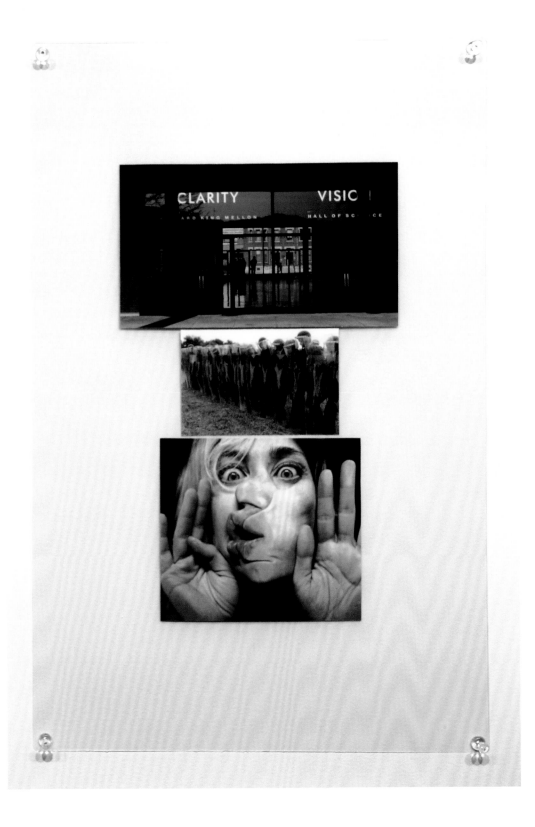

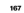

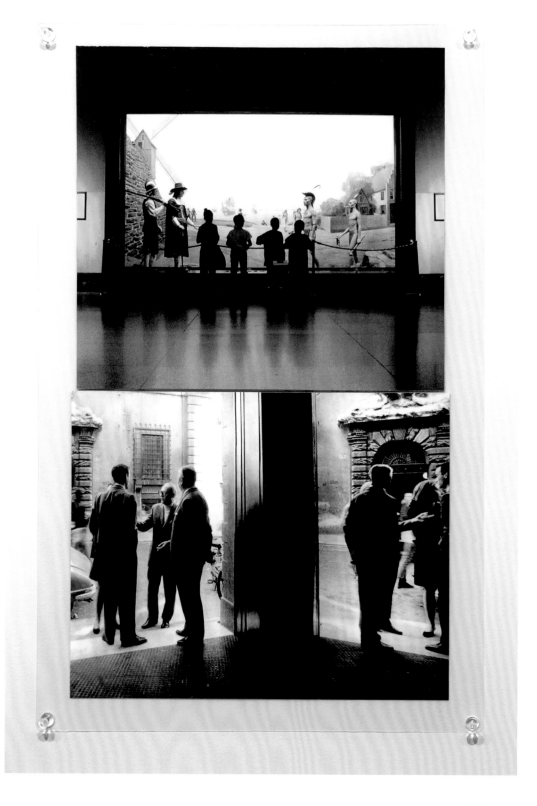

above and opposite/ *Album X*, 2010.
Image montage in plastic laminate,
80 panels, 44.5 x 29 cm (17 1/2 x 11 1/2 in)
each, view of panels 44 and 45. Collection of
Musée d'art contemporain de Montréal.

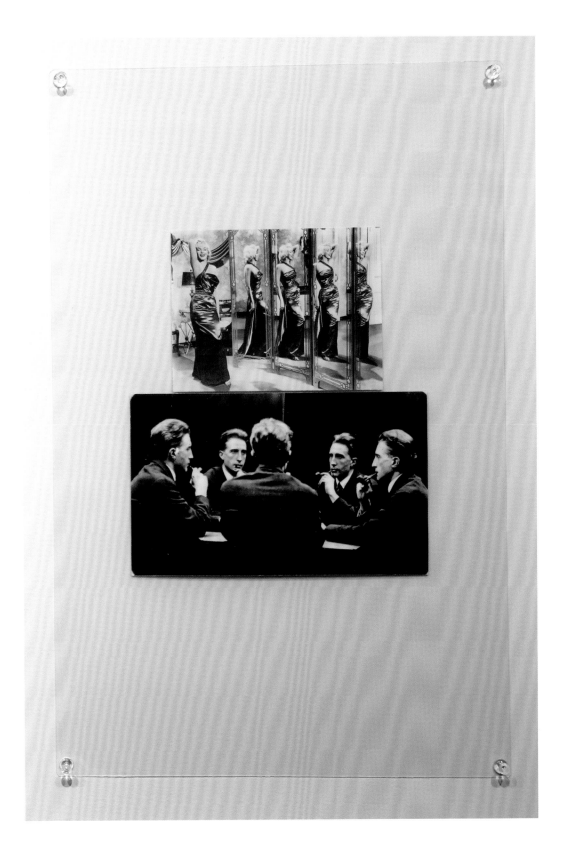

169

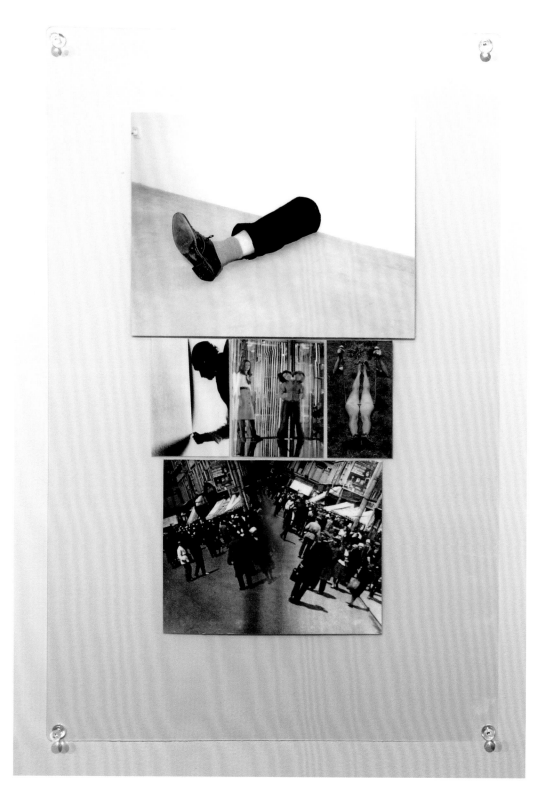

above and opposite/ *Album X*, 2010.
Image montage in plastic laminate,
80 panels, 44.5 x 29 cm (17 1/2 x 11 1/2 in)
each, view of panels 46 and 47. Collection of
Musée d'art contemporain de Montréal.

overleaf/ Exhibition view, McCord Museum,
Montreal.

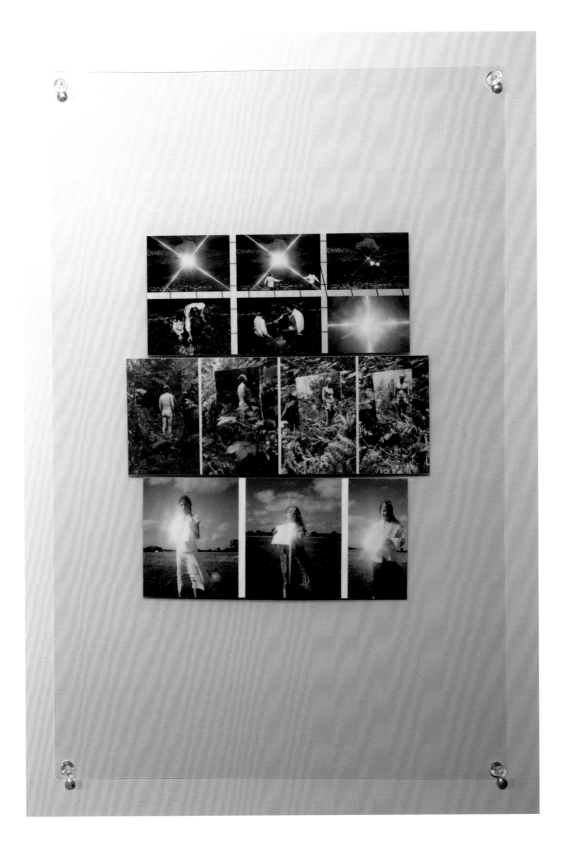

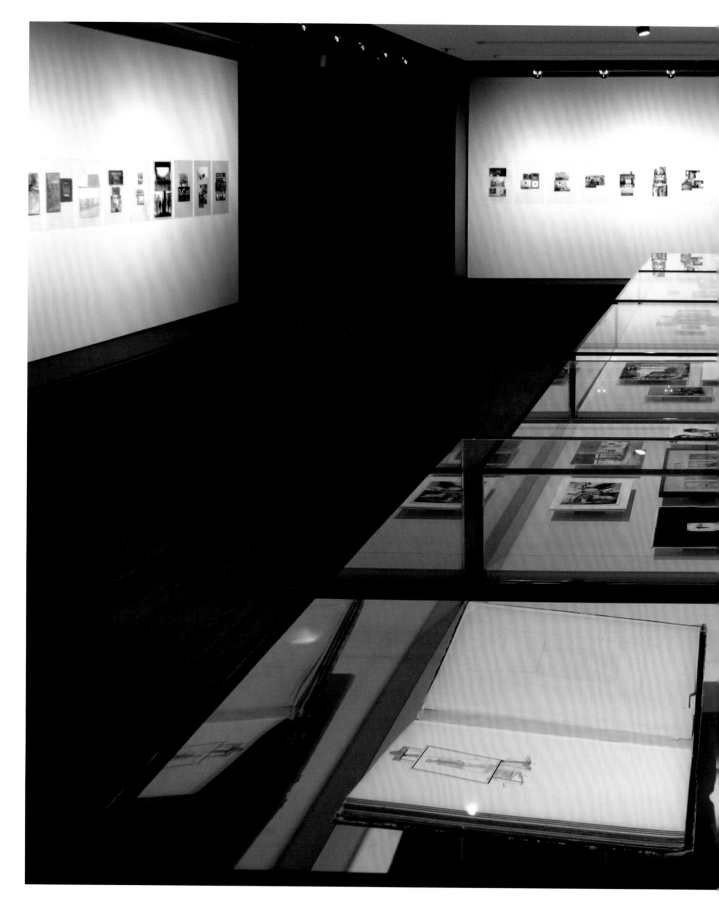

172

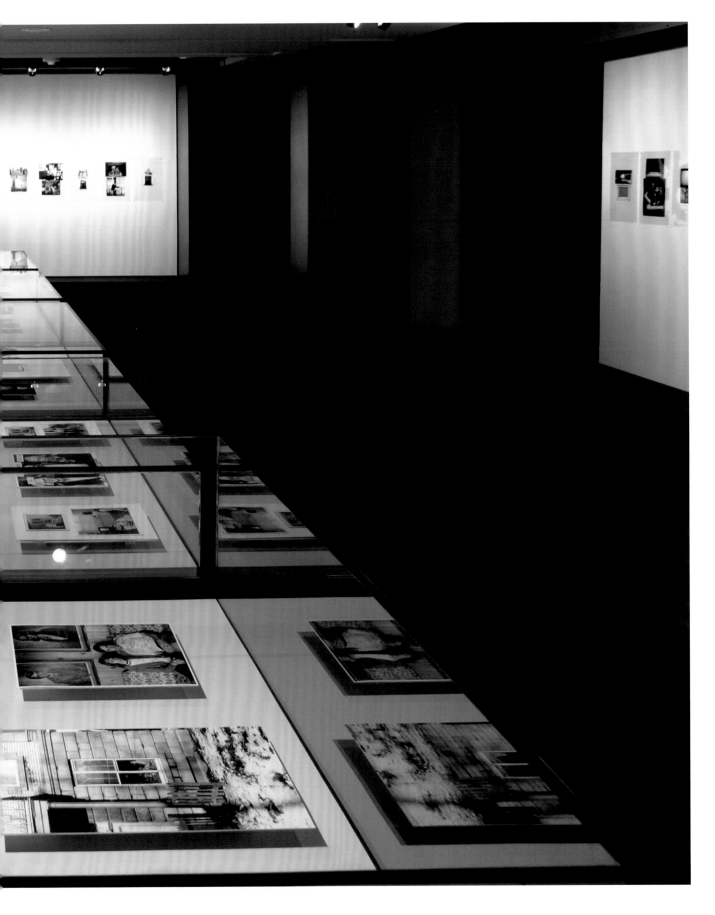

173

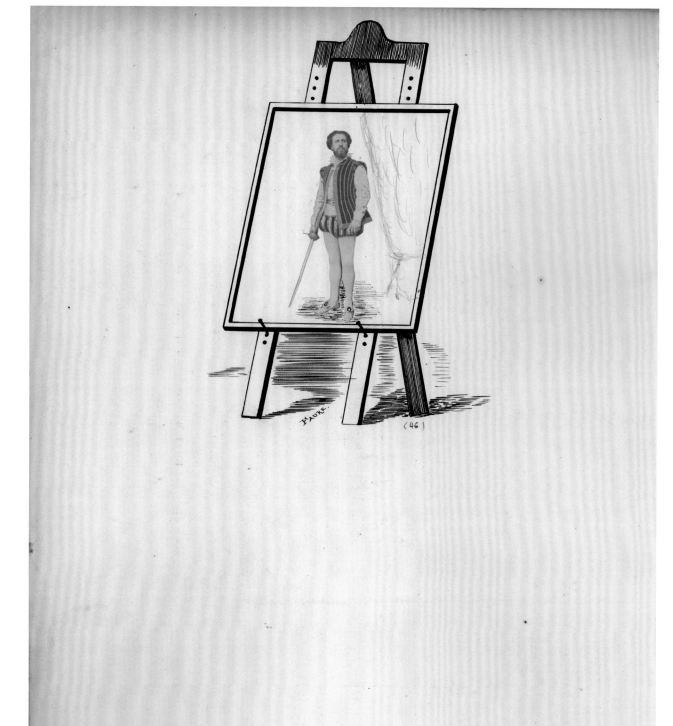

174

Photographer unknown, from an *Album of actors and actresses* compiled by Hugh Becket, about 1875.

2/ *Boy with a bag and blanket, about 1930.*
Photographer unknown, McCord Museum,
MP-1978.107.266.

3/ *Woman at a window, Montreal, about 1968.*
David Wallace Marvin, gift of Mrs. David
Marvin, McCord Museum, MP-1978.186.2.4.59.

1/ *Album of portraits of actresses compiled by*
Hugh Beckett, about 1875.
Photographer unknown, McCord Museum,
MP-1978.27.1.1-129.

4/ *Mr. and Mrs. Adrien Ouellette, Saint-Joseph-de-*
Beauce, QC, 1973.
Gabor Szilasi, gift of Gabor Szilasi, McCord
Museum, MP-1974.16.21.

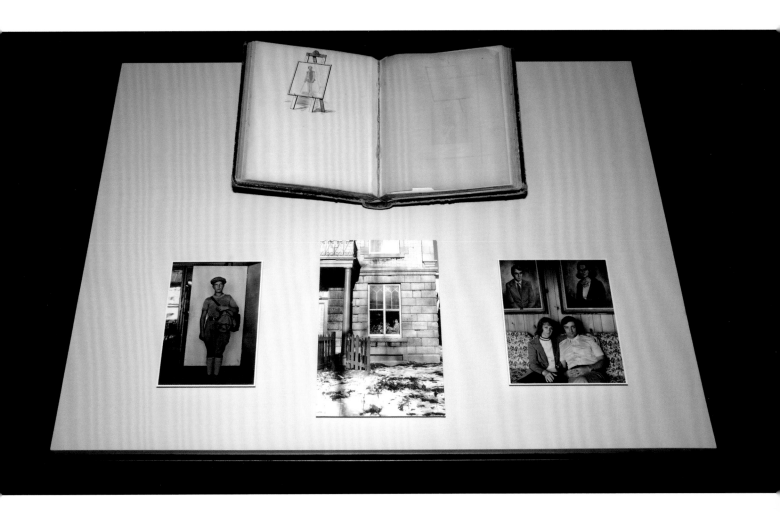

Cabinet (Montréal), 2011.
Montage of photographs and objects drawn
from the Notman Photographic Archives of
the McCord Museum, view of display case #1.

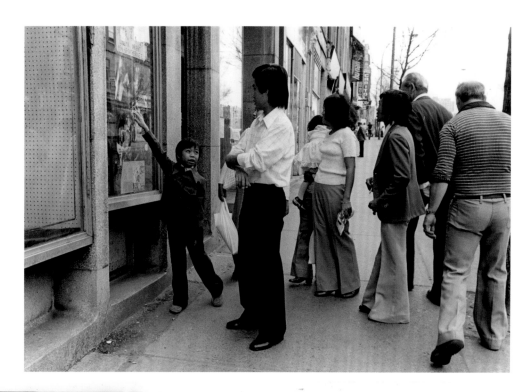

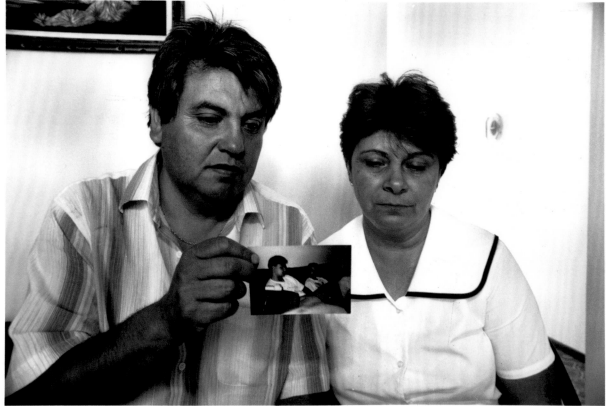

ANDREW TAYLOR

Claire Beaugrand-Champagne, *Family in front of a store window*, Montreal, about 1975 (top); Andrew Taylor, *Jaime and Theresa Araneda Riquelme mourning their sons*, 1989 (bottom).

3/ *Hunters posing in front of Peter Pitseolak, Cape Dorset, Nunavut, 1944–1960.*
Photographer unknown, Canadian Museum of Civilization, iconographic document 2000-190.

1/ *Family being Photographed at dinner, Montreal, about 1975.*
Claire Beaugrand-Champagne, collection of the artist, MP-1981.69.5001.

2/ *Art vendor at Place Jacques Cartier, Montreal, about 1968.*
David Wallace Marvin, gift of Mrs. David Marvin, McCord Museum, MP-1978.186.2.2.58.

4/ *"D.D. Intimate Friends at an Impressionable Period, 1861–66".*
Honorable Colonel Robert Rollo, gift of David Ross, McCord Museum, M6795.

5/ *Jaime and Theresa Araneda Riquelme mourning their sons, 1989.*
Andrew Taylor, gift of Nathalie Taylor, McCord Museum, MP-1999.5.150.5011.

6/ *Al Kravitz holding a photograph of the interior of Bens Delicatessen below portraits of his parents, Montreal, 1980.*
Photographer unknown, Bens Delicatessen Collection in Honour of its Founders: Ben & Fanny Kravitz, Irving Kravitz, Al Kravitz and Sollie Kravitz, McCord Museum, M2008.8.2.1.66.

7/ *Child pointing at the television, Montreal, about 1975.*
Claire Beaugrand-Champagne, collection of the artist, MP-1981.69.5002.

8/ *The Kravitz brothers, Al, Irving and Sollie, Montreal, about 1991.*
Photographer unknown, Bens Delicatessen Collection in Honour of its Founders: Ben & Fanny Kravitz, Irving Kravitz, Al Kravitz and Sollie Kravitz, McCord Museum, M2008.8.2.1.72.

9/ *Al Kravitz hanging a photograph of the interior of Bens Delicatessen below portraits of his parents, Montreal, 1980.*
Photographer unknown, Bens Delicatessen Collection in Honour of its Founders: Ben & Fanny Kravitz, Irving Kravitz, Al Kravitz and Sollie Kravitz, McCord Museum, M2008.8.2.1.67.

10/ *Family in front of a store window, Montreal, about 1975.*
Claire Beaugrand-Champagne, collection of the artist, MP-1981.69.5003.

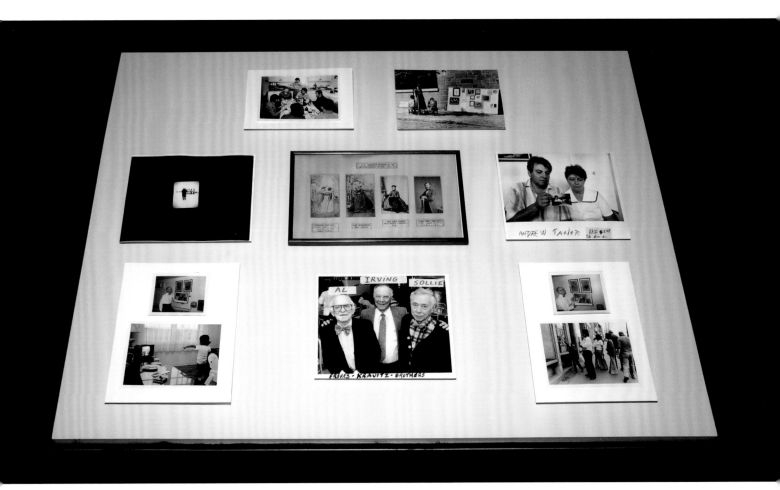

Cabinet (Montréal), 2011.
Montage of photographs and objects drawn
from the Notman Photographic Archives of
the McCord Museum, view of display case #2.

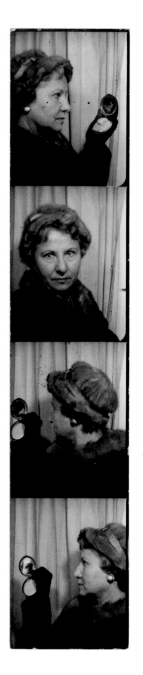

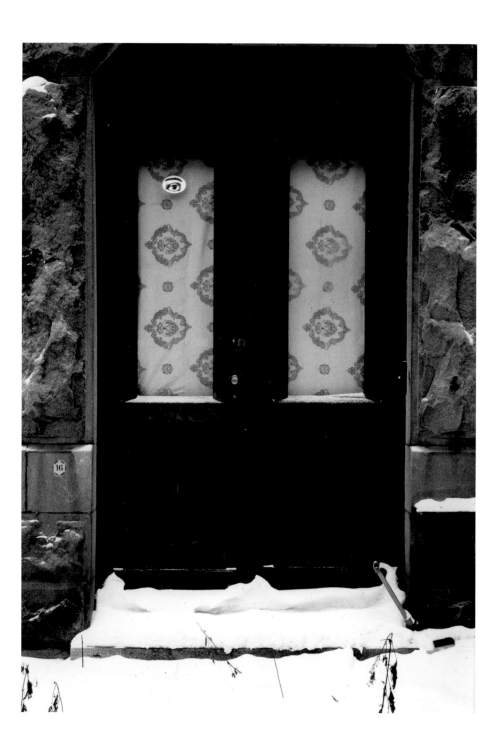

Anne Kew, *Self-portrait, photobooth*, Montreal,
1961 (left); David Miller, *Door, Milton Park
neighbourhood*, Montreal, 1972 (right).

1/ *Master J.R. and Miss E. Smith, Montreal, 1866.*
William Notman, McCord Museum, I-21764.1.

2/ *Reflection of a street in a mirror, Montreal,*
about 1968.
David Wallace Marvin, gift of Mrs. David
Marvin, McCord Museum, MP-1978.186.2.4.45.

3/ *Mrs. Stevenson, Montreal, 1865.*
William Notman, McCord Museum, I-14648.1.

4/ *Anne Kew, Self-portrait, photobooth,*
Montreal, 1961.
Anne Kew, gift of Anne Kew, McCord
Museum, M2002.77.1.5038.1-4.

5/ *Door, Milton Park neighbourhood,*
Montreal, 1972.
David Miller, collection of the artist, MP-
0000.2125.5.

6/ *Viscountess of Dunlo, actress, about 1891.*
Copy by Wm. Notman & Son, 1891, McCord
Museum, II-96353.0.1 (top).
Mary Ansell, actress, about 1891.
Copy by Wm. Notman & Son, 1891, McCord
Museum, II-96354.0.1 (bottom).

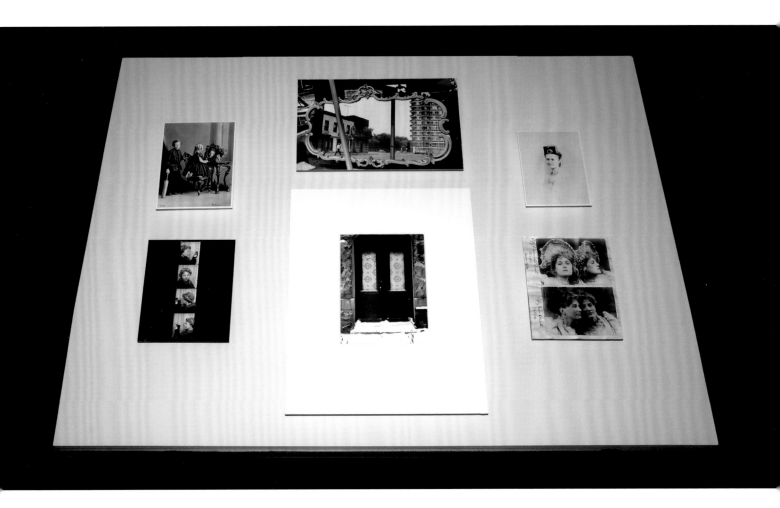

Cabinet (Montréal), 2011.
Montage of photographs and objects drawn
from the Notman Photographic Archives of
the McCord Museum, view of display case #3.

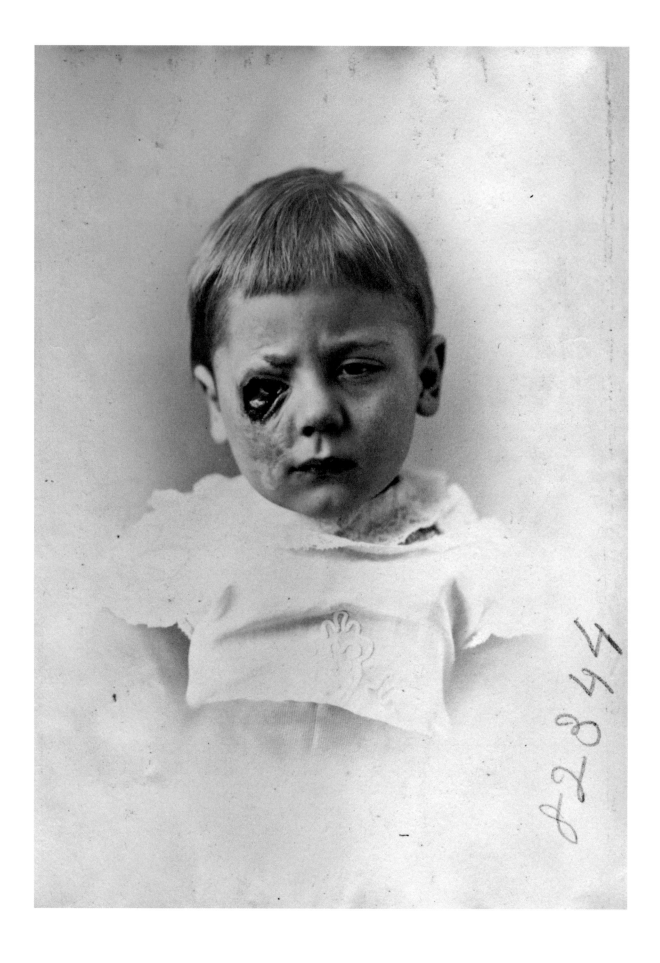

Wm. Notman & Son, *Mrs. Saltin's child*,
Montreal, 1887.

1/ *Girls with cameras, Cape Dorset, Nunavut, about 1977.*
Photographer unknown, gift of Aggeok Pitseolak, McCord Museum, MP-1977.4.1.

2/ *Election poster, Montreal, about 1968.*
David Wallace Marvin, gift of Mrs. David Marvin, McCord Museum, MP-1978.186.2.9.38.

3/ *Anne Kew, Self-portrait, Gaspé region QC, 1952.*
Anne Kew, gift of Anne Kew, McCord Museum, M2002.77.2.15.5013.

4/ *Self-portrait with a camera, about 1915 (top).*
Photographer unknown, McCord Museum, MP-0000.586.76.

5/ *Mrs. Saltin's child, Montreal, 1887.*
Wm. Notman & Son, McCord Museum, II-82344.1.

6/ *Peter Pitseolak with 122 camera, Keatok Camp, South Baffin Island, Nunavut, 1948.*
Photographer unknown, Canadian Museum of Civilization, iconographic document 2000-187.

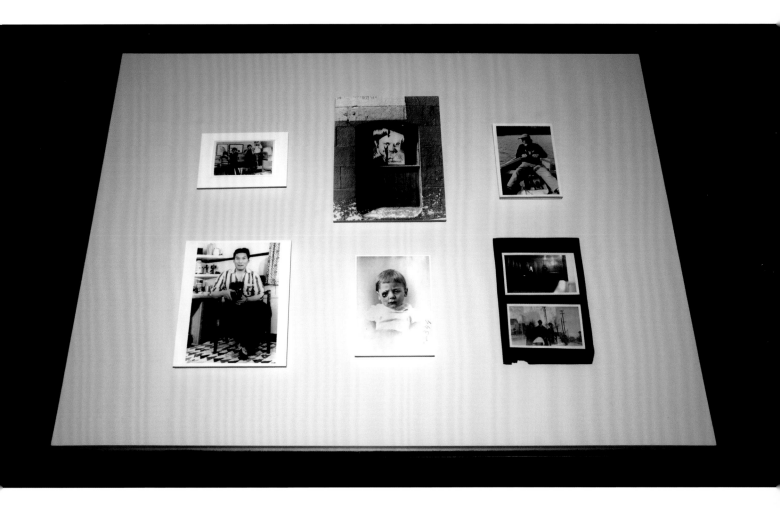

Cabinet (Montréal), 2011.
Montage of photographs and objects drawn
from the Notman Photographic Archives of
the McCord Museum, view of display case #4.

190

Photographer unknown, *Sun and clouds*,
about 1915 (top); Photographic paper
envelope used to hold a negative in
1932–1933 (bottom).

192

2/ *Young man with an eye patch, Montreal, about 1968.*
David Wallace Marvin, gift of Mrs. David Marvin, McCord Museum, MP-1978.186.2.6.40.

3/ *Sun and clouds, about 1915.*
Photographer unknown, McCord Museum, MP-0000.586.1.

4/ *Nineteenth-century camera on a stand.*
Iconographic document, McCord Museum.

5/ *Photographic paper envelope used to hold a negative in 1932–1933.*
McCord Museum, View-25295E.

1/ *Flashbulbs in box.*
McCord Museum, M992.146.7.6.1-13.

Cabinet (Montréal), 2011.
Montage of photographs and objects drawn
from the Notman Photographic Archives of
the McCord Museum, view of display case #5.

1

1/ *Phaneuf family album 1885–1895.*
Gift of Luc d'Iberville-Moreau, McCord
Museum, MP-1995.7.2.1-42

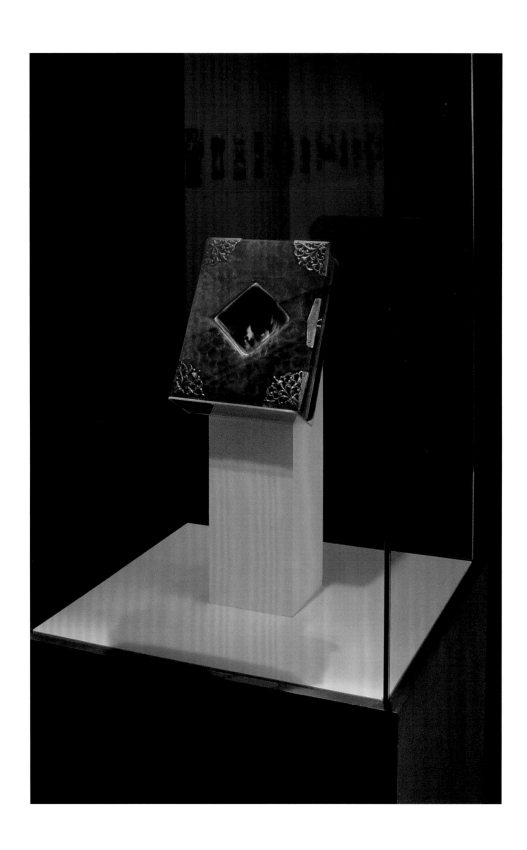

Cabinet (Montréal), 2011.
Montage of photographs and objects drawn
from the Notman Photographic Archives of
the McCord Museum, view of display case #6.

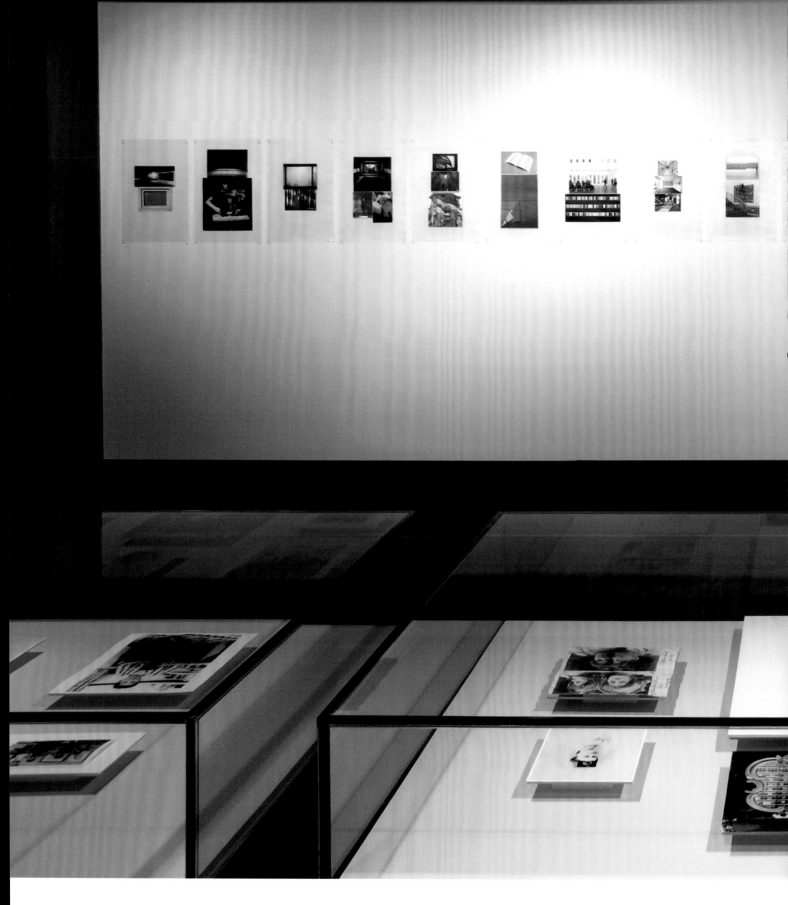

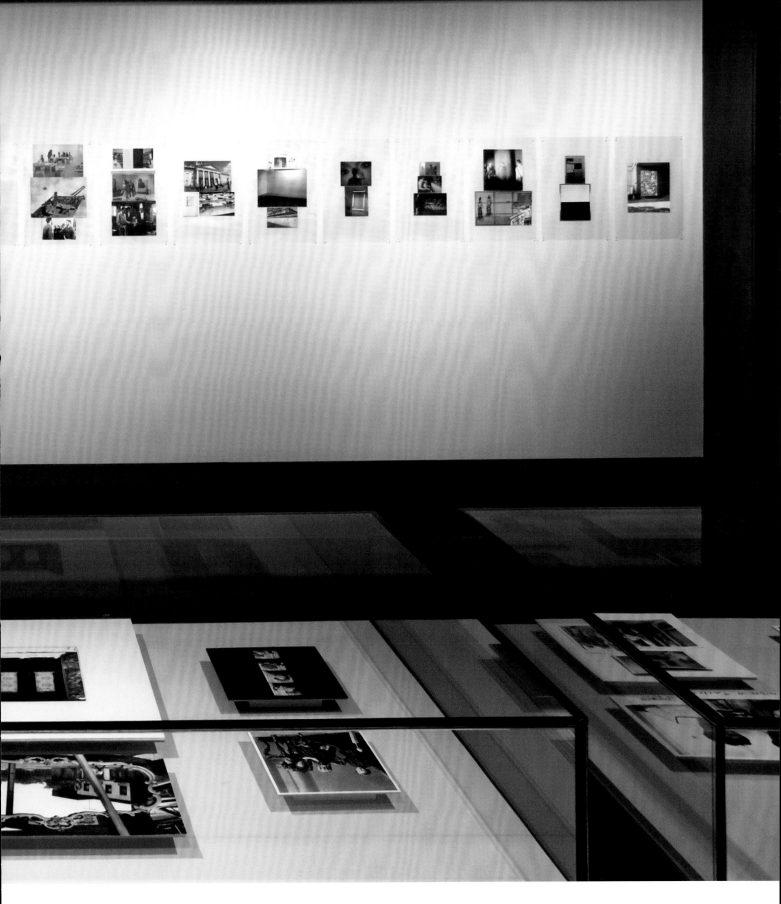

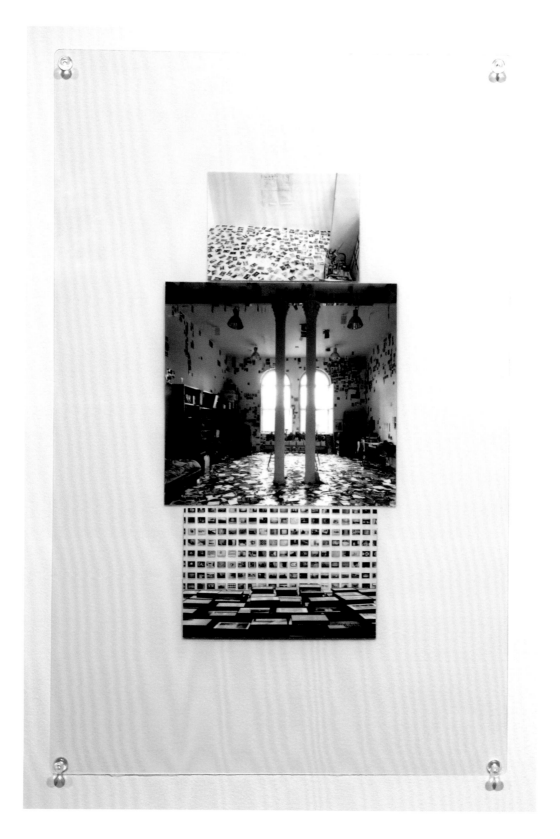

198

previous pages/ Exhibition view, McCord
Museum, Montreal.

above and opposite/ *Album X*, 2010.
Image montage in plastic laminate,
80 panels, 44.5 x 29 cm (17 1/2 x 11 1/2 in)
each, view of panels 52 and 53. Collection of
Musée d'art contemporain de Montréal.

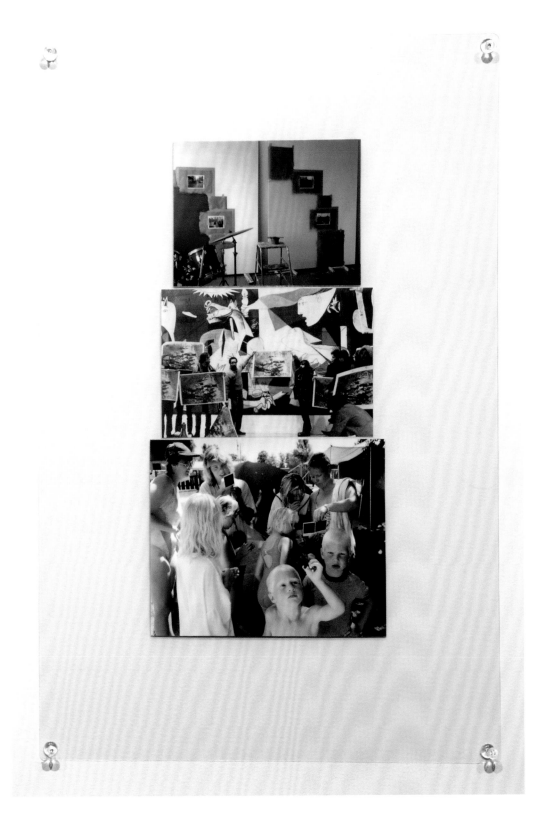

199

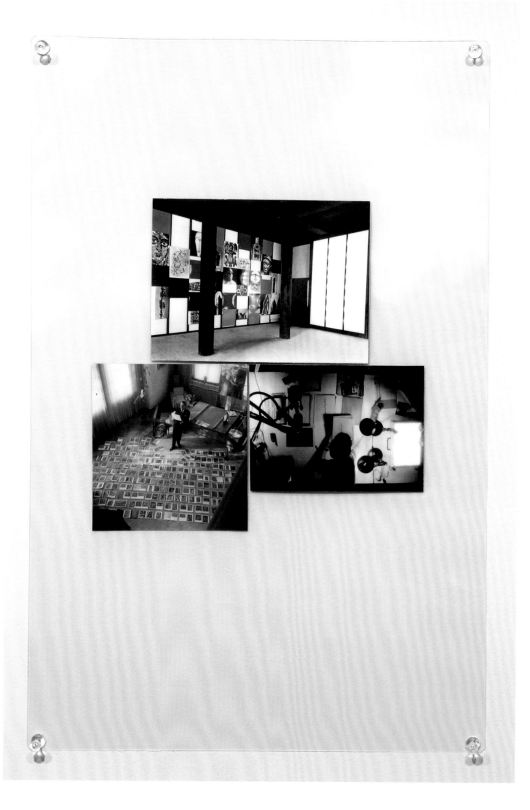

above and opposite/ *Album X*, 2010.
Image montage in plastic laminate,
80 panels, 44.5 x 29 cm (17 1/2 x 11 1/2 in)
each, view of panels 54 and 55. Collection of
Musée d'art contemporain de Montréal.

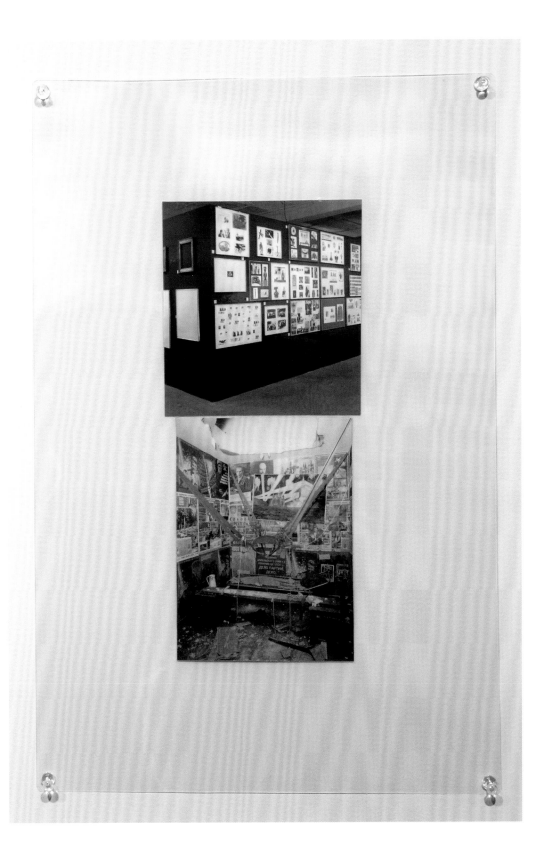

201

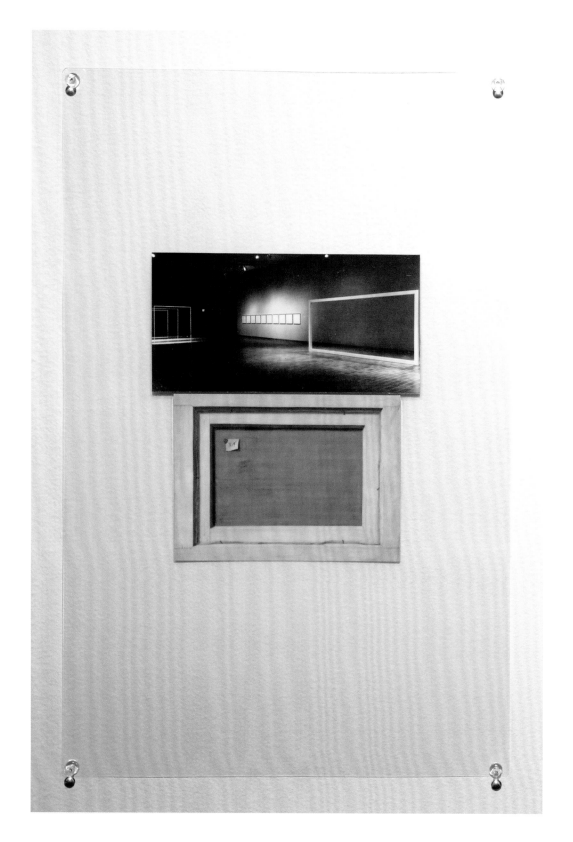

above and opposite/ *Album X*, 2010.
Image montage in plastic laminate,
80 panels, 44.5 x 29 cm (17 1/2 x 11 1/2 in)
each, view of panels 62 and 63. Collection of
Musée d'art contemporain de Montréal.

LUIS JACOB

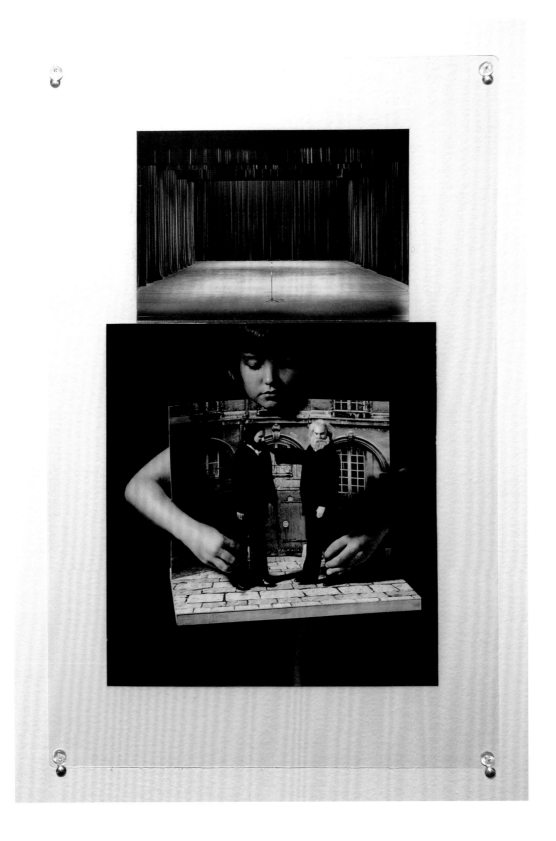

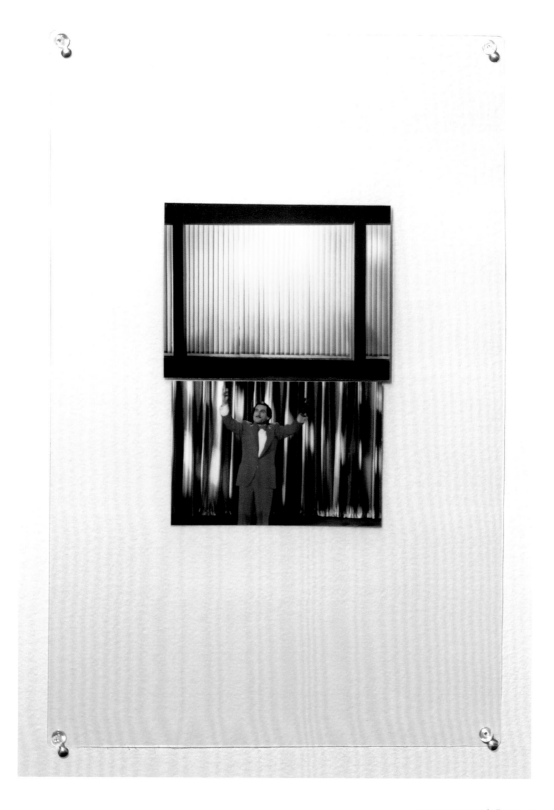

above and opposite/ *Album X*, 2010.
Image montage in plastic laminate,
80 panels, 44.5 x 29 cm (17 1/2 x 11 1/2 in)
each, view of panels 64 and 65. Collection of
Musée d'art contemporain de Montréal.

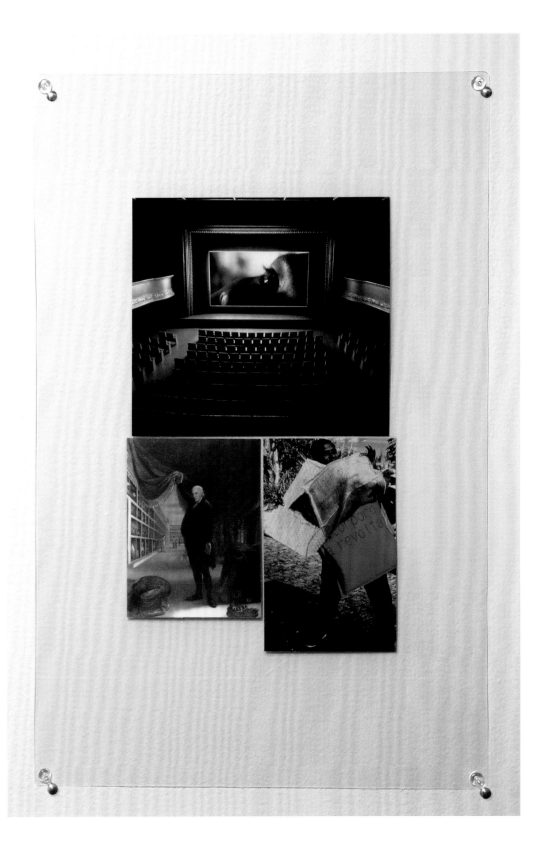

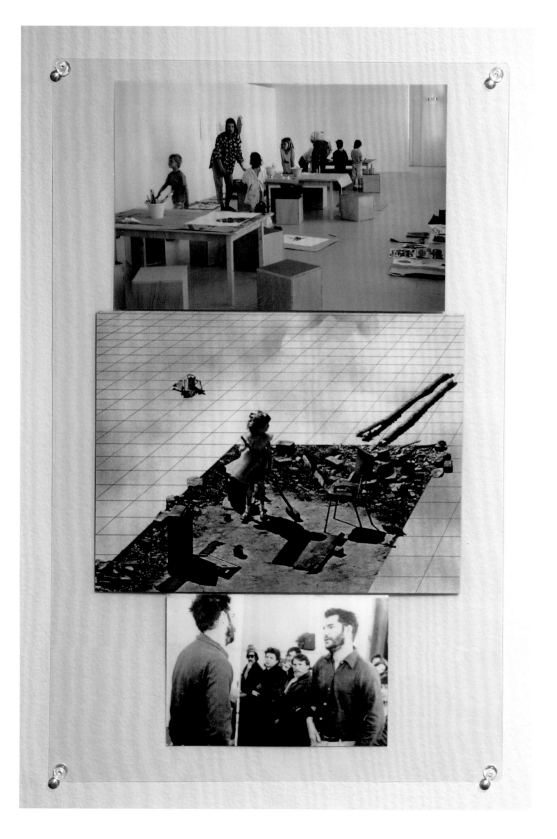

above and opposite/ *Album X*, 2010.
Image montage in plastic laminate,
80 panels, 44.5 x 29 cm (17 1/2 x 11 1/2 in)
each, view of panels 72 and 73. Collection of
Musée d'art contemporain de Montréal.

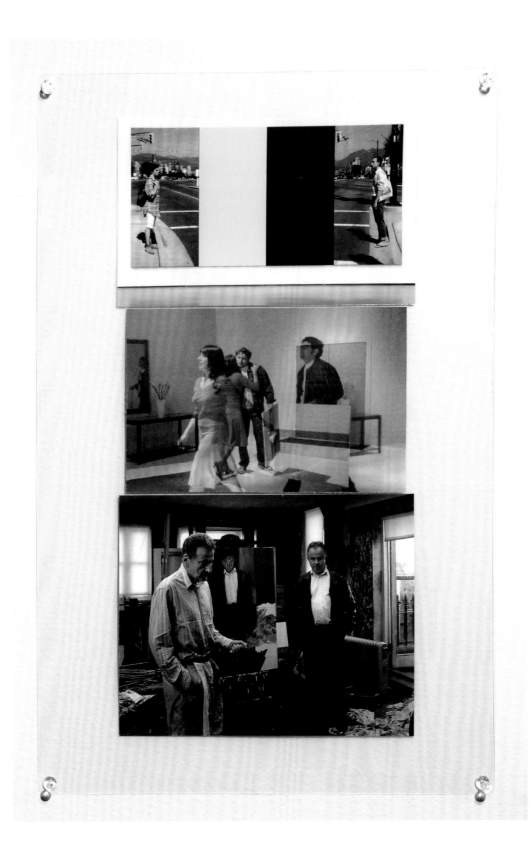

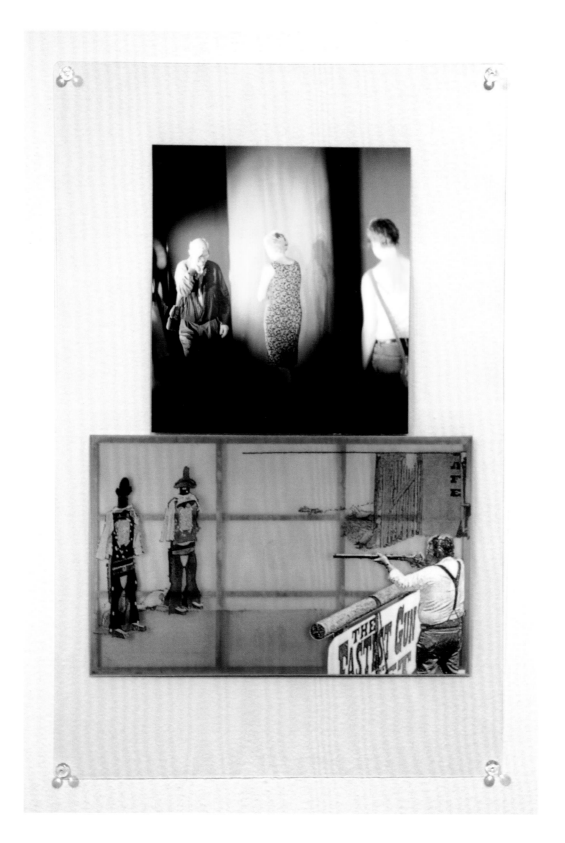

above and opposite/ *Album X*, 2010.
Image montage in plastic laminate,
80 panels, 44.5 x 29 cm (17 1/2 x 11 1/2 in)
each, view of panels 79 and 78. Collection of
Musée d'art contemporain de Montréal.

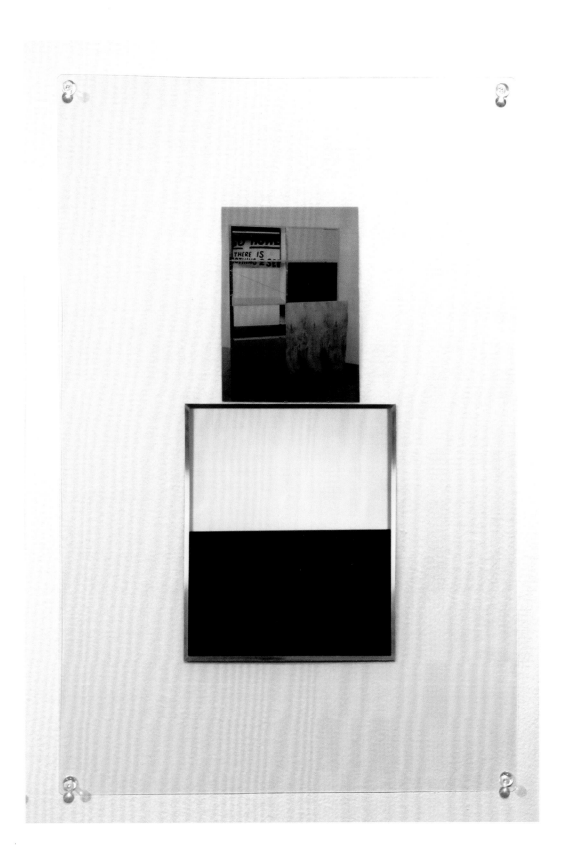

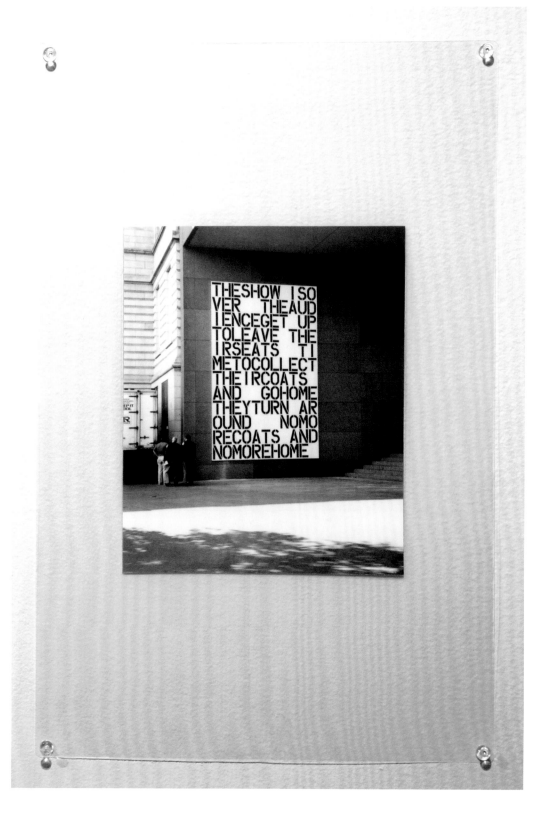

Album X, 2010.
Image montage in plastic laminate,
80 panels, 44.5 x 29 cm (17 1/2 x 11 1/2 in)
each, view of panel 80. Collection of Musée
d'art contemporain de Montréal.

211

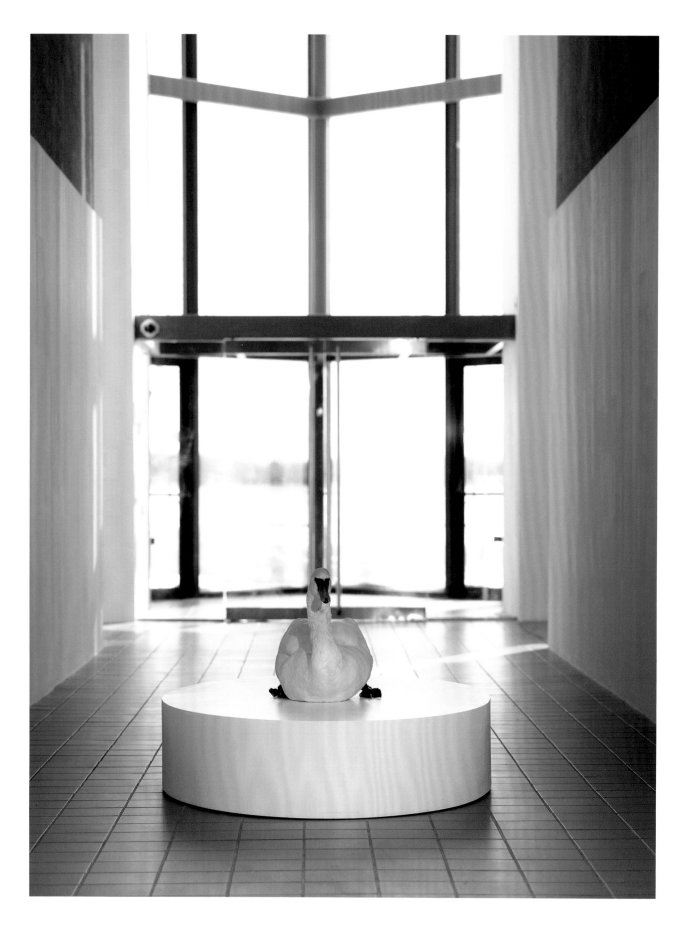

LUIS JACOB

GROUNDLESS IN THE MUSEUM: ANARCHISM AND THE LIVING WORK OF ART

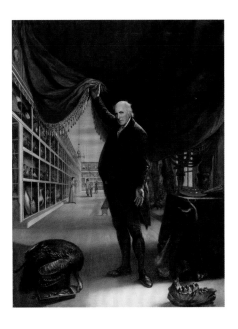

213

In 1967, the two artists Allan Kaprow and Robert Smithson had a conversation focused on the question "What is a Museum?" They began their dialogue by tackling the relationship between Art and Life—how close, or how distant, can Art and Life become within the context of the art museum? Kaprow stated,

> Museums tend to make increasing concessions to the idea of art and life being related. What's wrong with their version of this is that they provide canned life, an aestheticised illustration of life. 'Life' in the museum is like making love in a cemetery.

Kaprow's words might strike a chord with many of us, and remind us of the atmosphere of some museums we have visited in the past.

This painting by Charles Willson Peale, titled *The Artist in His Museum* depicts the painter lifting a curtain and signaling in a gesture of welcome, for those of us in front of the canvas to enter his private museum, which, it turns out, is filled with biological specimens—what Kaprow described as "canned life"—the bodies of dead animals displayed in glass vitrines. The resemblance between the typical nineteenth century museum—such as the British Museum in London—and mausoleums—such as the Rosehill Mausoleum in Chicago—has been frequently observed. This similarity between museum and mausoleum holds true even in attempts to 'jazz up' the museum building, as in Daniel Liebeskind's recent architectural expansion to the Royal Ontario Museum in Toronto. Though outdoors the building might appear updated to the twenty-first century, indoors the function of the museum remains the same as a storehouse of skeletons, dead objects presented as 'history'.

This function of the museum as cemetery haunts the art museum, too, and the works of art that we find there—cold, dead objects on display in a cold, dead environment.

I confess that I would find pleasure in playing this game of resemblances, but then I would run the risk of "thinking in clichés". I believe there is something 'anarchist' at stake here. Through a Google image-search it's easy enough to find many examples of museum buildings that look like mausoleums; but Kaprow's point—his idea that Life appears in the museum only in its "canned" form—would elude us. Thinking in clichés does not let us off the hook; it does not accomplish the more difficult task of thinking 'in action', for ourselves.

The problem with clichés, from an anarchist perspective, is not that they are necessarily *wrong ideas*, so much as they are the *dead* version of ideas. Clichés are readymade thoughts, thoughts performed automatically—thinking performed in a 'default setting', if you will. Clichés are thoughts inherited unthinkingly from others, rather than thought digested by us through the filter of our own experiences. Thinking in clichés, then, is the "canned" form of thinking in action, and is as far removed from actual thinking as the canned laughter in a television comedy is from real, joyous laughter. Clichés are the dead version of ideas—ideas lacking the spark of life. The recognition that there is a *dead* version of things, and a *living* version of things, strikes me as a profoundly anarchist recognition.

A classic example of this is the anarchist conception of democracy. For anarchists, voting every four years can be provisionally called "democratic", but only by reference to the "canned" version of democracy—not democracy understood as direct democracy, self-representation, and every-day participation in the decisions that affect our lives. For an anarchist, democracy-by-vote is what you get after you remove the principle of "democracy" from actual democracy—it's the dead skeleton compared to the living organism. Why is that? If democracy is supposed to mean the ability to participate in the decisions that affect your life, then being able to vote—to choose between A and B—is the false version of this decision-making, since the very option between A and B on your ballot was a decision made beforehand, over which the voter has no choice. You vote between Liberals and Conservatives; you choose between Republicans and Democrats. For anarchists, however, 'making a choice' is not the same as 'making a decision'. This is so because making a decision is a creative act, the result of which is to produce the options in terms of which choices are made.

Much like the difference between 'thinking in clichés' and 'thinking in action', we may say that voting is in fact 'making a decision' but in a default setting. Voting is like canned life, the taxidermy version of the living experience of making a decision. (I am reminded of the anarchist slogan, "If voting changes anything they'd make it illegal.") On the other hand, making a decision in your life entails real, living uncertainty, the experience of a kind of 'groundlessness' where even the option between A or B remains as something not yet given to you. Making a decision requires an open-endedness compared to which voting appears as an impoverishment of the imagination with regards to its own freedoms.

Artists have ceaselessly tried to invent images that allow us to perceive the difference between the dead version of things, and the living version of things. Some of these images are better than others, of course; but I believe that this is what all artists are endeavouring to do, when they are involved in making Art. One of the prototypes of this effort, in the tradition of European painting, is provided by the story of Pygmalion and Galatea.

214

In Jean-Léon Gérôme's painting *Pygmalion and Galatea*, we see that what the artist strives for is not necessarily a 'realistic' representation of a living model in sculpture, a representation which no matter how realistic would retain its 'thingness' as cold stone—but rather what the artist strives for is an artwork that is itself alive, the 'living'—not canned—version of Life. In this painting, the marble sculpture responds to the artist's desire for *the living version of things*, by miraculously becoming an animated body and grabbing him in a kiss.

It is unfortunate that in paintings like this, which we inherit from a long pictorial tradition, the artistic (and, I claim, *anarchistic*) desire for the living version of things is mixed or confused with patriarchal desires—the sexist fantasy of an inert, female object waiting for the masterful touch of the male artist who will give it life and meaning. Here, life and death, flesh and stone, strangely co-inhabit the same body, while the artist Pygmalion and the sculpture-come-alive Galatea are depicted as existing on unequal footing—he stands upon a worker's block, she on a pedestal. I believe that the patriarchal desire embodied by their encounter is represented by the small sculpture in the background on the right-hand side, as a female body whose essence is depicted as primarily seductive, a body that achieves its subjectivity by turning itself into an object of someone else's desire. But different narratives are possible, even within this sexist pictorial tradition....

left/ Jean-Léon Gérôme, *Pygmalion and Galatea*, 1865–1870.

right/ Jean-Léon Gérôme, *Working in Marble*, 1890. Dahesh Art Museum of Art.

Gérôme's painting *Working in Marble*, while repeating many of the same tropes as his own *Pygmalion and Galatea*, presents a rather different version of the story. In this painting, we see Gérôme himself—the artist—accompanied by a model whom he is in the process of depicting in a marble carving. The difference between

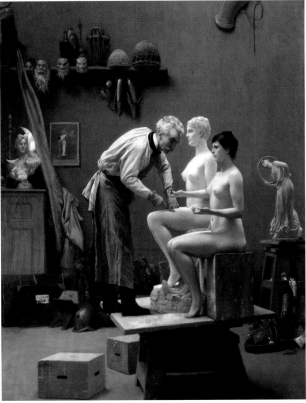

the living model and the inert marble sculpture is clear—life and death do not occupy the same body, as in Galatea's body, but a gap separates the two. The difference between life and death, though represented as a clear difference between two distinct bodies, appears nonetheless as a surrealistic difference, as an uncanny mirroring, repetition, or act of camouflage. The three figures—model, artist, and sculpture—are here placed on equal footing and share the space of the same pedestal. Already this marks a significant departure from the previous painting. And notice: the little sculpture in the background has morphed from an image of feminine seduction, in *Pygmalion and Galatea*, to one that here I would describe as an image of the experience of groundlessness. A dancer crosses the empty space of the hoop she is holding and, like Alice in Wonderland about to cross the looking-glass, the dancer seems to be discovering a new reality on the other side of the round hole, a reality where model, artist and sculpture are intertwined, and exist as distinct bodies placed on equal footing to create a single grouping. Gérôme's earlier *Pygmalion and Galatea* appears on this canvas as well, as a small reproduction pinned to the wall on the left, offering a point of contrast to this new narrative where, to my eyes, different desires are represented.

Let's return now to Kaprow and Smithson's conversation. Immediately prior to Kaprow's statement quoted earlier, Smithson had said:

> It seems that now there's a tendency to try to liven things up in museums, and that the whole idea of the museum seems to be tending more towards entertainment. It's taking on more and more of the aspects of a discotheque and less and less the aspects of art. So, I think that the best thing you can say about museums is that they really are nullifying in terms of action, and I think that this is one of their major virtues. It seems that your position [that is, Kaprow's position] is one that is concerned with what's happening. I'm interested for the most part in what's not happening, that area between events which could be called the gap. This gap exists in the blank and void regions or settings that we never look at. A museum devoted to different kinds of emptiness could be developed.

I admit these are astonishing remarks. Here, Smithson is in agreement with Kaprow, on the idea that museums are involved in a kind of negation. For Kaprow, it's the negation of the living version of things, for the sake of the dead or taxidermy version of things; for Smithson, it's the *negation*—the 'nullification'—of action. It's not certain what exactly Smithson meant by the cryptic phrase "nullifying in terms of action", but one thing is for sure: he considers this negative aspect of museums as a virtue, rather than as a fault that needs to be overcome. He prefaced his comments earlier in the conversation, by saying, "I think the nullity implied in the museum is actually one of its major assets, and that this should be realised and accentuated. The museum tends to exclude any kind of life-forcing position."

There is a nice double meaning here. Museums "exclude any kind of life-forcing position" in the sense that, as mausoleums, they exclude anything having to do with life-forces—vital energies, making love, what I have been calling *the living aspect of things*. But in a different way, museums can be understood to "exclude any kind of life-forcing position" in the sense, perhaps, that "Life" is that very thing that cannot be forced. I believe that Smithson embraced both of these meanings.

What does this Life that cannot be forced look like? Slavoj Zizek begins his book *Tarrying With the Negative* with an attempt to illustrate this "Life that cannot be forced". He writes:

216

The most sublime image that emerged in the political upheavals of the last years... was undoubtedly the unique picture from the time of the violent overthrow of Ceausescu in Romania: the rebels waving the national flag with the red star, the Communist symbol, cut out, so that instead of the symbol standing for the organising principle of the national life, there was nothing but a hole in its centre. It is difficult to imagine a more salient index of the 'open' character of a historical situation "in its becoming"... of that intermediate phase when the former Master-Signifier, although it has already lost the hegemonical power, has not yet been replaced by the new one. The sublime enthusiasm this picture bears witness to is in no way affected by the fact that we now know how the events were actually manipulated [by the Secret Police]: for us as well as for most of the participants themselves, all this became visible in retrospect, and what really matters is that the masses who poured into the streets of Bucharest 'experienced' the situation as 'open', that they participated in the unique intermediate state of passage from one discourse (social link) to another, when, for a brief, passing moment, the hole in the symbolic order, became visible. The enthusiasm which carried them was literally the enthusiasm over this hole, not yet hegemonised by any positive ideological project; all ideological appropriations (from the nationalistic to the liberal-democratic) entered the stage afterwards and endeavoured to 'kidnap' the process which originally was not their own.

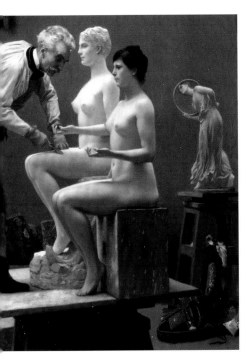

Jean-Léon Gérôme, *Working in Marble* (detail view), 1890. Dahesh Art Museum of Art.

This hole in the flag at the moment of rebellion—Zizek's image for "the 'open' character of a historical situation 'in its becoming'"—and, to my eyes, the image of Life in the process of being lived, of openness and profound ambiguity at the moment of making a decision in your life prior to the option between A or B—this hole reminds me of the dancer figurine in Gérôme's painting. The open hole of the hoop she holds, through which she peers and into which she inserts her body as she dances "in the unique intermediate state of passage from one social order to another", is a manifestation of the groundlessness of the experience of 'Life' in the mode of its freedom, Life no longer *and also not yet* subject to the forces that construct reality merely as a series of choices, thoughts performed in a default setting, and canned laughter. It's perfectly appropriate that Life in the process of its becoming should assume the form of a dancer, whose gestures disappear the moment they appear. But the dancer on the canvas is a strange figure, paradoxical, and suffused with ambiguity. This dancer is represented as a sculpture—as an object immobile, incapable of dancing, no longer in the mode of becoming—a sculpture depicted, in turn, as oil paints on canvas, upon the illusionistic surface of an Academic painting. This ambiguous nature of the open hole is articulated—is spelled out—in the three intertwined figures: the sculpture that is also a model that is also an artist, though simultaneously it cannot be an artist, because it cannot be a model, because it cannot be a sculpture—because this grouping is, in actuality, *a picture*.

I described this ambiguous dancer in the background as having discovered a new reality on the other side of the hole—reality itself experienced as a hole—a reality where the distinct roles of the artist, of the model, and of the work of art exist as distinct but on equal footing, each a strangely distorted mirror for the other, each a camouflaged version of the other, and all conjoined in an intricate dance between intertwined identities.

I often wonder why it is that we look at pictures—why at times we turn towards fictions in order to conceive something true. There are two pictures that I can see

217

Joan Semmel, *Intimacy-Autonomy*, 1974.
Oil on canvas, 127 x 248.92 cm (50 x 98 in).
Courtesy Alexander Gray Associates,
New York.

hanging at the entrance of Smithson's Museum of the Void. One of them is a painting
by Joan Semmel, titled *Intimacy-Autonomy*. Two young bodies are depicted lying on a
pink mattress of global, even cosmic, proportions, in a room whose walls are
painted the same blue as that of a clear day when you can see forever. The setting
is one of intimacy: a woman and a man lie naked, their bodies are turned towards
one another but they are not touching. A gap runs down the middle of the canvas
and separates them, though an invisible energy, a consciousness, seems to unite
them as well. That consciousness belongs to the viewer in front of the work of
art. We might presume that the woman's body on the right is the artist's own,
but the image as a whole presents us with a scenario of ambiguous identities.
The viewpoint orienting the scene allows the viewer to as easily identify with the
man's body as with the woman's. Outside of the fiction's frame, on this 'real'
space in front of the picture, where I stand, I will identify as being either male
or female—as being either bisexual, or heterosexual, or homosexual—as being
brown-skinned, or black-skinned—as being middle-aged, or as having grown
old.... But within the fiction of the picture itself, I can as naturally see this leg,
this nipple, this forearm downy with hair as being like my own, while those two
breasts, that arm, that belly is 'yours', not mine—as I intuit that your soft penis,
which I see surrounded by reddish pubic hair, corresponds in mysterious ways to
my vagina, which 'you' do not see.

I might leave the Museum with my identity and the power of the Master-Signifier
intact, and walk away as that same brown-skinned, gay man that I was before. But
during the moment of my engagement with the artwork, when its nature as inert
object on the wall and my nature as living presence before it were intertwined,

during that moment when the art object opened its eye and spoke to me in alien tongues, I experienced something groundless and I glimpsed a hole in my reality. The experience does not render me into a free-floating existence without limits or conditions. "Groundless" is not the fantasy of limitless freedom with no sexual difference, no history to tie me down, no cultural traditions that separate the people of this earth, no constraints—an angelic freedom that admits to there being no living bodies, either. There *are* indeed the facts of a situation to which I am bound, within which I must always choose one path and not another, in the context of influences and compulsions from others who share my point of view and others who challenge it, others who wish to thwart my efforts or others who invite me to collaboration. "Groundless" is the idea that, from the viewpoint of Life as I live it, the meaning of these facts of my situation and of my having taken this path instead of another—the significance of these things is never written in stone, and never ceases to be an open question.

The second picture I see on exhibit at the entrance to Smithson's imaginary "museum devoted to different kinds of emptiness" is a photograph by Chris Curreri, titled *Model in the Sculptor's Studio*. The photograph performs an act of self-doubling—and depicts one, as well. A figure is folding in upon itself inside a sculptor's studio, a figure that I suspect is actually a stand-in for the artwork itself. I suspect this because the square frame of the photograph before me is echoed by the square platform on which the figure stands. The figure re-enacts the story of Pygmalion and Galatea. It is the work of art, depicted this time as a sculpture still in progress, still unfinished and not yet admitted to the cold and well-lit spaces of the art museum. This figure dwells inside the studio.

Here once again is Galatea, not in the form of stone that must against all odds transform into flesh, but Galatea in the form of that pliant and fleshy point of origin prior to petrification. We call that point of origin "the model"—the idea of the *artwork as model*, as picture of the world—and we can see in the strain of the model's pose, and in the tension of his hands, the tremendous effort that is required for the figure to simulate being a 'thing' that can function as such a model. But the model is not properly a thing, although it flirts with 'thingness'. The model is porous; and the effort of its pose is expended for the sake of constructing a hole within the density of its body open to something beyond. The figure appears to my vision perched upon its pedestal and framed inside the picture, but it does so in order to perform a vanishing act, as it, in turn, becomes a lens that frames a view of something else—no, not another 'thing', but a *space* paradoxically more substantial than itself.

This space is nothing special. It contains a work-table covered with tools, work in progress, and the leftovers of failed attempts at some uncertain task—attempts suspended in an intermediate state, not deemed as having produced art, but also not yet considered as garbage worth discarding. The studio is that living realm where you, the artist, never know for sure when the artwork has been completed, because the rationale for making the work is created along with the work itself.

The studio, in Curreri's picture, serves as a theatre-set for "Life" in the aspect of its freedom. Inside the studio there exists, for the artist, no stamp of approval from the Master-Signifier that confirms, once and for all, that Art has been accomplished. That confirmation comes later, outside the studio's four walls, in the Museum; and sometimes it does not come at all. Art museums contain objects whose origin was in every case a place of uncertainty. Museums provide a place of rest for the artwork; but that is not where the artwork lives. Art lives whenever I approach the

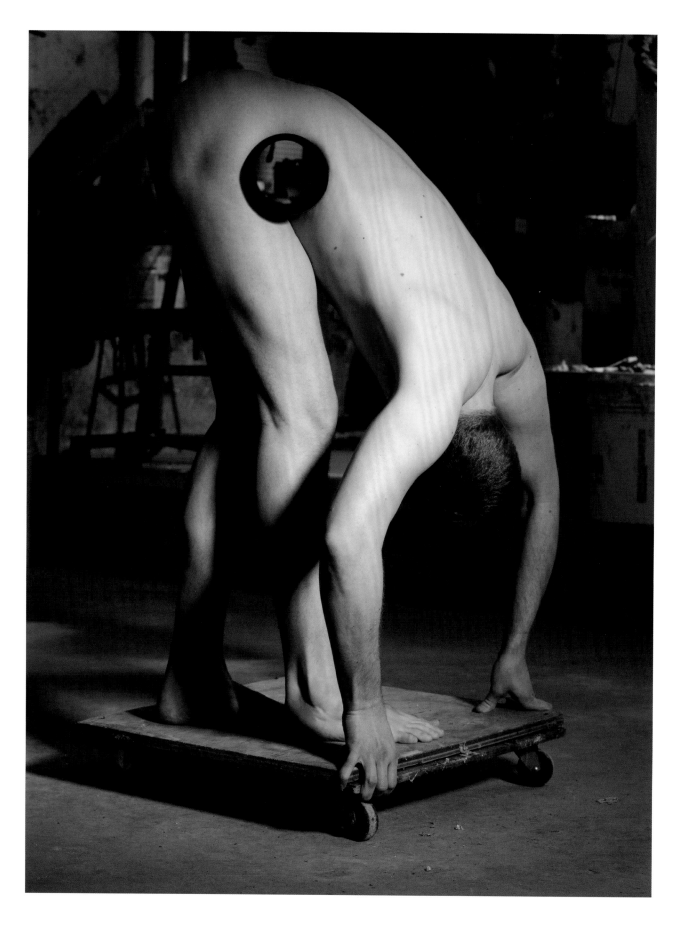

work stored in the museum with the hypothesis that the work's objective forms—its colours, its shapes, its textures, its sounds, its iconography, its gestures—are a reflection or echo outside of myself, of the forms of my own experience as a living presence—the hypothesis that the interplay of those sensible forms of which the artwork is made intertwine and correspond in mysterious ways to the dynamic of forms of that which, by definition, I cannot see—my Life experienced in its becoming—which I cannot see *as such* because I am one who lives it.

"Life" points us towards the possibility of a negative power—the black monochrome of the anarchist's flag—an ever-renewable incipiency suspicious of "positive ideological projects". "Life" responds to forces wishing to usurp it by ceasing to be, and by transforming into the taxidermy version of itself. Museums do connect with Life, but not when museums become 'user-friendly' places of entertainment. Museums connect with Life through paths that in every case remain to be created by each of us. "Life" cannot be forced, and admits to no shortcuts; it turns to ice if we try. Art reminds us that we can be at home in the hole, and nowhere else.

This text was first presented at the Second North American Anarchist Studies Network Conference, Toronto, 15 January 2011.

LUIS JACOB CURRICULUM VITAE

1971/ Born in Lima, Peru
1994/ BA in Semiotics and Philosophy, University of Toronto, Canada

SOLO EXHIBITIONS

2012/ . Show Your Wound, Birch Libralato, Toronto, Canada
. Show Your Wound, Galerie Max Mayer, Düsseldorf, Germany
. A finger in the pie, A foot in the door, A leg in quicksand, Kunsthalle Lingen, Germany

2011/ . The Eye, The Hole, The Picture, presented as part of Le Mois de la Photo à Montréal, McCord Museum, Montreal, Canada
. Pictures at an Exhibition, Museum of Canadian Contemporary Art, Toronto, Canada

2010/ . Without Persons, Art in General, New York City, USA
. Tableaux: Pictures at an Exhibition, Darling Foundry, Montreal, Canada
. Manual, Action Art Actuel, Saint-Jean-Sur-Richelieu, Canada

2009/ . 7 Pictures of Nothing Repeated Four Times, In Gratitude, Städtisches Museum Abteiberg, Mönchengladbach, Germany (catalogue)
. Without Persons, Union Gallery, Queens University, Kingston, Canada
. They Sleep With One Eye Open, Birch Libralato, Toronto, Canada

2008/ . PKM Gallery, presented as part of Platform Seoul 2008, Seoul, South Korea
. The Thing, September Gallery, Berlin, Germany
. Without Persons, presented as part of Nuit Blanche 2008, Maple Leaf Gardens, Toronto, Canada
. A Dance for Those of Us Whose Hearts Have Turned to Ice, Musée d'art de Joliette, Canada
. Wildflowers of Manitoba (with Noam Gonick), Wilde Gallery, presented as part of the Berlinale 58. Internationale Filmfestspiele Berlin, Germany; Glenbow Museum, presented as part of the Sled Island Festival, Calgary, Canada; Justina M Barnicke Gallery, University of Toronto, Canada
. Habitat, Kunstverein in Hamburg, Germany (catalogue)

2007/ . A Dance for Those of Us Whose Hearts Have Turned to Ice, and Other Works, Morris and Helen Belkin Art Gallery at the University of British Columbia, Vancouver, Canada
. A Dance for Those of Us Whose Hearts Have Turned to Ice..., Birch Libralato, Toronto, Canada
. Wildflowers of Manitoba (with Noam Gonick), Plug In ICA, Winnipeg; Museum of Canadian Contemporary Art, presented as part of Toronto International Film Festival 2007, Toronto, Canada; Parisian Laundry, presented as part of La Biennale de Montréal, Canada

2006/ . Just Do It!, The Khyber Centre for the Arts, Halifax, Canada

. Habitat, Art Gallery of Ontario, Toronto, Canada
. Open Your Mouth and Your Mind Will Follow, Articule Gallery, Montreal; Artspace Gallery, Peterborough; AKA Gallery, Saskatoon; The NEW Gallery, Calgary, Canada
. Flashlight, Toronto Sculpture Garden, Toronto, Canada

2004/ . Adamant, Robert Birch Gallery, Toronto, Canada

2002/ . Collapsing New Buildings, Latitude 53 Society of Artists, Edmonton, Canada

2001/ . Saving Face, Eric Arthur Gallery, Faculty of Architecture, Landscape and Design, University of Toronto
. Collapsing New Buildings, Helen Pitt Gallery, Vancouver, Canada
. Robert Birch Gallery, Toronto, Canada

2000/ . ALBUM, Anoush Gallery, Toronto, Canada

GROUP EXHIBITIONS

2012/ . Pop Politics: Activism at 33 Revolutions, CA2M—Centro de Arte Dos de Mayo, Madrid, Spain (catalogue)
. Schaubilder—Stratgien der Visualisierung in der Kunst/Diagrams—Strategies of Visualisation in the Arts, Bielefelder Kunstverein, Germany (catalogue)
. Learning for Life, Henie-Onstad Kunstsenter, Oslo, Norway
. Taipei Biennial 2012: Modern Monsters / Death and Life in Fiction, Taipei Museum of Fine Arts, Taiwan (catalogue)
. Surplus Authors, Witte de With Contemporary Art, Rotterdam, The Netherlands
. Oh, Canada, MASS MoCA, Massachusetts Museum of Contemporary Art, North Adams, USA (catalogue)
. It is what it is. Or is it?, Contemporary Art Museum, Houston, USA (catalogue)
. Rollercoaster. Het beeld in de 21e eeuw / Rollercoaster. The image in the 21st century, MOTI, Museum of the Image, Breda, The Netherlands
. Animism, e-flux, New York City, USA
. Discontinued Colours, Agnes Etherington Art Centre, Kingston, Canada (curated by Jan Allen)

2011/ . Animism, Generali Foundation, Vienna, Austria (catalogue)
. Contour 2011: 5th Biennial of Moving Image, Mechelen, Belgium

2010/ . Dance with Camera, Contemporary Art Museum, Houston; Scottsdale Museum of Contemporary Art, USA (catalogue)
. An Unpardonable Sin, Castillo/Corrales, Paris, France
. Second Hand, IMO Gallery, Copenhagen, Denmark
. Haunted: Contemporary Photography/Video/Performance, Solomon R Guggenheim Museum, New York City, USA; Guggenheim Museum Bilbao, Spain (catalogue)
. Animism, Extra City Kunsthal Antwerpen; Kunsthalle Bern, Switzerland

2009/
- Collider, Margini Arte Contemporanea, Massa MS, Italy
- Dance with Camera, Institute of Contemporary Art (ICA), University of Pennsylvania, Philadelphia, USA (catalogue)
- What a Wonderful World, The 2009 Göteborg International Biennial for Contemporary Art, Göteborg, Sweden (catalogue)
- "Images Recalled—Bilder auf Abruf" 3. Fotofestival Mannheim Ludwigshafen Heidelberg, Kunstverein Ludwigshafen, Germany (catalogue)
- New Entries! Museion, Museum of Modern and Contemporary Art, Bolzano, Italy
- Search For the Spirit, presented as part of "All That is Solid Melts Into Air", Mechelen, Belgium (catalogue)
- OPEN e v+ a 2009/Reading the City, Limerick, Ireland (catalogue)

2008/
- If We Can't Get It Together, The Power Plant Contemporary Art Gallery, Toronto, Canada (catalogue)
- The Order of Things, Museum voor Hedendaagse Kunst, Antwerp, Belgium
- Sweet Dreams, Justina M. Barnicke Gallery, University of Toronto, Canada
- Idyll: 3 Exhibitions, Morris and Helen Belkin Art Gallery at the University of British Columbia, Vancouver, Canada
- I_wanna_see_YOU, YYZ Artists' Outlet, Toronto, Canada; De Overslag, Eindhoven, The Netherlands (catalogue)
- Martian Museum of Terrestrial Art, Barbican Art Gallery, London, UK (catalogue)

2007/
- documenta12, Museum Fridericianum, Kassel, Germany (catalogue)
- Street Scene, Murray Guy Gallery, New York, USA

2006/
- We Can Do This Now, The Power Plant Contemporary Art Gallery, Toronto, Canada
- The Networked City, (collaboration with Amos Latteier) InterAccess and University for Peace, Toronto, Canada

2005/
- Downtime: Constructing Leisure, New Langton Arts, San Francisco, USA (catalogue)

2004/
- Spill #2: Meniscus—Luis Jacob, Kelly Mark, Corin Sworn, Kara Uzelman, Artspeak Gallery, Vancouver, Canada

2003/
- Tomorrow's News, Gallery Hippolyte, Helsinki, Finland (co-organised with Gallery 101, Ottawa, Canada)

2002/
- Better Worlds: Activist and Utopian Projects by Artists, Agnes Etherington Arts Centre, Queen's University, Kingston, Canada (catalogue)
- Art is Activism, Fine Arts Building Gallery, University of Alberta, Edmonton, Canada

2001/
- House Guests: Contemporary Art at the Grange, Art Gallery of Ontario, Toronto, Canada (catalogue)

CURATORIAL PROJECTS

2009/
- Funkaesthetics (co-curated with Pan Wendt), Justina M Barnicke Gallery, University of Toronto and Confederation Centre of the Arts, Charlottetown, Canada (catalogue)

2002/
- Golden Streams: Artists' Collaboration and Exchange in the 1970s, Blackwood Gallery, University of Toronto at Mississauga (catalogue)

1999/
- 1000 Gracias: Germaine Koh and Lucy Pullen (co-curated with Francois Dion), Optica, Montreal, Canada
- The JDs Years: 1980s Queer Zine Culture from Toronto, Art Metropole, Toronto; Helen Pitt Gallery, Vancouver, Canada

1998/
- Made in Mexico/Made in Venezuela, Art Metropole, Toronto, Canada
- See-Thru Cities (co-curated with Adrian Blackwell and Kika Thorne), Christopher Cutts Gallery, Toronto, Canada

SELECTED PUBLICATIONS

- Luis Jacob, ed, "Commerce by Artists", Art Metropole, Toronto, 2011
- Luis Jacob, "Album IX" insert in *A Prior Magazine* issue #21, vzw Mark and Koninklijke Academie van Schone Kunsten, Ghent, 2011
- Luis Jacob, "Album IV", Art Metropole, Toronto, 2010
- Meike Behm and Yilmaz Dziewior, eds, "Luis Jacob: Towards a Theory of Impressionist and Expressionist Spectatorship", Kunstverein in Hamburg and Verlag der Buchhandlung Walther König, Köln, 2009
- Susanne Titz, ed. "7 Pictures of Nothing Repeated Four Times, In Gratitude", Städtisches Museum Abteiberg, Mönchengladbach and Verlag der Buchhandlung Walther König, Köln, 2009
- Noam Gonick and Luis Jacob, "Wildflowers of Manitoba", Illingworth Kerr Gallery, Calgary, 2008
- Luis Jacob, "Album VII/ÐÐ VII", SAMUSO: Space for Contemporary Art, Seoul, 2008
- Luis Jacob, "Album V", insert in *Das Magazin der Kulturstiftung des Bundes*, Halle an der Saale, 2007
- Luis Jacob, "Album III", Verlag der Buchhandlung Walther König, Köln, 2007
- Luis Jacob, "ALBUM", Art Metropole, Toronto, 2002

223

© 2013 Black Dog Publishing Limited, the artist and authors. All rights reserved.

Black Dog Publishing Limited
10A Acton Street
London WC1X 9NG

t. +44 (0)207 713 5097
f. +44 (0)207 713 8682
e. info@blackdogonline.com

All opinions expressed within this publication are those of the authors and artist
and not necessarily of the publisher.

Designed by Rachel Pfleger at Black Dog Publishing.
Edited by Luis Jacob.
Translated by Prudence Ivey (English) and Rachel Pfleger (French)
at Black Dog Publishing.

British Library Cataloguing-in-Publication Data.
A CIP record for this book is available from the British Library.

ISBN 978 1 908966 06 3

Black Dog Publishing is an environmentally responsible company. *Luis Jacob:
Seeing is Believing* is printed on sustainably sourced paper. Printed in Germany by
Optimal Media.

Photo credits: Elaine Yau: front cover; Luis Jacob: 34–35, 46–49, 212; Achim Kukulies:
135; Guy L'Heureux (Darling Foundry): 15, 18–21, 32–33, 36–45, 56–59, 68–69; Toni
Hafkenscheid (Museum of Contemporary Canadian Art): 81–87, 99–103, 110–117,
121–133, 141; Marilyn Aitken (McCord Museum): 6, 150–173, 177, 181, 185, 189,
193, 195–210.

McCORD MUSEUM

 TORONTO Culture

 BMO Financial Group

CISCO

ONTARIO ARTS COUNCIL
CONSEIL DES ARTS DE L'ONTARIO

Canada Council
for the Arts

Conseil des Arts
du Canada

mocca
museum of
contemporary
canadian art

F

recycle
reuse
reduce

art design fashion
history photography
theory and things

www.blackdogonline.com

black dog
publishing

london uk